Zaida Ben-Yusuf

Zaida Ben-Yusuf

Zaida Ben-Yusuf

New York Portrait Photographer

Frank H. Goodyear III

With contributions by

Elizabeth O. Wiley and Jobyl A. Boone

National Portrait Gallery, Smithsonian Institution

MERRELL

LONDON · NEW YORK

First published 2008 by Merrell Publishers Limited

Merrell Publishers Limited
Head office
81 Southwark Street
London SE1 0HX

New York office
740 Broadway, Suite 1202
New York, NY 10003

merrellpublishers.com

in association with

National Portrait Gallery
Smithsonian Institution
8th and F Streets, NW
Washington, D.C.

Mailing address:
MRC 973/P.O. Box 37012
Washington, D.C. 20013-7012

An exhibition at the National Portrait Gallery, Smithsonian Institution, Washington, D.C., April 11–September 1, 2008

Produced by Merrell Publishers Limited
Project coordinator: Dru Dowdy,
 National Portrait Gallery
Designed by Dennis Bailey
Copy-edited by Elisabeth Ingles
Proof-read by Charlotte Rundall
Indexed by Diana LeCore

FRONT JACKET/COVER ILLUSTRATION
Miss Ben-Yusuf Announces a Private View of Photographs
Zaida Ben-Yusuf
Platinum print, 1899
The Museum of Modern Art, New York; gift of Mrs. Elizabeth Guy Bullock. Photograph © The Museum of Modern Art/Licensed by SCALA/ART Resource, NY (see p. 58).

A catalog record for this book is available from the Library of Congress.

British Library Cataloguing-in-Publication Data:
Goodyear, Frank Henry, 1967–
Zaida Ben-Yusuf : New York portrait photographer
1. Ben-Yusuf, Zaida – Exhibitions 2. Portrait photography –
New York (State) – New York – Exhibitions
I. Title II. National Portrait Gallery (Smithsonian Institution)
770.9'2

ISBN-13: 978-1-8589-4439-5 (hardcover edition)
ISBN-10: 1-8589-4439-2 (hardcover edition)
ISBN-13: 978-1-8589-4440-1 (softcover edition)
ISBN-10: 1-8589-4440-6 (softcover edition)

Printed and bound in Singapore

Contents

Foreword

This foreword is the last I will write as director of the National Portrait Gallery, and it is in celebration of an exhibition that represents the best of the Portrait Gallery's past work and future expectations. When I first arrived here as chief historian in 1974, the museum had only just begun to acquire photographs. The collection grew remarkably, and so did our photography exhibition schedule. Not long after my appointment as director in 2000, I received a call from the publisher of *ARTnews*, America's magazine of record for the arts. He proposed an exhibition that would commemorate the magazine's one-hundredth birthday by featuring one hundred photographs it had commissioned of artists. That telephone call resulted in *Portrait of the Art World*, which the Portrait Gallery presented in 2002.

As it happened, biblically put, one exhibition begat another. Frank Goodyear, one of our rising generation of Portrait Gallery curators and then only recently hired as assistant curator of photographs, worked on *Portrait of the Art World*, and in the process discovered the artistry of Zaida Ben-Yusuf (1869–1933), whose contribution to early twentieth-century photography had been all but forgotten. Curators live for such moments. Goodyear's interest was piqued, his research skills invested, and the result—aided by a Smithsonian Scholarly Studies Grant—is the exhibition and catalogue we celebrate here, a "recovery," in his phrasing, of Ben-Yusuf's life and work.

But although this exhibition has a history of its own, its great importance, of course, lies in what it achieves. Ben-Yusuf, as it turns out, was more than a fine photographer. Hers was a career built at the intersection of the development of photography itself and of the situation—one might say the predicament—of professional women in her time.

Ben-Yusuf's aspirations to artistry in photography were clear. However, they were expressed in the context of a form that represented to many at the beginning of the twentieth century—only some fifty years after the medium's invention—more a product of the machine than of the spirit. Because the world of painting still seemed the standard of what constituted art, Ben-Yusuf took her place with those photographers who sought the expressive effects of a painted portrait in some of their work. To those both within and outside photography who disagreed with the emphasis on mood, soft effect, and carefully constructed studio arrangement, these were the aspirations of "fuzzographers." To the converted, however, they represented claims for a now universally accepted medium.

Ben-Yusuf also stood at the crossroads of art and commerce. Although some of the images that she took and that were taken of her were entirely products of artistic ambition, many—most—were creations that had to satisfy the customer as

well as the artist. In some ways, portraiture of any type suffers to some degree in reputation among critics because of this question of "ownership" of the final vision. Yet when the portraitist is truly an artist, there should be no doubt who shapes the image. Ben-Yusuf might have collaborated with her subject on the pose, for example, but she was unquestionably in charge of the result. Among the many pleasures of this volume is the occasional discussion of the issue of getting just the right pose. I particularly recommend Goodyear's discussion of Ben-Yusuf extracting from the then-Governor Theodore Roosevelt a pose that was not predictably cheerful but instead reflective of his "weary determination."

Ben-Yusuf straddled yet another border: between the role of women understood as only domestic and supportive and their role as full participants in professional life. There was at least room for female photographers to practice their craft or art in the late nineteenth and early twentieth centuries (even the most misogynistic observer would have had to grant Julia Margaret Cameron of Great Britain, for example, the status of a great artist), but true respect was rare and even then grudging. "Unlike the gun, the racquet and the oar, the camera offers a field where women can compete with men upon equal terms," opines Clarence Moore, who goes on to conclude that "a lack of concentration and sustained effort often stands in the way of complete success."

So there was a lot of nonsense that Zaida Ben-Yusuf had to put up with. And other challenges hinted at: the dilemma of being a foreigner, really a double foreigner, both British and Algerian in origin, and—one can only speculate— perhaps also the dilemma of sexuality, undiscussed, but conceivably another element underpinning her "bohemian exoticism." Yet for a time she persisted—and succeeded—before disappearing from her profession and then from the attention of historians of photography.

It may have taken a century, but it is time to give Ben-Yusuf her due.

Marc Pachter
Director, National Portrait Gallery
January 2008

Acknowledgments

Many people have provided invaluable assistance and advice during the course of my effort to recover the life and photographs of Zaida Ben-Yusuf. Their ideas have enriched the content of this project, and their support has made this research a rewarding adventure.

I am indebted to my colleagues at the National Portrait Gallery, especially Ann Shumard, Amy Baskette, and Dru Dowdy. Research assistants Elizabeth Wiley, Jobyl A. Boone and Chris Saks have likewise shown special dedication to this project.

A Smithsonian Scholarly Studies Grant permitted me to visit more than a dozen different museums and archives. Many thanks to the curators, librarians, and archivists who assisted me during these visits, especially those at the Archives of American Art, Smithsonian Institution; The Art Museum, Princeton University; the Beinecke Rare Book and Manuscript Library, Yale University; the Center for Creative Photography, University of Arizona; the Delaware Art Museum; the Harvard Theater Collection; the Library of Congress; The Metropolitan Museum of Art; The Museum of Modern Art; the National Academy Museum; the National Museum of American History, Smithsonian Institution; the National Media Museum (Bradford, England); the New York Public Library; the Philadelphia Museum of Art; and the Pratt Institute.

I have also benefited from contributions from scholars of the history of photography who have been generous in sharing their expertise with me. I should particularly like to thank Beverly Brannan and Verna Curtis at the Library of Congress; Peter Bunnell at Princeton University; Michelle Delaney at the National Museum of American History; Jane Fletcher at the National Media Museum; Sarah Greenough at the National Gallery of Art; William Homer at the University of Delaware; George R. Rinhart; and Edward Robinson.

And, finally, I am especially grateful to have such a caring family. To Mom and Dad, Alison and Charlie, Grace and Adam, and my dear wife, Anne, thank you for all your love and support.

Frank H. Goodyear III
Assistant Curator of Photography
National Portrait Gallery, Smithsonian Institution
Washington, D.C.

Lenders to the Exhibition

Archives of American Art, Smithsonian Institution, Washington, D.C.

ARTnews Collection, New York City

Beinecke Rare Book and Manuscript Library, Yale University, New Haven, Connecticut

Center for Creative Photography, University of Arizona, Tucson

John Sloan Manuscript Collection, Delaware Art Museum, Wilmington

The J. Paul Getty Museum, Los Angeles

Harvard Theater Collection, Harvard University, Cambridge, Massachusetts

Library of Congress, Washington, D.C.

The Metropolitan Museum of Art, New York City, Alfred Stieglitz Collection

The Museum of Modern Art, New York City

National Academy Museum, New York City

National Museum of American History, Behring Center, Smithsonian Institution, Washington, D.C.

National Portrait Gallery, Smithsonian Institution, Washington, D.C.

New York Public Library, Astor, Lenox, and Tilden Foundations

Philadelphia Museum of Art, Pennsylvania

Private collection

George R. Rinhart

Zaida Ben-Yusuf:
Portrait Photographer in the New New York

Frank H. Goodyear III,
National Portrait Gallery, Smithsonian Institution

In October 1897, the twenty-seven-year-old Zaida Ben-Yusuf wrote to Alfred Stieglitz regarding his invitation to submit photographs to *Camera Notes*, the new journal that he edited in conjunction with the Camera Club of New York. Stieglitz had probably seen her photography at the New York studio she had opened earlier that spring, and he may have heard about her participation in the most recent London Photographic Salon, where his own work was also on display. Ben-Yusuf wrote in her letter that she was "very pleased to hear that my work has attracted any favorable comment, because I am very much in earnest about it all." She went on to explain that George Davison, a British landscape photographer, had mentored her and that "he has done much to inspire me with a wish to accomplish portraits which are equal in merit to his landscapes."[1] Several months later, Stieglitz published the first example of her work in the pages of *Camera Notes*. This act, by one of the most prominent figures in pictorial photography, was significant to Ben-Yusuf and helped to ignite her young career.

Alfred Stieglitz
Edward Steichen
Autochrome, 1907
The Metropolitan Museum of Art,
New York, Alfred Stieglitz Collection,
1955 (55.635.10)

George Davison
Frederick Hollyer
Platinum print, 1895
Victoria and Albert Museum, London

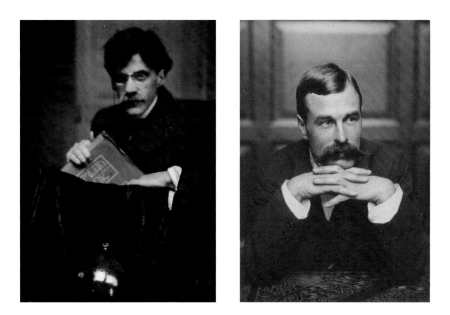

Over the next ten years Ben-Yusuf was one of the most actively engaged professional photographers in New York City. From her Fifth Avenue studio, she produced hundreds of portraits, many depicting the leading men and women of her day. To supplement her income and further her reputation, she published her photographs widely—in more than two dozen different periodicals—and contributed magazine articles on a variety of photographic topics, including work she had completed on two trips to the Far East. During this period, she exhibited regularly throughout the United States, Europe, and, on one occasion, in Russia. As a testament to her renown, she served as a spokeswoman for the Eastman Kodak Company and was profiled in several magazines and newspapers. And yet, though Ben-Yusuf was well regarded in her day, the memory of her achievement as a photographer, and her photographs themselves, have largely vanished. The object of this study is to recover her extraordinary life and work, and, in so doing, to explore further the significant role of women in the field of late nineteenth- and early twentieth-century American photography. Because Ben-Yusuf photographed so

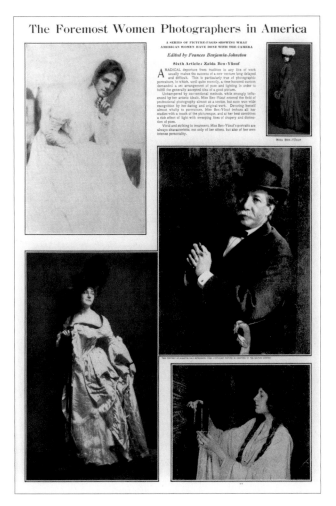

The Foremost Women Photographers in America

"The Foremost Women Photographers in America"
Ladies' Home Journal, November 1901
Library of Congress, Washington, D.C.

many noteworthy figures who lived in or visited New York City, it also brings into sharper focus the different cultural and political networks that made up America's largest city at the dawn of the new century.[2]

Of the many individuals who became involved in pictorial photography during this period, Ben-Yusuf stands apart for her commitment to the artistic possibilities of photographic portraiture. Certainly, other American photographers—most notably Gertrude Käsebier, Edward Steichen, and F. Holland Day—dedicated attention to this genre; however, as Ben-Yusuf noted in her letter to Stieglitz, and as she demonstrated in subsequent years, she—unlike others—focused her work almost exclusively on the art of portraiture. At this time many women with aspirations to pursue photography as a hobby were encouraged to direct their cameras toward still-life subjects or the human figure within a domestic setting. As one writer noted in 1890, "photography makes a strong appeal to woman for the reason that she may study and practice it in her own home, in the very corner of her room; yet it does not interfere with daily duties and pleasures by demanding of its disciples long, tedious courses of study and hours of unremitting practice to gain mere facility in the use of the camera's parts."[3] For Ben-Yusuf, though, photography was much more than a recreational pursuit. Instead, she saw it both as a profession that could support her as a single woman and as an art form that required study and practice.[4]

Portraiture fulfilled both of these goals for Ben-Yusuf. Needing to earn an income, yet aspiring to create work that merited display and critical attention, she found that portraiture gave her a means to make her mark. Furthermore, as a British citizen newly arrived in the United States, she discovered that her work provided her with a new-found community and lessened the sense of displacement she must have experienced at leaving her former home behind. As her career and fame grew, portraiture also put her in contact with celebrities, a segment of society to which she seemed drawn. Indeed, despite her relative youth, Ben-Yusuf attracted to her studio many prominent political, artistic, literary, and theatrical figures. At times these portraits were commissioned by a particular magazine or publicity agent; yet Ben-Yusuf was also sought out through her reputation as a portraitist.

While Ben-Yusuf did not favor subjects because of their age, vocation, or political stripe, she did gravitate toward individuals of accomplishment, or at least

those with ambition. Her subjects were rarely members of New York's social elite—Ward McAllister's celebrated "Four Hundred"—but rather a relatively newer generation of upwardly mobile men and women. Fashion-conscious, she was concerned about portraying her subjects in a manner consistent with the most contemporary ideas regarding style and taste. As she explained in her essay of 1901, "The New Photography—What It Has Done and Is Doing for Modern Portraiture," "my best work represents the man of brains, either in business or professional life, and the thoroughly modern, modish, clever woman, and these are the ones I enjoy photographing when I am in the mood for work. The 'sloppy,' so-called artistic person does not appeal to me at all, for I consider a perfectly set-up modern woman to be as picturesque a subject as any ever portrayed."[5]

Ben-Yusuf's commitment to photographic portraiture was not made lightly, nor was her studio simply a business enterprise. Rather, she pursued this interest with an increasing understanding of the field's history and its leading practitioners, and a desire to make a lasting contribution. Her ambition reveals itself in the quality and number of photographs that she created and in the variety of photography-related activities in which she immersed herself. Others commented upon it, including the critic Sadakichi Hartmann, who wrote one of the first and most revealing profiles of the young photographer. In describing his initial meeting with Ben-Yusuf, Hartmann related that "during a conversation the lady told me that her ambition was to become the 'Mrs. Cameron of America,' i.e., to photograph all celebrities she could get hold of, and thus go down to posterity with them as a depicter of geniuses." Although he dismissed the notion that she had attained the status of Julia Margaret Cameron, the British photographer renowned for her artistic portraits of England's cultural elite, Hartmann acknowledged then and later the central place that Ben-Yusuf occupied among the practitioners of this photographic genre.[6]

In addition to photographing different men and women in New York, Ben-Yusuf frequently posed before her own camera and, on at least one occasion, before that of one other photographer, F. Holland Day, arguably the most progressive fine art photographer then working in the United States. From these images—of which there exist no fewer than ten self-portraits—Ben-Yusuf's interest in experimenting with her artistic persona and her desire to complicate traditional understandings of male and female identity are readily evident. The often elaborate outfits she wore and the striking poses she assumed in these photographs suggest her allegiance to a

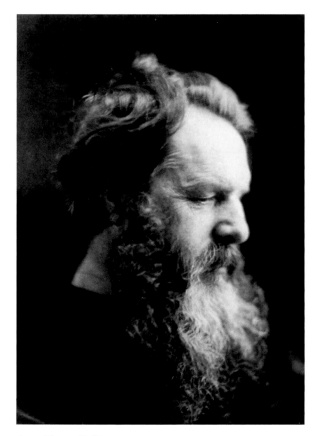

James Thomas Fields
Julia Margaret Cameron
Albumen silver print, 1869
National Portrait Gallery, Smithsonian Institution, Washington, D.C.

bohemian femininity that at times followed convention and at other times sabotaged it. The scholar Martha Banta has explored how women have carried out such activities for the purpose of "masking, camouflage, inversions, and play." The photographs that Ben-Yusuf took of herself and those of her by Day reflect her unique engagement with the community of photographers and artists with whom she associated at the turn of the century. Together with her larger body of work, they present a compelling portrait of a thoroughly modern woman—one who was very much the architect of her own life.[7]

Although she accomplished much, Ben-Yusuf's photographic career lasted little more than a decade. By the time of her fortieth birthday in 1909, she had moved on—both literally and figuratively—to a new home and new professional opportunities. Several factors motivated her to give up her photographic studio, including, most importantly, the economic challenge of operating such a business. She had experienced a great deal during the ten years or so since opening her first studio in 1897. Photographic practices in America and Europe had likewise undergone profound changes during this period. What Stieglitz described as an "organized movement" in pictorial photography—begun in the early 1890s—had brought about important breakthroughs in the field, but by 1910 had largely disintegrated.[8] Although Ben-Yusuf was only one contributor to this movement, her story reveals much about the campaign to legitimize photography as a fine art medium and the effort of women to carve out a niche in this genre.

<p style="text-align:center">⥈</p>

Miss Ben-Yusuf made her first photograph 3½ years ago. It was begun as a pastime, and after a very slight experience in this way [she] decided to adopt it as a profession. Particularly, making portraits. The venture appeared to be a success from the start, although she is the only photographer in New York who conducts her business without the traditional showcase at the door. The studio is one ordinarily used by a painter and contains no vestige of the customary painted background scenery or iron head rests, etc. Miss Ben-Yusuf had not had the advantage of any previous artistic training and knew almost nothing of the contemporary photographer when she first took up the work. Her greatest wish had always been towards an artistic profession however. [She] has done all her own developing and printing so far, as her idea is to take only so much business as she can conveniently handle alone, or with one assistant. [She was] born in England [and] came to America several years ago.[9]

Ben-Yusuf drafted this short autobiographical statement for the photographer Frances Benjamin Johnston, most probably on the eve of Johnston's trip to Paris in July 1900 to oversee the installation of an exhibition of photographs by thirty American women at that summer's Universal Exposition. Earlier that spring, Stieglitz had angrily canceled a larger exhibition of American salon photographers after officials in Paris refused to hang photographs alongside more traditional artistic media in the Art Section. To fill the designated space and to make up for the potential absence of American photographers at this world fair, the organizers asked Johnston to arrange, at short notice, an exhibition that highlighted women's achievements in the photographic arts.[10] From her home in Washington, D.C.,

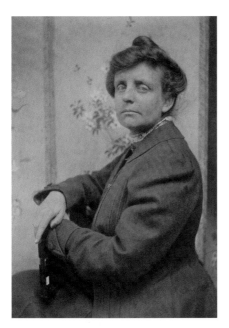

Frances Benjamin Johnston
Gertrude Käsebier
Platinum print, 1905
National Portrait Gallery, Smithsonian
Institution, Washington, D.C.

Johnston wrote to Stieglitz asking him to review her list of potential contributors and to suggest names of other female photographers who merited inclusion in this new show. His perfunctory letter back to Johnston suggested that her list was "complete." In closing, he added, perhaps patronizingly, "the women in this country are certainly doing great photographic work and deserve much commendation for their efforts."[11]

Although Ben-Yusuf had exhibited her work on at least ten separate occasions prior to the Universal Exposition, her contribution of five photographs to this prestigious international exhibition and her correspondence with Johnston, one of the most accomplished female photographers of the day, presented an opportunity to reflect on her rapid ascent within professional and fine art photography circles.[12] By the summer of 1900, Ben-Yusuf had attained a degree of success that she probably could not have imagined at the time when she opened her studio in the spring of 1897. This sense of pride at what she had accomplished is evident in her descriptive profile. Not only was she a frequent contributor to the important photographic exhibitions that opened each fall, but her work was also regularly reproduced and reviewed in a variety of popular magazines and photographic journals. Furthermore, by this time she could claim to have photographed the man who was then running for vice president, Theodore Roosevelt, not to mention such national luminaries as the author William Dean Howells, the actress Julia Marlowe, and Major General Leonard Wood.

It is noteworthy that the details of the profile Ben-Yusuf supplied to Johnston are fairly accurate, suggesting a sense of self-confidence that at times eluded other aspiring artists. While she is somewhat too self-congratulatory in claiming that she was the only photographer in New York to conduct her portrait business along new lines, she is otherwise a reliable autobiographer. As she claims, she had in fact taken up photography only a few years earlier, first as a pastime and then as a profession. Furthermore, from the start, she had always embraced portraiture and saw in it the opportunity to break new aesthetic ground. And she worked largely by herself, having moved to New York from England only several years before.[13]

Yet this straightforward narrative—while factually trustworthy and probably consistent with the type of profile that Johnston desired—tends to simplify a more complex personal history. Although it acknowledges the country of Ben-Yusuf's birth, it neglects details about her upbringing in England and the reasons for her decision to emigrate to America. While the evidence is limited, the two-and-a-half decades of her life in England before she left for New York in 1895 appear not to have been a picture of harmony and stability. In particular, her parents' troubled marriage and financial difficulties contributed to a childhood in which she was never in one place for long. This sense of rootlessness persisted throughout her life.

Ben-Yusuf was born Esther Zeghdda Ben Youseph Nathan on November 21, 1869, in the Hammersmith district of west London. Her birth certificate lists her

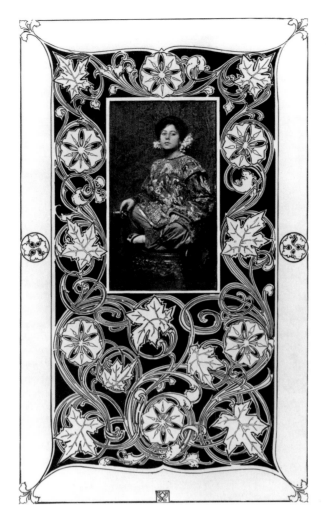

Pearl Benton as a Chinese Idol in "San Toy"
Zaida Ben-Yusuf
Halftone print published in
Metropolitan Magazine, March 1901
Library of Congress, Washington, D.C.

father, Mustafa Ben Youseph Nathan, as simply a "gentleman." (Nathan may have been a name that the family adopted after settling in England; however, they used it infrequently. Ben-Yusuf became the more common spelling of the family's surname.) Mustafa Ben-Yusuf was a native of Algeria and had first visited England in 1862. He returned several years later and enrolled at King's College, London, with the goal of obtaining a medical degree. Yet his studies did not last. At various times over the next two decades he tried to resume his coursework, including a stint at the University of Cambridge, but he never fulfilled the requirements necessary to graduate. His hope was to return to Algiers to work as a physician, but this seems never to have occurred. Instead, during this period he met Anna Kind, a German living in England. The two married and ultimately had four daughters together, Zaida being the eldest.[14]

The lack of a reliable source of income probably caused the couple to separate not long after their last child was born in 1877. Both before and after this separation, Mustafa Ben-Yusuf presented, in towns throughout England, illustrated lectures on the history and culture of Algeria, in part to aid the Moslem Mission Society, an organization to which he belonged. Despite his membership, it is unclear what role religion played in the life of the Ben-Yusuf family. For Zaida, it does not appear to have been a central concern; however, as the daughter of an Algerian

father with a distinctly Middle Eastern name, Zaida was surely aware—especially after relocating to New York—that her ethnicity shaped how others perceived her. It is also unclear whether the proceeds from Mustafa's periodic lectures were enough to support him and his family, or whether he possessed other sources of income. After their separation, both husband and wife sought new lines of work. Anna Ben-Yusuf retained custody of the children and lived in Ramsgate, an English coastal town, where she worked as a governess. By this time Zaida was enrolled in school.[15]

In the next decade, two major—and most probably related—developments occurred that further disrupted life for Zaida Ben-Yusuf and her three sisters. At some time during this period Mustafa Ben-Yusuf remarried and, once again living in London, began to establish a second family. He and his new bride, Henrietta Crane, had a daughter in 1891, whom they named Zaida. Whether the elder Zaida ever knew her father's new daughter or not, the birth and naming of this child suggest that the estrangement between her and her father was in all likelihood permanent. Two years later, Mustafa and Henrietta had a son named Mussa, but he died as an infant. By this time Mustafa Ben-Yusuf was working as a tavern owner.[16]

The second event involved the girls' mother and was surely no less difficult for them. Perhaps prompted by her former husband's new marriage, perhaps in response to the economic panic that gripped England following the collapse of that nation's largest bank, Baring Brothers, in 1890, Anna Ben-Yusuf decided to leave her daughters, and to resettle in America. Nothing is known about who took custody of the girls, but by 1891 Anna was working as a milliner in Boston. Her youngest daughter, Pearl, joined her in Boston in 1895 before embarking on a theatrical career under the stage name Pearl Benton. Anna Ben-Yusuf never remarried, nor did she return to England. Instead, she developed a successful career in the millinery trade, writing two books on the subject and later serving as an instructor in the Department of Domestic Arts at the Pratt Institute in Brooklyn. In 1909 she died, having recently opened her own millinery school at her apartment in New York.[17]

Her father's new marriage and her mother's emigration to America provide the backdrop for Zaida Ben-Yusuf's decision in 1895 to leave England for New York. No specific evidence exists to suggest why she decided to emigrate at this point, nor are there details about why she chose New York, or whether she traveled with anyone. According to a New York city directory, though, she settled initially in an apartment on the corner of Twenty-eighth Street and Fifth Avenue. Several blocks north of Madison Square, this apartment was above a fashionable jewelry store in an upwardly mobile neighborhood. There she worked as a milliner, the same trade in which her mother was involved and one to which it seems likely Zaida was introduced back in England.[18]

Working as a milliner fulfilled both an economic need and also a personal desire to be part of a specific profession. This independent attitude was, at least in part, inculcated by Ben-Yusuf's mother, who must have impressed upon her daughters the progressive opinions she held about women's work and equal rights. In an essay published in the *Boston Globe* during the same summer that her daughter settled in New York, Anna Ben-Yusuf wrote about the professional opportunities now available to American women and the wisdom of a rigorous education to prepare

"The Making and Trimming of a Hat"
Zaida Ben-Yusuf
Ladies' Home Journal, August 1898
Library of Congress, Washington, D.C.

them for working outside the home. Arguing that "a wise mother now-a-days brings up her daughter with the idea of self support, rather than dependence by marriage on (as in former days) a man," she explained that "it is no longer considered a degradation for a woman to work for her own living outside of domestic life. Especially is this true in this great country, where every woman claims her birthright of freedom and independence. American women are the pioneers of woman's elevation."[19]

Ben-Yusuf inherited not only her mother's interest in millinery, but also the desire to make a name for herself in this profession. For her, it was not enough simply to design and manufacture stylish hats for ladies. She also wanted to be known for her work and to pass on helpful advice to others. Toward this end, she published in the leading women's magazines several articles that provided readers with a variety of patterns and detailed instructions for making one's own hat. These articles suggest that Ben-Yusuf was well versed in both the techniques for crafting a hat and the latest trends in women's fashion. This concern for technique, for style, and for self-promotion would ultimately become hallmarks of her photographic portraiture.

Despite her apparent success in this trade, Ben-Yusuf chose not to share her experience as a milliner with Frances Benjamin Johnston or other members of the photographic community with whom she corresponded after turning to photography as a new career. Perhaps she believed that millinery's status as a profession did not measure up in the eyes of the circle of fine art photographers. Perhaps she thought that, like the subject of her upbringing in England, it was not relevant to an audience of photographers. Whatever the case, after several years working in the fashion business, Ben-Yusuf gave up millinery to pursue full-time her burgeoning interest in photography. Although she left the craft of millinery behind, this experience would shape how she approached her new chosen art form.

❧

For a woman to succeed in professional life is still, for all the betterment of woman's chances in the business world, a result marked more by its unusualness than by its frequency. Therefore it is all the more remarkable when a woman makes a success in her business or profession when she has done so by departing from the old lines and making innovations. Miss Zaida Ben-Yusuf's success as a photographer is due in large part to her having done this very thing—to her having struck out along new paths in commercial photography and dared to carry out in her business her ideals. The photography of Miss Ben-Yusuf is artistic in the extreme: her success is probably due to this. Of a thoroughly artistic temperament, the photographer brought to her work the enthusiasm, the imagination, the ideals of an artist.[20]

As this passage from an anonymous 1903 profile suggests, Ben-Yusuf's success in running a business was perceived to be as significant an achievement as her contributions to the field of portrait photography. Her decision to open her own photographic studio in the spring of 1897 did not represent the first instance of a woman operating such an enterprise; however, her ability to attract so many leading figures and to exhibit and publish many of these portraits elevated her to a select group of female photographic pioneers. Over the next ten years Ben-Yusuf would experience professional triumphs and a variety of challenges—some of which grew out of the economics of the photographic trade and others that were a by-product of her gender. Indeed, while more women took up photography during this period, their status in both that field and in society remained a contested issue.

Ben-Yusuf's embrace of photography coincided with a period that witnessed the first sustained involvement of women with this medium. Concurrent with the invention of the dry plate and the development of the handheld Kodak camera, first introduced in 1888, there arose a growing acceptance of—even enthusiasm for—women pursuing photography as both a hobby and a profession. Throughout the decade of the 1890s, popular magazines and photographic journals promoted these opportunities and celebrated outstanding female practitioners.[21] One of the leading figures in this campaign was Catherine Weed Barnes Ward, an editor at *American Amateur Photographer*, who for several years wrote a regular column about women and photography. Her advocacy for the admittance of women as members of photographic societies and for the inclusion of women's work in photographic exhibitions contributed to the rapid growth of women's participation in all aspects of the field. As she wrote in 1896:

I cannot speak too strongly as to women's taking up photography; it has far more in its favor than many of the so-called "fads" devised to kill time. It is not a selfish pleasure, and increased experience enables one to render often real service thereby to family and friends. . . . In my own case the work has brought many pleasant friendships, given increased powers of observation, thereby adding more delight to travel, and in countless other ways broadened and deepened my life.[22]

While some photography clubs continued to bar women, and men typically outnumbered women by four to one in juried photographic exhibitions at the century's end, an increasing number of women saw photography as a worthwhile pursuit. Often this interest began as a leisure activity, but as with Ben-Yusuf, the pastime occasionally grew into something larger.[23] As Ben-Yusuf explained to the journalist Richard Hines in 1899:

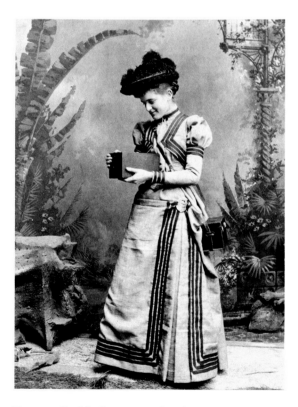

Eastman Kodak Company advertisement, 1889
George Eastman House, Rochester, New York, used with permission of Eastman Kodak Company

I took up photography at first for amusement, but only for a short time, as I was about to go abroad. While away, strange to say, I did not have the "Kodak craze" at all, as I made no views on my trip; but I showed one or two of my very limited number of prints to Mr. George Davison, of London, and he at once advised me to go ahead and make more, as he considered what I had done indicated the spirit of the new school of photography. Shortly after my return from Europe I arranged my studio and started to work seriously.[24]

Other accounts also credit the British landscape photographer as an important figure in encouraging her interest.[25]

It is most likely to have been Davison who suggested that Ben-Yusuf submit work to the 1896 salon exhibition sponsored by the Linked Ring, the London-based photographic society that he and Henry Peach Robinson founded in 1892. The jury's acceptance of her work, *A Portrait*—described by one British critic as "a dark, spectral-like form, with a faint, white face, free from any hint of odious detail or obvious verisimilitude such as might offend Mr. Whistler"[26]—further motivated her to continue working in this medium. Although British photographic societies and exhibition juries were slower on average than their American counterparts in accepting women into their ranks, Davison's encouragement surely influenced Ben-Yusuf's thinking about opening her own studio.

Ben-Yusuf's admiration for Davison is further significant because the British photographer had been a lightning rod in recent debates about the creative possibilities of photography. A strong supporter of a soft-focus aesthetic that shared attributes with Impressionism, Davison upset many of his photographic peers with his unorthodox prints and his highly opinionated writings. His occasional use of a simple pinhole camera—rather than one with a lens—was symptomatic of his interest in experimentation. When his pinhole landscape *The Onion Field* (above) won a medal at the annual exhibition of the prestigious Photographic Society of Great Britain in 1890, a controversy ensued that embraced many of the leading figures in British photography. Davison's leadership in the

effort to legitimize photography as a fine art medium and his commitment to challenging traditional notions of the craft won him great acclaim, but also a host of critics.[27] To Ben-Yusuf, he was an inspiration for pursuing a photographic career.

Upon returning to America from her trip to Europe in 1896, Ben-Yusuf settled in a new Fifth Avenue apartment about ten blocks south of her previous location. There she made preparations for opening her own commercial studio. Yet, as several profiles made explicit, the style in which she set this up—indeed, the very manner in which she approached the portrait trade—differed significantly from that of the vast majority of photographic portraitists then working in New York. A writer for the *New York Daily Tribune* noted as much upon visiting her in the fall of 1897:

Only six months ago the pretty studio at No. 124 Fifth Ave. was set up and this season has been the first in which Miss Ben-Yusuf has worked as a professional. Furnished with Oriental draperies and rugs, a couch strewn with gay colored pillows, a teakwood table and picturesque chairs, and mounting guard over all, a gilded and bejeweled Burmese god, stalling [*sic*] blandly from his corner pedestal under a canopy formed by a silky Yucatan hammock, the room where sitters are posed is as unlike the ordinary photographic gallery studio as possible.[28]

As the scholar Sarah Burns has explained, the last quarter of the nineteenth century witnessed an increased effort by artists to carve out a unique and marketable identity for themselves within the larger consumer culture. In addition to dress and public behavior, the studio was a prime locus for making one's mark. Many artists went to great lengths to fabricate an environment that supported their artistic goals.[29] Ben-Yusuf's work in creating a studio that was so markedly different from the typical—and one that strove to match the bohemian exoticism cultivated by the celebrated painter William Merritt Chase—suggests much about her personality and her desire to align herself with those photographers who sought to move the practice and art of photography beyond its past traditions. Ironically, by accentuating her cosmopolitanism with foreign-made furniture and *objets d'art*, Ben-Yusuf was consolidating her position within the highly codified world of the fine arts in New York.

Various descriptions of her public manner further the notion that Ben-Yusuf worked to project a stylish unconventionality. Again, the critic Sadakichi Hartmann provides insightful commentary in his 1899 profile: "Personally she is very fastidious in her taste, one of those peculiar persons who can only live in a room with wall paper of a most violent blue. In her dresses she is a second Mrs. Hoving, although not quite as eccentric. She attends Ibsen performances, and everything else that mildly stirs up the Bohemian circles; reads decadent literature, and fancies high-keyed pictures, such as out-shout each other in color, best."[30] The degree to which she affected this personality and the possibility that her public face changed over time can only be a matter for speculation; however, as a photographic portraitist dedicated to new ways of rendering an individual's likeness, Ben-Yusuf was a keen observer of her subjects and knew well how to convey an impression.

For all her concern for appearances and for nurturing a reputation as a progressive woman and a pictorial photographer, Ben-Yusuf also knew how to

create opportunities for herself. Despite having only recently arrived in New York, she moved quickly to secure assignments and to publish and exhibit her work. In the early years of her studio, she provided photographs for reproduction on advertising posters, sought out portrait commissions from local theaters, and negotiated relationships with a variety of the illustrated magazines and newspapers headquartered there. This period witnessed a revolution in the magazine business, with the introduction of new reproductive technologies and skyrocketing circulation growth.[31] Ben-Yusuf's first experience of publishing her photographic work predated the establishment of her studio, and within two years of its opening she was supplying images and occasionally articles to more than a dozen different periodicals. Such work appears to have paid relatively well. Whereas Ben-Yusuf might have received several dollars for one of her individual prints, magazines paid her at times a far greater amount for the right to publish her work. In the spring of 1898, for example, the editors of *Ladies' Home Journal* paid her eighty dollars for a two-part illustrated article on millinery.[32] As a single woman who depended upon this freelance income, Ben-Yusuf displayed great resourcefulness and adaptability.

"In Woman's Realm:
A Remarkable Woman Photographer"
Illustrated American,
November 11, 1898
Library of Congress, Washington, D.C.

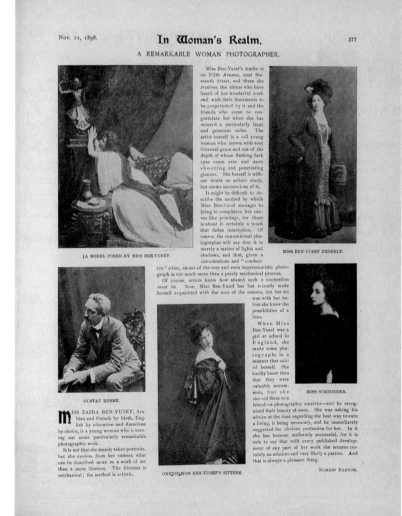

Although often as well dressed, she was a far cry from the domestic lady of leisure so often represented by American artists at the century's end.[33]

Her pursuit of such opportunities set Ben-Yusuf apart from the great majority of photographers with an interest in the medium's creative potential. Indeed, most who comprised this community saw themselves as amateurs working outside the demands of the marketplace. Believing that commerce would sully their efforts to transform photography into a fine art, these individuals defined themselves as being outside the world of the professional. It is noteworthy that many who chose the status of amateur did not rely on photography to sustain their livelihood. For them, photography was an independent activity, and some sought to exclude professional photographers from the exhibitions and publications that sprang up during this period. This tiered division was a hurdle that Ben-Yusuf often confronted in her efforts to establish a career as a portrait photographer with artistic ambitions.[34]

Although her photography on occasion may have been passed over by exhibition juries and dismissed on account of the perception that she worked solely as a professional, Ben-Yusuf acknowledged the distinction, sympathized with the pictorial photography movement, and admitted that the most important advances in the field were being initiated by amateurs. In her article of 1901 on "The New Photography," she explained:

It is to the influence of the amateur that the recent marked improvement in professional photography is due. I know this is a strong statement to make, but it is proved most conclusively in various ways. The amateur had time to think, and he was tired of the deadly monotony of the work that the professional was turning out in his mad desire for quantity. Soon the professional began abusing the amateur for making what he called "freaks," and the other retorted by demanding something more, or less, than the stereotyped painted background, a pedestal to lean his arm upon, and a highly polished print wherewith to show all these interesting details to his suffering friends. It is certain that the amateur, either by accident or design, has produced some fearful and wonderful things; but the aim was distinctly towards originality, and it made the professional wake up and abuse him, and—imitate him.[35]

Her regard for the amateur echoed sentiments expressed by numerous authors during this period.

Ben-Yusuf was circumspect about the changes that were occurring within the tradition of portrait photography as a result of the efforts toward a new fine art photography. As a professional, she responded not by turning inward or looking back, but rather by embracing aspects of this movement. One manifestation of her dedication to pictorial photography was her active participation in the different exhibitions that photographic societies were sponsoring during this period. Between 1896 and 1906, Ben-Yusuf contributed work to at least seventeen such shows. These exhibitions—though sponsored locally—typically featured the most compelling examples of contemporary photography throughout America and Europe, and attracted often extensive written commentary by the half-dozen or so journals devoted to the medium. Occasionally popular magazines also reviewed them. While some juries gave out awards, the majority embraced the belief that such

prizes detracted from the integrity of the exhibition, organizers arguing that having one's work chosen was enough of an honor.

Like most photographers, Ben-Yusuf was very deliberate about the work that she submitted for review. Although she exhibited certain images repeatedly, she tended to contribute new examples for each show. At times she was exceedingly self-conscious about the images she selected. Her concern for showing off an attractive selection of work reveals itself in a letter that she wrote to Alfred Stieglitz in the spring of 1901. Stieglitz was then in charge of organizing a selection of images by American photographers for the Glasgow International Exhibition. Ben-Yusuf had contributed work to three different exhibitions in the previous six months, and she found herself confounded about what to send to Stieglitz. She wrote: "I should very much like to be represented at Glasgow, but I absolutely don't know what to send. Nothing I have seems good enough. So if I disappoint you, you will know why."[36] Ultimately, Stieglitz accepted four works by her.

Such exhibitions enabled Ben-Yusuf to build a reputation not only for her commercial studio, but also among the community of New York photographers who were working to advance photography as a fine art medium. In addition to submitting prints for possible inclusion in these shows, she became involved in their organization. In the fall of 1898, for example, she was responsible for installing the decorations that adorned the galleries of the National Academy of Design, where an exhibition of photographs sponsored by the American Institute of the City of New York was being displayed. This involvement furthered her relationship with several others in the field, including Charles Berg, the exhibition's lead juror. During this time, Berg was serving as the head of the exhibitions committee at the Camera Club of New York, and Ben-Yusuf's work with him in preparing this exhibition may well have influenced the eventual decision to include her in a two-person show at the club's headquarters later that fall.

Installation at the Philadelphia Photographic Salon
William Rau
Gelatin silver print, 1899
National Museum of American History, Behring Center, Smithsonian Institution, Washington, D.C.

THE CAMERA CLUB
THREE WEST TWENTY-NINTH STREET

EXHIBITION OF PRINTS BY
Miss ZAIDA BEN YUSUF, of New York
AND
Miss FRANCES B. JOHNSTON, of Washington, D. C.
WEDNESDAY, NOVEMBER THE NINTH TO SATURDAY,
NOVEMBER THE TWENTY-SIXTH, 1898
FROM TEN A. M. TO SIX P. M. EIGHT TO TEN P. M

ADMIT
COMPLIMENTS OF MEMBER

Admission ticket to an exhibition of photographs
by Zaida Ben-Yusuf and Frances Benjamin Johnston at
the Camera Club of New York, November 9–26, 1898
Camera Club of New York Archives, Manuscripts and Archives
Division, New York Public Library, Astor, Lenox and Tilden
Foundations

Generally speaking, during this period exhibitions were group shows, the aim of which was to demonstrate the artists' achievements in different photographic genres and processes. While some hung the contributions of a particular person together on one wall or in one defined space, it was rare to dedicate an entire exhibition to a single individual. Yet, beginning in the fall of 1897, the Camera Club of New York—regarded as the foremost photographic society in New York and an incubator for pictorial photography—initiated a series of one- and two-person exhibitions that highlighted specific practitioners. Most of the participants were club members, and this program acted to focus attention on their recent accomplishments. Ben-Yusuf was not a member, a surprising fact given the level of her activity at the time within photographic circles.[37] Nevertheless, in November 1898 she was invited to hang her work alongside that of the non-resident club member Frances Benjamin Johnston. While Ben-Yusuf had exhibited in several group shows before, the opportunity to present her work within this venue and together with the highly regarded Johnston was surely a highlight of her early career.[38] The exhibition was a success, as it elicited numerous reviews and led the popular periodical, the *Illustrated American,* to publish a detailed profile of her. It also prompted a new series of commissions from different magazines and newspapers, including an opportunity several months later to photograph Theodore Roosevelt, then governor of New York.

Perhaps no other city in turn-of-the-century America was better suited than New York to accommodate someone with Ben-Yusuf's aspirations. Although the presence of more than two hundred commercial studios made her chosen field a competitive one, New York provided her with opportunities to market and showcase her work, and relatively few barriers to doing so. In addition to creating portraits for middle- and upper-class individuals and families, Ben-Yusuf took advantage of the rapidly increasing demand among the city's many publishers for photographic images of notable contemporary personalities. Furthermore, New York brought together and nurtured relationships among a large and diverse network of cultural figures. This milieu sustained her both professionally and as an emerging artist. While age-old conventions and expectations regarding women's status in society were being recast throughout the nation, New York allowed many women to transform themselves with startling rapidity. The almost overnight success of Ben-Yusuf's Fifth Avenue studio was a testament to her hard work and creative artistry and to the vitality of her adopted home.

❧

She is nothing if not original. It does not content her to stick to any beaten path or to pay attention to warnings against danger placed along the highway of photography. She resembles some of those uneasy spirits who sometimes join a party for a country walk and

keep you continually on pins and needles by jumping into the woods, or stalking across forbidden grounds regardless of man-traps and spring guns, and who are sure to bring to your attention some new plant or fruit or bird or animal that would otherwise escape your eyes. Some of the results of your rambling may be unsatisfactory; the plants may prove to be noxious, the mushrooms turn out poisonous toadstools, while the birds are as likely to be mud-hens as herons, but such people make you see and know new and interesting things by forcing them on your notice. And without the plagues of these restless souls our walks of life would be uneventful, commonplace, perfunctory "constitutionals." Such a genius is Miss Ben-Yusuf.[39]

Like William Murray, the author of this comment of 1899, reviewers of Ben-Yusuf's photography routinely picked out the refreshing originality of her portraiture. While critics acknowledged certain instances when her work was lacking for one reason or another, they were almost uniform in their regard for her creativity within the genre. What she was creating, they opined, was not simply a mechanical likeness, but a work of art that merited the type of attention and appreciation paid to portraitists working in more traditional artistic media. Ben-Yusuf was one of a growing school of photographers who aspired to create prints worthy of the fine arts; and, because of her dedication to portraiture above other subjects, she also became a significant voice in debates about portrait photography's creative potential.[40]

These issues were not insignificant at the time, for by the century's end a split had emerged within the field of photography that increasingly separated those who sought to legitimize it as an artistic medium and those who saw it principally as a utilitarian tool for faithfully recording the visible world. This divide—which was international in scope—extended into the realm of portraiture and at times pitted established studio operators against a new school of fine art portraitists. The British critic Andrew Pringle was one who favored fresh ideas, declaring in 1893 that "the prevailing style of professional portraiture has always been a sore point to those who wish photography well."[41] While the terms of this debate shifted over time, at its heart were differences in the approach and technique that photographers embraced in rendering likenesses. In general, those who wished to advance photography as a fine art created images that were self-consciously distinct from its more traditional forms. These individuals looked to challenge the conventional manner in which portraits were rendered by minimizing the use of backdrops and studio props, by adopting compositional lessons drawn from a select group of modern artists, and by crafting self-expressive prints that depended less on detail and more on atmospheric effect. To those who supported these changes, Ben-Yusuf was pursuing "her art on the right lines," as Sadakichi Hartmann exclaimed in 1899.[42]

Ben-Yusuf was at the leading edge of investigations into the art of portrait photography. Her work itself provides the clearest indication of her sustained commitment to the goals of this new school. In every element from composition to presentation, she strove to create work that differentiated itself from older forms of portrait photography. She knew well the type of images that had sustained commercial portraitists for more than a generation. Only two doors down from

the Fifth Avenue studio that she began occupying in 1899 was the studio of Aimé Dupont, one of New York's most prolific and conventionally minded portrait photographers. Like other successful operators, Dupont placed her subjects in a richly appointed setting and posed them in ways that aligned more closely with established portrait formulas than with an individual's natural bearing. To Dupont, a dramatic posture was essential to capturing one's personality, even if achieving it required substantial manipulation from the photographer or her assistant. Although she created prints that figured her subjects in crisp detail, she was not against retouching her negatives in order to conceal a blemish or an awkwardly rendered passage. Dupont's work proved to be commercially successful, for it satisfied a mass audience hungry for flattering—and cheap—images of contemporary celebrities.[43]

Ben-Yusuf, interested, like Dupont, in photographing the leading figures of the day, often found herself working with the same subjects. Yet the approach that she pursued and the images that she ultimately realized were very different from Dupont's and those of other commercial portraitists in New York. One noteworthy difference was in the number of prints that Ben-Yusuf created in comparison with other operators. Whereas some generated hundreds of images of a chosen individual, she was dedicated to producing only a limited number of hand-crafted works. Although desirous of earning an income through her photography, Ben-Yusuf felt that there existed a demand for higher-quality, limited-edition prints. Believing that "photography still remains a factory product," and "by reason of the bulk of the business, cannot express much individuality," she explained in an essay of 1901 that a new clientele "has created the existence of another class of professional photographers, whose aim is quality rather than quantity. The work of these few artists naturally shows in a very marked way the distinct differences of individual treatment and point of view. To express these qualities the thoughtful and educated person is needed in place of the former mechanic; the artist supersedes the artisan."[44]

Together with other professionals such as Gertrude Käsebier and Frances Benjamin Johnston, Ben-Yusuf endeavored to redefine excellence in portrait photography and, in the process, to elevate the public's taste in this field.[45] The materials and formats she utilized in creating and presenting her work further indicate her artistic bent. By employing the platinotype, or platinum print, by varying the shape of her portraits, and by affixing many of her finished prints to artistically conceived colored mounts, she created individual images that were distinct from the majority of mass-produced photographic portraits. The

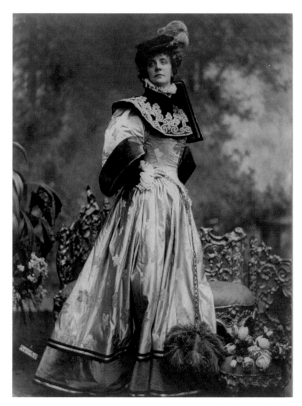

Ada Rehan
Aimé Dupont
Gelatin silver print, *c.* 1897
Library of Congress, Washington, D.C.

platinum print—first introduced in England in 1873—was a more expensive process than the commercially popular gelatin silver print, yet it produced a more subtle tonal range and a soft matte finish that attracted a new generation of photographers less interested in glossy detail. In writing about different photographic processes in a 1902 issue of the *Saturday Evening Post*, Ben-Yusuf championed the results achievable with the platinum print. She explained, "there is no paper so simple, so clean, or so varied in its possible manipulations as platinotype; the dull surface allows one's interest to be given to the picture without the disturbing influence that a highly polished one will have upon the artistic sense. All printing papers which require toning with gold entail much more work in the finishing than the platinum papers do, and this, to my mind, is again wasted energy."[46]

Ben-Yusuf's preference for the platinotype and her use of subtly colored mounts aligned her with pictorial photographers both in America and abroad. In England, such practitioners as Peter Henry Emerson, Frederick Evans, and Frederick Hollyer embraced the process. Concurrently, in the United States, it became the favored medium for like-minded photographers. Ben-Yusuf was certainly not the only professional photographer to execute work using borrowed tools. Yet, while she learned much from this new school—a group for whom she had a great affinity and whose support meant much—she also carved out her own niche, establishing a personal style between the mass-market operators and those artists who adopted a more radical approach to portrait photography.

Another manifestation of the divide that separated most professionals and most art photographers was the regard that each paid to the handling of details within an image. The great majority of commercial photographers regarded clarity of focus as a hallmark of a successful photograph, and many went to great lengths to heighten the amount of visual information available in a finished print. Those who subscribed to a new outlook regarding photography's creative possibilities increasingly rejected this approach, choosing instead to create images that favored such formal elements as shape, line, and tone over concern for depicting specific details. Influenced by such new trends as Aestheticism and the Arts and Crafts Movement, this group sought to create prints that might compare well with works executed in other graphic media. In the realm of portraiture, photographers drew upon lessons from such modern painters as James McNeill Whistler to fashion portraits that were filled with atmospheric effect but showed little detailed information. In England, some critics lampooned adherents to this approach as "fuzzographers," a term coined by the writer George Bernard Shaw. In America, a similar outcry arose about the significance of portraits where "all trace of likeness … is gone."[47] Against the backdrop of this debate, the majority of pictorial photographers in America and abroad continued to work against professional photographers' allegiance to traditional modes of expression.[48]

While Ben-Yusuf owed a good deal to lessons drawn from this new school, she regarded both positions as the outcome of personal decisions and specific circumstances. To her, photographers should be free to pursue their work along lines that fulfilled individual goals. Her essay of 1901 on "The New Photography" argued as such: "Because one is fuzzy and the other microscopically clear, it is absolutely

absurd for either one to assert that his is the only proper point of view. One type of photograph cannot create a fixed standard for excellence any more than one type of painting can fix the standard for that form of graphic art. Generally considered, the 'microscopic' man is as much an extremist as the fuzzy man."[49] Yet, having acknowledged photographers' license to develop their work along personal lines, Ben-Yusuf also used this occasion to argue for a path between these two extremes. Here she believed photography was capable of making new inroads as a fine art medium. As she explained, "It is in this middle way and its branches that we find the true dignity of expression in any art, but I believe one must have gone through the other two either mentally or actually to arrive at this with a true understanding and a proper toleration for other people's views."[50]

Although during her career she experimented at times in both directions, Ben-Yusuf created most of her work in a manner that subscribed to this point of view. Well-versed critics recognized her position in the spectrum of pictorial photographers, and most applauded her commitment to this so-called "middle way." The photographer Juan Abel—who also served as the librarian at the Camera Club of New York—was one of several reviewers who noted this quality in her work, stating:

Miss Ben-Yusuf strikes a happy medium in her work. She neither runs to the extreme of the new school, nor will she follow the old well-worn paths of the average professional.

Self-portrait
Frederick Hollyer
Platinum print, *c.* 1890
National Media Museum/Science and Society Picture Library, Bradford, England

Self-portrait
Edward Steichen
Platinum print, 1899
The Metropolitan Museum of Art, New York, Alfred Stieglitz Collection, 1933 (33.43.1)

Kahlil Gibran
F. Holland Day
Platinum print, 1897
Library of Congress, Washington, D.C.

Her composition is simple but effective, and her pictures are generally more noticeable for a certain broadness of effect than for the delicacy of line which we may find in the work of others. Her work is thoroughly intelligent and has nothing of the bizarre effect to be noted in some adherents of the new school, although from a cursory inspection of her studio one would be led to expect something out of the ordinary. . . . Altogether, a more interesting personage than Miss Ben-Yusuf one could not meet in a tour of the New York photographic studios.[51]

While striving to formulate an independent style, Ben-Yusuf adopted lessons on composition and posing from other photographers whom she admired. In particular, she came to appreciate how "a good portrait must be well studied out, but look thoroughly spontaneous."[52] The care and creativity displayed by such figures as F. Holland Day and Frederick Hollyer suggested to her possibilities either not considered or unrealized by the majority of professional photographers. Yet, in applying these lessons to the demands of the portrait business, she learned again that compromises often needed to be struck. Individuals who entered her studio brought their own demands and peculiarities, and she found that most compositions resulted from an often tiring exchange that transpired between her and her subject. In her essay "Celebrities Under the Camera" for the *Saturday Evening Post*, she spoke about the challenges of working with different individuals:

To concentrate one's thoughts in an effort to understand properly the personality of an entire stranger in the course of fifteen or twenty minutes is often very fatiguing, and its effects are sometimes very curious. There have been occasions when something, unexplainable, in my sitter has affected me so that after he had gone I had to have quite a nice, good cry, and felt rather like a cat with its fur rubbed the wrong way. A few have made me feel the other extreme of exhilaration. Sometimes I find myself so fatigued, mentally and physically, that I am unable to do anything else for some hours. When I try to analyze this it seems to me that it is particularly with men that these mental qualities are appealed to. With women the question of gown and effective pose almost obliterates the other part.[53]

Although some critics wrote with admiration that her subjects looked unposed, she often had to work hard to achieve this effect. Having an individual assume a naturalistic appearance required her active hand, a point about which she later wrote:

It is extremely rare for any one to assume just the right pose at the very beginning of a prearranged sitting for a portrait. Generally, if it is an entire stranger, I don't know what is right for him at that time. By working slowly and carefully over the taking of the first two or three plates, in ways that vary as much as the subjects themselves, the most interesting

point of view gradually develops itself. The important thing, then, is to be able to see and grasp the opportunity when it arises. At other times the pose and accessories are prearranged in my own mind, but I have to work gradually around to them by a series of positions, so that as far as my sitter is concerned the effect I am trying to get is perfectly spontaneous.[54]

This commitment to individualizing each portrait is a hallmark of her work.

While Ben-Yusuf learned much from the work of other pictorial photographers, her models extended beyond this field and included artists working in a host of different media, especially painting. Stating that "a study of the great paintings, especially the modern ones, is of more value than the study of photographic text-books," she took advantage of opportunities in New York and during her travels abroad to examine compositions by a wide-ranging group of artists.[55] Like many photographers of this period, she found Whistler's work especially compelling. His rebellious personality and his philosophical commitment to art for art's sake made him a hero among the younger generation. For many American artists—especially those in New York—Arthur Wesley Dow served as the principal figure in codifying Whistlerian aesthetics. In his highly regarded book *Composition* (1899) and in his classes at Brooklyn's Pratt Institute, Dow championed Whistler's work—together with the influence of Japanese art and the Arts and Crafts movement—as a model for aspiring students.

For Ben-Yusuf, the American expatriate painter John Singer Sargent was also important. His ability to capture a subject's personality with elegance and flair encouraged her to work in a similar direction. In writing about posing, Ben-Yusuf held up his double portrait of Asher Wertheimer's two daughters (page 34) as a model for aspiring portrait artists. She explained that it was "not merely an agreeable position that we want." Instead:

Certain tricks of pose and expression, even though slightly awkward but belonging exclusively to the individual, will stamp a portrait at once as having some importance. One of the most splendid lessons on this point is the recent painting by Mr. Sargent of the daughters of Mr. A. Wertheimer. This picture positively breathes the whole past, present and future of those two young women—the dashing vitality of body, the alert and ultra-modern mind expressed so wonderfully, and then the story that those marvelously painted hands tell! It is not only the daughters of Mr. Wertheimer that we see, but the portrait of a type with all the characteristics of race and environment, and we recognize instantly the lifelike quality of the true portrait.[56]

Ben-Yusuf's admiration for this painting by Sargent suggests how up to date she was on developments in the larger art world, for her remark was made only several months after the portrait's completion. It also indicates something more about her artistic preferences. Although dedicated to progressive principles, she remained wedded to a style that—like Sargent's—was ultimately accessible and appealing to a wide public. As a professional who depended upon a steady clientele to make ends meet, Ben-Yusuf could not afford to experiment too radically in one direction or the other. Her portraits strove to reveal the personality of her subjects in a manner that was modern, yet also flattering and tasteful.

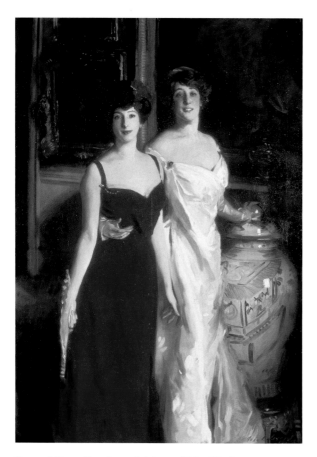

Ena and Betty, Daughters of Asher and Mrs. Wertheimer
John Singer Sargent
Oil on canvas, 1901
Tate Gallery, London/Art Resource, New York

By crafting prints that subscribed to this "middle way," Ben-Yusuf rose rapidly in the estimation of critics and colleagues in the world of New York photography. However, though she continued to produce work significant in both quality and quantity, her career as a photographer began to falter from around 1902 or thereabouts. Not only did she encounter a series of financial difficulties, but the community of photographers whose work she respected and whose endorsement she desired was beginning to splinter. These divisions acted to marginalize her and the type of photographs that she produced. While she would continue to operate her studio for another four years or so and to be involved in photographic projects for another couple of years after that, Ben-Yusuf found herself increasingly frustrated in her efforts to run a business and to participate fully in the photographic movement that she had supported. Rather than struggling on with these challenges, she chose instead to reinvent herself. Like her decision to open a photographic studio back in 1897, the decision to give it up in order to pursue other activities reflected a deep-seated desire— shared by many single, independent-minded, and upwardly mobile women of the period—to create a world where she might find a greater degree of personal and professional satisfaction.

＄

Unlike the gun, the racquet and the oar, the camera offers a field where women can compete with men upon equal terms; and that some women have so successfully striven should encourage more to follow in their lead, especially as the only distasteful portion of the work—the staining of the fingers—can now be entirely avoided. Still, it cannot be denied that fewer women than men produce good work in photography. . . . If I were compelled to hazard a suggestion as to a cause of the inferiority of many women in camera work, it would be that a lack of concentration and sustained effort often stands in the way of complete success.[57]

Beginning in the 1890s, for the first time in the medium's history, significant numbers of women took up photography. In the process, however, many of them encountered challenges—institutional, economic, and personal—that limited their ultimate success. Clarence Moore's remarks, quoted above, from an essay published in 1893, are representative of the simultaneous encouragement and scorn proffered to women by photographic colleagues during this period. While willing to accept women in the field, many believed for different reasons that they lagged behind men

in terms of quality of work, that they were unsuited to positions of leadership, and that their careers inevitably stagnated before being abandoned.[58]

Such was the climate that confronted Ben-Yusuf and the other female photographers who sought to make their mark. Although they sometimes benefited greatly from the support of male colleagues, they often faced an uphill climb in their efforts to build and to sustain careers. In Ben-Yusuf's case, economic difficulties were a recurrent problem throughout the time she operated her business. The situation seems to have been especially acute in the early years of the new century. Ben-Yusuf enjoyed travel and preferred living comfortably, and the proceeds from her business during this period often failed to cover her expenses. On repeated occasions, she was listed in the *New York Times* as owing money to creditors.[59] Remarks in her correspondence also point to the difficult financial situation she faced.

Unlike most who involved themselves in the cause of fine art photography, Ben-Yusuf did not have the resources to underwrite an independent career. Because the amateurs who dominated the field believed that the marketplace would compromise their lofty goals, they treated such professionals as her largely as outsiders. As Stieglitz concluded about the pictorial photography movement, "nearly all the greatest work is being, and has always been done, by those who are following photography for the love of it, and not merely for financial reasons."[60] Even Sadakichi Hartmann, the critic who first wrote extensively about Ben-Yusuf and championed her work over a lengthy period, acknowledged a fundamental difference between the work of the amateur and that of the professional, including her. In reviewing the *New School of American Photography* exhibition organized in the fall of 1900 by F. Holland Day, Hartmann explained:

I was attracted to "artistic photography" because I learnt to admire the sincerity and unselfishness, the patience and the perseverance, which certain men like Stieglitz, Day, and even [Joseph] Keiley applied to their vocation. They merely worked for the sake of working, of advancing the artistic side of photography, and with no other aim in view, a quality rarely met with in modern art. Käsebier, Ben-Yusuf, and [Frank] Eugene, on the other hand, are strictly mercenary, and I have said so whenever I had the opportunity.[61]

Although Hartmann would later praise Ben-Yusuf as "our leading portraitist on semi-artistic lines," such public slights as these frustrated her.[62] Likewise, being turned down or altogether excluded from certain exhibitions added to the sense of disillusionment she increasingly felt about the photographic community in New York. Ben-Yusuf's thoughts about not being a part of Stieglitz's landmark *Photo-Secession* exhibition in 1902 are not known. However, having participated with enthusiasm in exhibitions that he had organized in the past, she must surely have felt like an outsider on the occasion of this hand-picked showcase of works by thirty-two American pictorial photographers. Shown at the National Arts Club— a space only thirteen blocks from her studio—the exhibition drew wide notice in part because of the provocative title that Stieglitz assigned it, but also because, after several high-profile photography exhibitions elsewhere, it represented the first group show of its kind in New York in almost three years.[63]

While Ben-Yusuf may have decided not to contribute, or perhaps circumstances prevented her from doing so, it is probably the case that Stieglitz never extended the invitation. Having encouraged her at the start of her career, Stieglitz aimed in his creation of the Photo-Secession to draw a line between those American photographers with serious artistic ambitions and others whom he deemed principally professionals or simply amateur "Kodakers." In the process, he also sought to consolidate his position as the leading arbiter in the movement on behalf of pictorial photography, especially after his rival Day's success with the *New School* exhibition in London. Ben-Yusuf's absence from Stieglitz's exhibition can also probably be explained by the fact that she continued to claim British citizenship, and by her status as a professional. Her essays in popular magazines advocating a "middle way," and her friendship with Day, probably did not help matters either. Although she contributed to the London salon later that fall, Ben-Yusuf's involvement in public exhibitions dropped off precipitously in subsequent years, a clear sign that she had grown tired of the larger cause and her place in it. In a letter to Day in the fall of 1902, Stieglitz asked for his assistance in returning one of Ben-Yusuf's prints and complained that "she has been quite impatient with me."[64]

To Stieglitz and others, the birth of the Photo-Secession in 1902 represented a new chapter in the history of American photography. Yet, in many respects, this inaugural exhibition paradoxically signaled the beginning of the end for the movement of which it was a part. Increasingly, differences over issues large and small divided those who had formed the core of this community. Stieglitz enjoyed great success for a time with the founding of *Camera Work* in 1903 and the establishment of his own exhibition space at 291 Fifth Avenue two years later; however, while he continued to photograph for the rest of his life, the relatively tight-knit movement he had led since the mid-1890s was fast unraveling. Some participants went in a new direction, in a few cases because they were tired of Stieglitz's autocratic manner. Others new to the field simply never became a part of this circle.

Many organizations across the United States promoted the photographic arts during this period. It was the Salon Club of America, though, that established itself as the leading alternative to the Photo-Secession. Organized by two Midwesterners, Louis Fleckenstein and Carl Rau, in December 1903, the Salon Club sought to be a more inclusive group reaching out to a younger generation of pictorialists. With the support of Curtis Bell, the president of New York's Metropolitan Camera Club, they held their first group exhibition a year later under the motto "Many Schools in Art and All Good." With 175 participants, including such veterans as Day and Rudolph Eickemeyer, Jr., this exhibition re-energized the field. Sadakichi Hartmann—having broken ties only months earlier with Stieglitz—wrote comments supportive of the Salon Club, and it appeared for a time that the cause of fine art photography might be reborn under more democratic auspices.[65]

Ben-Yusuf took tentative steps to involve herself with the Salon Club. Yet, while she put her name on its roster, she chose not to contribute prints to its inaugural exhibition. She did review members' portfolios circulated by the club, and served as a juror for the Second American Photographic Salon, which opened at the Art

Institute of Chicago in March 1906. However, she undertook these tasks more out of support for this new organization and less as one who hoped to further her career. Perhaps she also sensed that the Salon Club—founded largely as the result of a clash between specific individuals rather than because of a competing aesthetic vision—would ultimately be unable to fulfill its larger mission. Linking photographers from across the nation was a noble goal, yet the organizers soon discovered that its different programs were unmanageable given the growing number of practicing photographers in America. Lacking leadership, the Salon Club fell apart in 1907.

The dissolution of the Salon Club served to underscore the fact that neither one person nor organization was wholly suited to carry the banner for photography as a fine art. With the folding of the Salon Club and the decline in the number of large-scale international exhibitions devoted to pictorial photography, the movement of which Ben-Yusuf had been a part was reaching extinction. Yet this moment did not mark the defeat of photography as a medium of creative expression. In many ways that argument had been won, if for no other reason than because of the sheer number of people who now took up the camera with artistic intentions.

For Ben-Yusuf, this period marked the end of her career as a professional photographer in New York. Beset with financial challenges and increasingly adrift within the splintering world of pictorial photography, around 1907 she decided to close her studio to pursue other interests. She left no written record to explain her reasons, yet clearly a series of frustrations compelled her to reconsider her chosen career. In the context of professional photography, leaving this trade after a decade was certainly not uncommon; a survey of female photographers reveals that women were rarely able to sustain careers in the same way as the leading male photographers of the day. When considered more broadly, Ben-Yusuf's experience mirrored that of thousands of professional women who faced a complex mix of challenges that ultimately compelled them to make such decisions.

As discouraged as Ben-Yusuf was at the time of her studio's closing, she chose not to retreat from the arena of professional life. Not yet forty years old, she immersed herself—seemingly with equal energy and ambition—in a host of different pursuits. In particular, she worked again as a milliner and traveled more. Having first visited Japan and China in 1903, she ventured again to the Far East and to different destinations in Europe and the Caribbean. Although she claimed at the outset of her first trip to Japan and China that she "longed for the possibility of leaving cameras behind" on account of being "tired of them," she always brought them along.[66] Many of the photographs she took on these trips appeared later in various magazines. She also worked for a time as a lecturer, speaking to audiences in New York and London about the countries she visited. On several occasions she published essays drawn from these lectures. Such activities—together with her reputation as a portrait photographer—led Ben-Yusuf to achieve a modest level of renown in New York society, and newspapers often sought her out for remarks about celebrities she knew or the latest in fashionable dress.[67] Upon her return to New York after a lengthy trip in 1908, the *New York Times* published a short article noting that "Miss Ben-Yusuf comes back enthusiastically declaring that New York

is a remarkable place and that the women here are prettier and more stylishly dressed than are the women of other lands."[68] Apart from her photographic business, she remained a woman in the news.

Approximately two years after the closing of her studio, Ben-Yusuf celebrated her fortieth birthday in London, the city in which she was born. She had delivered an illustrated lecture on "Picturesque Japan" to a group at the Waldorf Hotel two nights earlier. While it is unclear how long she had been there, she was increasingly spending extended periods of time in England.[69] It is likely that she was in London too when she learned, three weeks after her birthday, of her mother's death. Whether Ben-Yusuf returned to New York at this time is not known. Regarding her whereabouts, former associates there, such as Sadakichi Hartmann, seemed to know little. In 1912, in an article on portraiture, Hartmann remarked, probably fancifully, that Ben-Yusuf had "given up the vanities of the photographic world for an unrestrained life in the South Sea Islands."[70]

Yet, in fact, Ben-Yusuf had not given up portrait photography altogether. Having led a peripatetic life since closing her studio, she decided to settle in London on a more permanent basis after her mother's death. Although it is unclear whether she tried to reconnect with family members or English friends, she did return to photography, opening a new studio in Chelsea. No photographs from this period are currently known, nor is there any evidence of her activities.

"Japan Through My Camera"
Zaida Ben-Yusuf
Saturday Evening Post, April 23, 1904
Library of Congress, Washington, D.C.

Characteristically, Ben-Yusuf did not remain in London more than a few years, for by the time of the outbreak of the First World War in 1914, she was living in France. She would not stay there long either. Like many who fled Europe at that point, she chose to pull up her fresh roots in Paris less than a month after Germany's declaration of war. Having decided to return to New York, she booked passage in Le Havre and arrived in America only a week after the Battle of the Marne—the first major battle in Germany's advance on Paris in the late summer of 1914.[71]

There, once again, Ben-Yusuf tried to restart her career as a portrait photographer. On this occasion, though, her enthusiasm quickly flagged, and she retired within a year or two. Having given up photography for good, she returned to the millinery trade. This business was not a fallback for her, and she worked hard to advance her standing in its community. As a testament to her success, she served as the director of the Retail Millinery Association of America for several years during the 1920s, organizing fashion shows and lecturing on industry trends. And, as before, she continued to associate with New York's bohemian set. A photograph by Jessie Tarbox Beals from around 1920 shows her among the guests at a party in Beals's studio (opposite: Ben-Yusuf is in the back row, fourth from the right). Among the group is Frederick J. Norris, a textile designer whom Ben-Yusuf met and married during this period. Details about this relationship, and whether it was simply a marriage of convenience, are largely lost.

Group portrait in the Fifth Avenue studio of Jessie Tarbox Beals
Jessie Tarbox Beals
Gelatin silver print, c. 1920
Schlesinger Library, Radcliffe Institute, Harvard University, Cambridge, Massachusetts

Although she had retained her British citizenship throughout her entire photographic career, Ben-Yusuf decided to become an American citizen only months before her fiftieth birthday. It is notable that she listed her age on the naturalization application as ten years younger than she actually was. She would be evasive about her age on other occasions during this period, too. Living in New York, she remained an independent-minded and energetic figure until her death at age sixty-three on September 27, 1933.[72]

<hr>

But to-day a new New York is coming to birth which bids fair to vie, if not in historic interest, at least in magnificence and beauty, with even so splendid a capital as that of France.[73]

This pronouncement from the pages of *Century Magazine* in 1902 was typical of the pride expressed by many about the "new New York." Ben-Yusuf's ten-year career as a portrait photographer there coincided with this period of unprecedented change and renewed optimism. At the turn of the century, New York emerged as America's first truly modern city. With the binding together of the five boroughs in 1898, it also became the second largest city in the world. The rapid influx of a wealth of new residents, many from overseas, the growth of new buildings and transportation systems, and the expansion of business and industry were all responsible for reshaping the city's physical, political, and cultural landscape. From her studio

Frederick J. Norris
Jessie Tarbox Beals
Gelatin silver print, *c.* 1920
The New-York Historical Society

on Fifth Avenue, Ben-Yusuf photographed many of the most prominent men and women of her day. Not all were from New York, and some held ambivalent feelings about the developments there and throughout the nation. Yet, seen together, they shed light on this stage in the city's history, a moment in which New York stood at a crossroads between the old and the new. The individuals whom Ben-Yusuf photographed did more than bear witness to this era; they gave shape to the rich textures of society that developed there in the twentieth century.

Ben-Yusuf's portraits contribute to a greater understanding of her subjects and draw attention to larger cultural and political trends of the time. In the profiles that follow, figures whose lives intersected are grouped together to reflect these broad thematic movements. Ben-Yusuf's portraits also reveal much about her as an artist and as an independent woman. As such, the photographs in the first grouping, "The New Woman," are brought together to highlight instances when she used a camera explicitly to explore her self-image, to experiment with the medium's creative potential, and to document encounters during her travels.

Starting afresh in New York, Ben-Yusuf remade herself and in the process contributed in significant ways to portrait photography's break from the conventions of the past. During a period when much debate surrounded its status in relationship to the fine arts, she subscribed enthusiastically to the notion that photography was a medium of creative expression. Her portraits repeatedly reveal this search for its aesthetic potential. As an outsider who worked to become a noted authority, she saw photography also as a means of finding her own personal identity in her adopted home. Like New York itself, Ben-Yusuf and the photographs she created were thoroughly modern.

1 Zaida Ben-Yusuf to Alfred Stieglitz, October 21, 1897, letter in the Alfred Stieglitz/Georgia O'Keeffe Archive, Yale Collection of American Literature, Beinecke Rare Book and Manuscript Library.

2 Ben-Yusuf has received scant attention in the scholarly literature to date. Elizabeth Poulson's essay, "Zaida," privately published in 1985 for *The History of Photography Monograph Series*, was the first noteworthy study of her career. Ben-Yusuf's inclusion in *Ambassadors of Progress: American Women Photographers in Paris, 1900–1901*, ed. Bronwyn Griffith (Hanover, NH: University Press of New England, 2001), contextualized and reproduced the work that she submitted to an exhibition of American women photographers at the Universal Exposition in Paris in 1900. While Ben-Yusuf has been noted in other publications since 1985, these two studies remain the only secondary sources to focus specific attention on her life and photography.

3 Margaret Bisland, "Women and Their Cameras," *Outing Magazine*, Vol. 17, no. 1 (October 1890): 38.

4 The scholarly literature on the history of women in photography has grown in recent years. In particular, see Naomi Rosenblum, *A History of Women Photographers* (New York: Abbeville Press, 1994); Judith Davidov, *Women's Camera Work: Self/Body/Other in American Visual Culture* (Durham, NC: Duke University Press, 1998); and Laura Wexler, *Tender Violence: Domestic Visions in an Age of U.S. Imperialism* (Chapel Hill, NC: University of North Carolina Press, 2000). Of related interest in the field of painting, see Kirsten Swinth, *Painting Professionals: Women Artists and the Development of Modern American Art, 1870–1930* (Chapel Hill: University of North Carolina Press, 2001); Erica Hirshler, *A Studio of Her Own: Women Artists in Boston, 1870–1940* (Boston: MFA Publications, 2001); and Laura Prieto, *At Home in the Studio: The Professionalization of Women Artists in America* (Cambridge, Mass.: Harvard University Press, 2001).

5 Zaida Ben-Yusuf, "The New Photography—What It Has Done and Is Doing for Modern Portraiture," *Metropolitan Magazine*, Vol. 16, no. 3 (September 1901): 395.

6 Sadakichi Hartmann, "A Purist," *Photographic Times*, Vol. 31, no. 10 (October 1899): 452.

7 Martha Banta, *Imaging American Women: Idea and Ideals in Cultural History* (New York: Columbia University Press, 1987): 221–82. See also Carroll Smith-Rosenberg, *Disorderly Conduct: Visions of Gender in Victorian America* (New York: Knopf, 1985).

8 Alfred Stieglitz, "Pictorial Photography," *Scribner's Magazine*, Vol. 26, no. 5 (November 1899): 528.

9 Zaida Ben-Yusuf, untitled and undated manuscript in the Papers of Frances Benjamin Johnston, Manuscript Division, Library of Congress.

10 For a thorough study of this exhibition, see Griffith, ed., *Ambassadors of Progress*.

11 Alfred Stieglitz to Frances Benjamin Johnston, June 8, 1900, letter in the Papers of Frances Benjamin Johnston, Manuscript Division, Library of Congress. Although Stieglitz championed many women throughout his career, he seemed to have little respect for Johnston. A year earlier, he wrote to F. Holland Day complaining about her qualifications to serve as a juror at the 1899 Philadelphia Photographic Salon. Alfred Stieglitz to F. Holland Day, March 31, 1899, letter in the Alfred Stieglitz/Georgia O'Keeffe Archive, Yale Collection of American Literature, Beinecke Rare Book and Manuscript Library.

12 Johnston also wrote to Ben-Yusuf seeking her input on other New York-based female photographers of note. Ben-Yusuf recommended Emily and Lillian Selby, two British-born sisters who had recently opened a studio on Fifth Avenue. Despite the short notice, Johnston invited them to submit a contribution, which they ultimately did. Zaida Ben-Yusuf to Frances Benjamin Johnston, May 31, 1900, letter in the Papers of Frances Benjamin Johnston, Manuscript Division, Library of Congress. For more about the career of Johnston, see Bettina Berch, *The Woman Behind the Lens: The Life and Work of Frances Benjamin Johnston, 1864–1952* (Charlottesville: University Press of Virginia, 2000); Pete Daniel and Raymond Smock, *A Talent for Detail: The Photographs of Miss Frances Benjamin Johnston, 1889–1910* (New York: Harmony Books, 1974); and Edward Robinson, "Photographer Frances Benjamin Johnston (U.S. 1864–1952): The Early Years, 1889–1904," D.Phil. Thesis, Faculty of Modern History, University of Oxford, 2005.

13 Ben-Yusuf sent Richard Hines, a journalist who was writing an essay about women in photography, a similar profile roughly a year earlier. In this statement, she outlined the same narrative regarding her career's beginning. Richard Hines, "Women and Photography," *American Amateur Photographer*, Vol. 11, no. 3 (March 1899): 120–21.

14 Birth Certificate for Esther Zeghdda Ben Youseph Nathan, Family Records Centre, London, England; "Illustrations of Eastern Life and Bible Customs," program in The Warden's Log Book, 1855–1900, Parish Records, St. John the Baptist, Frenchay, Bristol, England; and J. A. Venn, ed., *Alumni Cantabrigienses: A Biographical List of All Known Students, Graduates, and Holders of Office at the University of Cambridge*, Volume 1 (Cambridge: Cambridge University Press, 1954): 240.

15 1881 British Census, National Archives, Kew, England.

16 Birth Certificate for Zaida Ben-Yusuph, Family Records Centre, London, England; and Death Certificate for Mussa Ben-Yusuf, Family Records Centre, London, England.

17 *The Boston Directory* (Boston: Sampson, Murdock, & Company, 1891): 133; and "Notices," *Pratt Institute Students' Bulletin*, Vol. 8, no. 10 (January 7, 1910): unpaginated.

18 *Trow's New York City Directory* (New York: Trow Directory, Printing, and Bookbinding Company, 1895): 104.

19 Anna Ben-Yusuf, "Is It a Disadvantage to Be a Woman?" *Boston Globe* (July 7, 1895): 20. According to the scholar Wendy Gamber, "millinery and dressmaking [at the century's end] did not 'liberate' women, but they provided a space in which their ambitions might flourish." Wendy Gamber, *The Female Economy: The Millinery and Dressmaking Trades, 1860–1930* (Urbana: University of Illinois Press, 1997): 57.

20 "An Artist-Photographer," *Current Literature*, Vol. 34, no. 1 (January 1903): 21.

21 According to the historian William Darrah, prior to this period women accounted for approximately 2 percent of the total number of professional photographers working in America. William Darrah, "Nineteenth-Century Women Photographers," in *Shadow and Substance: Essays on the History of Photography*, ed. Kathleen Collins (Bloomfield Hills, Mich.: Amorphous Institute Press, 1990): 90.

22 Catherine Weed Barnes Ward, "Women in

Photography," *American Amateur Photographer*, Vol. 8, no. 3 (March 1896): 97–98. The scholarly literature on Ward is limited. One study of note is Elizabeth Poulson's essay, "Catherine Weed Barnes Ward: Another Forgotten Victorian Photographer," privately published in 1984 for *The History of Photography Monograph Series*.

23 Women pursued photography as amateurs to a far greater extent than as professionals. According to New York city directories, only 10 percent of the more than two hundred commercial studios were headed by women. Although many women served as assistants in male-led studios, the barriers to opening a studio prevented more women from doing so. Floride Green, a professional photographer in New York, articulated this sentiment in an 1898 article in the *New York Daily Tribune*. While enthusiastic about women taking up photography, she cautioned that "I could not honestly recommend it to a college girl as a livelihood. The road is so long, there are so many discouragements. There is the constant struggle between your artistic feeling, your ideal, and the indifference of the uneducated eye to which you must cater if you would succeed financially." "Specialized Photography," *New York Daily Tribune* (June 27, 1898): 5.

24 Hines, 120–21.

25 In particular, see Zaida Ben-Yusuf to Alfred Stieglitz, October 21, 1897, letter in the Alfred Stieglitz/Georgia O'Keeffe Archive, Yale Collection of American Literature, Beinecke Rare Book and Manuscript Library; and "Pictorial Photographer," *New York Daily Tribune* (November 7, 1897): 4.

26 Hector Maclean, "The Two Chief Photographic Exhibitions of the Year—II. The Salon," *Photographic Times*, Vol. 29, no. 2 (February 1897): 70.

27 Brian Coe, "George Davison: Impressionist and Anarchist," in *British Photography in the Nineteenth Century: The Fine Art Tradition*, ed. Mike Weaver (Cambridge: Cambridge University Press, 1989): 215–41; and Margaret Harker, *The Linked Ring: The Secession Movement in Photography in Britain, 1892–1910* (London: Heinemann, 1979).

28 "Pictorial Photographer," 4.

29 Sarah Burns, *Inventing the Modern Artist: Art and Culture in Gilded Age America* (New Haven, Conn.: Yale University Press, 1996).

30 Hartmann, "A Purist," 452. Other profiles echo Hartmann's characterization. In particular, see Marion Barton, "In Woman's Realm: A Remarkable Woman Photographer," *Illustrated American*, Vol. 24, no. 456 (November 11, 1898): 377; and William Murray, "Miss Zaida Ben-Yusuf's Exhibition," *Camera Notes*, Vol. 2, no. 4 (April 1899): 168–72.

31 Matthew Schneirov, *The Dream of a New Social Order: Popular Magazines in America, 1893–1914* (New York: Columbia University Press, 1994); and Carolyn Kitch, *The Girl on the Magazine Cover: The Origins of Visual Stereotypes in American Mass Media* (Chapel Hill: University of North Carolina Press, 2001).

32 *Ladies' Home Journal* Remittances, Box 10, Curtis Publishing Company Records, *c.* 1887–1960, Rare Book & Manuscript Library, University of Pennsylvania. As financial records related to Ben-Yusuf's photography are scarce, it is difficult to determine accurately the income that her studio generated. Financial records from the Curtis Publishing Company indicate that there was no fixed rate for those who supplied articles and photographs to its magazines. At least one

photographer during this period, Gertrude Käsebier, was critical of the magazines and newspapers for their stinginess in compensating photographers and for their poor standards, declaring that "anybody can get into print." Gertrude Käsebier, "Studies in Photography," *Photographic Times*, Vol. 30, no. 6 (June 1898): 270.

33 Bailey Van Hook, *Angels of Art: Women and Art in American Society, 1876–1914* (University Park: The Pennsylvania State University Press, 1996).

34 For studies concerning the role of the amateur in the fine art photographic movement, see Paul Spencer Sternberger, *Between Amateur & Aesthete: The Legitimization of Photography as Art in America, 1880–1900* (Albuquerque: University of New Mexico Press, 2001); and Christian A. Peterson, "American Arts and Crafts: The Photograph Beautiful, 1895–1915," *History of Photography*, Vol. 16, no. 3 (Fall 1992): 189–232.

35 Ben-Yusuf, "The New Photography," 394.

36 Zaida Ben-Yusuf to Alfred Stieglitz, undated letter in the Alfred Stieglitz/Georgia O'Keeffe Archive, Yale Collection of American Literature, Beinecke Rare Book and Manuscript Library.

37 No specific evidence exists to account for her absence from membership rolls. Although she worked commercially—a fact that might explain her absence—the club had a number of professional members. Her gender also does not seem to have been the reason, as the club was relatively forward-thinking in its acceptance of women as members. Perhaps it was the high fees associated with membership, or some other reason altogether. Given the company that the club attracted, it is striking that she was not a member.

38 While Ben-Yusuf happily embraced the opportunity to exhibit at the Camera Club, Johnston was less enthusiastic about sharing the limelight. Correspondence between Johnston and Charles Berg suggests that she expected to exhibit her work alone. Yet Johnston's delay in preparing her prints prompted Berg to invite Ben-Yusuf to show alongside her. Charles Berg to Frances Benjamin Johnston, October 18, 1898, letter in the Papers of Frances Benjamin Johnston, Manuscript Division, Library of Congress.

39 Murray, "Miss Zaida Ben-Yusuf's Exhibition," 168.

40 Despite concerted efforts to champion portrait photography's artistic potential, many painters during this period remained skeptical of the claims that photographers were making for their chosen medium. Although the debate about photography's status ranged widely within the fine art community, many agreed that photography had "no higher aesthetic quality or charm," as one painter claimed in 1900. "The photograph never supplies this finer quality—the machine cannot become sentient, and appropriately present in its complex mystery, a personality." "Portraiture and the Photograph: The Thoughts of Portrait Painters," *Scribner's Magazine*, Vol. 27, no. 3 (March 1900): 381.

41 Andrew Pringle, "The Naissance of Art in Photography," *The Studio*, Vol. 1, no. 3 (June 1893): 88–89.

42 Sadakichi Hartmann, "Portrait Painting and Portrait Photography," *Camera Notes*, Vol. 3, no. 1 (July 1899): 19.

43 Ben-Yusuf was also consciously avoiding newer developments in portraiture brought about by the introduction of the popular Kodak camera. Regarding the amateur snapshot, she explained, "the snapshot

records merely some instant of action, that has absolutely no permanent value as a portrait because it is not composite and because it generally expresses only arrested movement." Zaida Ben-Yusuf, "Advanced Photography for Amateurs: No. 1—Portraits," *Saturday Evening Post*, Vol. 174, no. 21 (November 23, 1901): 4.

44 Ben-Yusuf, "The New Photography," 394.

45 In turn-of-the-century New York, Gertrude Käsebier was the other key figure whose studio became a center for innovation in this photographic genre. Käsebier opened her studio less than a year after Ben-Yusuf. Although the two women embraced a similar photographic vision and worked not far from each other, the nature of their relationship is not well known. Married and nearly a generation older, Käsebier does not seem to have sought out Ben-Yusuf as a friend. Rather, it is likely that they regarded each other as competitors. Stieglitz probably furthered that rivalry when, in 1899, he declared in *Camera Notes* that Käsebier was America's leading "artistic portrait photographer." Alfred Stieglitz, "Our Illustrations," *Camera Notes*, Vol. 3, no. 1 (July 1899): 24. For a good biography of Käsebier's life and photographic career, see Barbara L. Michaels, *Gertrude Käsebier: The Photographer and Her Photographs* (New York: Harry N. Abrams, 1992).

46 Zaida Ben-Yusuf, "Advanced Photography for Amateurs: No. 6—Methods and Materials with Examples by the Author," *Saturday Evening Post*, Vol. 174, no. 40 (April 5, 1902): 11.

47 The unidentified author of this comment continued: "The desire for originality is allowed to over-ride every other consideration, and as a result we have portraits of quite harmless individuals, which, if faithful, would justify their immediate consignment to the gallows. . . . We have had friends treated by the new school whose portraits are barely recognizable." "American Portraiture," *American Amateur Photographer*, Vol. 12, no. 3 (March 1900): 111–12.

48 On pictorial photography, see Sarah Greenough, "'Of Charming Glens, Graceful Glades, and Frowning Cliffs': The Economic Incentives, Social Inducements, and Aesthetic Issues of American Pictorial Photography, 1880–1902," in *Photography in Nineteenth-Century America*, ed. Martha A. Sandweiss (New York: Harry N. Abrams, 1991): 256–81; Harker; Ulrich Keller, "The Myth of Art Photography: A Sociological Analysis," *History of Photography*, Vol. 8, no. 4 (October–December, 1984): 249–75; Peterson, "American Arts and Crafts: The Photograph Beautiful, 1895–1915"; Sternberger; and Weaver.

49 Ben-Yusuf, "The New Photography," 390.

50 *Ibid.*, 390, 392.

51 Juan Abel, "Women Photographers & Their Work," *The Delineator*, Vol. 58, no. 3 (September 1901): 407–408.

52 Ben-Yusuf, "Advanced Photography for Amateurs: No. 1—Portraits," 4.

53 Zaida Ben-Yusuf, "Celebrities Under the Camera," *Saturday Evening Post*, Vol. 173, no. 48 (June 1, 1901): 13.

54 Ben-Yusuf, "Advanced Photography for Amateurs: No. 1—Portraits," 5.

55 *Ibid.*, 4.

56 *Ibid.*

57 Clarence Moore, "Women Experts in Photography," *Cosmopolitan Magazine*, Vol. 14, no. 5 (March 1893): 581.

58 Various scholars have investigated the efforts of women to move outside the domestic sphere at the turn of the century in order to embrace modernity and to find their own individual voice. In particular, see Kathleen Pyne, *Modernism and the Feminine Voice: O'Keeffe and the Women of the Stieglitz Circle* (Berkeley: University of California Press, 2007).

59 "Business Troubles," *New York Times* (June 27, 1902): 14; and "Judgments," *New York Times* (January 12, 1905): 9.

60 Stieglitz, "Pictorial Photography," 528.

61 Sadakichi Hartmann, "American Photography at Russell-Square," *British Journal of Photography*, Vol. 47, no. 2117 (November 30, 1900): 767.

62 Sadakichi Hartmann, "The Salon Club and the First American Photographic Salon at New York," *American Amateur Photographer*, Vol. 15, no. 7 (July 1904): 302.

63 On Stieglitz's Photo-Secession, see William Homer, *Alfred Stieglitz and the Photo-Secession* (Boston: Little, Brown and Company, 1983); and William Homer, *Alfred Stieglitz and the Photo-Secession, 1902* (New York: Viking Studio, 2002).

64 Alfred Stieglitz to F. Holland Day, October 6, 1902, letter in the F. Holland Day Papers, Archives of American Art, Smithsonian Institution.

65 Gillian Greenhill Hannum, "The Salon Club of America and the Popularization of Pictorial Photography," in Collins, ed., *Shadow and Substance*, 255–60; and Homer, *Alfred Stieglitz and the Photo-Secession*, 114–17.

66 Zaida Ben-Yusuf, "Japan Through My Camera," *Saturday Evening Post*, Vol. 176, no. 43 (April 23, 1904): 6.

67 Ben-Yusuf's travel essays focus exclusively on Japan. In particular, see Zaida Ben-Yusuf, "Japan Through My Camera"; Zaida Ben-Yusuf, "A Kyoto Memory," *Booklover's Magazine*, Vol. 5, no. 2 (February 1905): 182–85; Zaida Ben-Yusuf, "The Period of Daikan," *Architectural Record*, Vol. 19, no. 2 (February 1906): 145–50; and Zaida Ben-Yusuf, "The Honorable Flowers of Japan," *Century Magazine*, Vol. 73, no. 5 (March 1907): 697–705.

68 "Miss Ben-Yusuf Returns," *New York Times* (November 10, 1908): 13.

69 "Court Circular," *The [London] Times* (November 19, 1909): 15. As an indication of how familiar she was with England at this time, Ben-Yusuf published three articles on life in London. Zaida Ben-Yusuf, "The Cost of Living in London," *Saturday Evening Post*, Vol. 180, no. 49 (June 6, 1908): 5–7; Zaida Ben-Yusuf, "American vs. English Prices," *Saturday Evening Post*, Vol. 180, no. 52 (June 27, 1908): 18; and Zaida Ben-Yusuf, "Our Practical Cousins," *Saturday Evening Post*, Vol. 181, no. 23 (December 5, 1908): 18–21.

70 Sadakichi Hartmann, "A Few American Portraits," *Wilson's Photographic Magazine*, Vol. 49, no. 670 (October 1912): 458.

71 New York State Supreme Court, Declarations of Intention Filed in New York County, 1907–1924, Declaration Volume 402, Declaration Page 270, County Clerk's Office, New York County, New York.

72 "Deaths," *New York Times* (September 28, 1933): 21.

73 Randall Blackshaw, "The New New York," *Century Magazine*, Vol. 64, no.4 (August 1902): 493. For a good history of New York during this period, see William Taylor, *In Pursuit of Gotham: Culture and Commerce in New York* (New York: Oxford University Press, 1992). Regarding the visual culture of turn-of-the-century New York, see Rebecca Zurier *et al.*, *Metropolitan Lives: The Ashcan Artists and Their New York* (New York: W.W. Norton, 1995).

The
New Woman

Zaida Ben-Yusuf was the epitome of the "New Woman"—a class of predominantly younger women who at the century's end sought to challenge prevailing gender norms. It was not simply the bohemian appearance that she adopted or the fact that she chose not to marry until almost the end of her life that made her representative of this new movement. As importantly, what differentiated Ben-Yusuf from the majority of American women during this period was her desire for an independent life within the public arena. Not content to depend on others for her livelihood within a domestic setting, she embraced the freedoms and risks associated with a professional career as a portrait photographer. Many women in the 1890s looked to photography as a means of both creative expression and personal liberation. Ben-Yusuf was a part of the first wave of women to open commercial studios and to participate in public photographic exhibitions in New York City. Her work in this field opened up a host of opportunities—to write, to travel, to meet new people—and she embraced them with a dedication that rivaled her commitment to photography. Yet being a "New Woman" at times elicited criticism from those who objected to women's public presence, and led such women as Ben-Yusuf to scrutinize—and even question—their own sense of identity. The photographs highlighted in this first section are unrepresentative of the commercial portraiture that sustained Ben-Yusuf financially. Instead, they testify to her artistic ambitions and her experiences as a "New Woman."

I.

Portrait of Miss Ben-Yusuf

While Ben-Yusuf was principally a commercial portrait photographer who depended on customers to make ends meet, the subject she photographed most often was herself. During her career, she created at least ten self-portraits, each different from the others in terms of dress, pose, and mood. As a young woman with aspirations to artistic fame and professional success, she realized that turning the camera on herself provided an opportunity to experiment with both the art of portraiture and her own feminine persona. These self-portraits reveal her commitment to the tenets of contemporary fine art photography and the culture of the "New Woman." Few professional or fine art photographers during this period—male or female—devoted such energy to their self-representation. While some—including, most famously, Alfred Stieglitz—would agree to pose before the cameras of other photographers on repeated occasions, only a few saw themselves as a relevant subject. As a young, independent woman recently arrived in the United States and needing to earn an income, Ben-Yusuf found that these self-portraits gave her a much-needed identity—one that would lessen her sense of displacement and would attract attention to her art.[1]

One of Ben-Yusuf's earliest such works is *Portrait of Miss Ben-Yusuf*, a platinum print that was probably created in the fall of 1898 at her 124 Fifth Avenue studio. Rendered in a narrow vertical format, this full-length self-portrait is striking for the costume she wears and the pose she adopts. Both mark her as a bohemian woman. Unlike more conventional dresses of the period, Ben-Yusuf's long gown is low-cut and form-fitting. Her dark jacket and hat are equally modern in fashion, and the manner in which she arranges her long necklace and holds her fur muffler at her side suggests a desire, if not to break free from stylistic traditions,

Portrait of Miss Ben-Yusuf
Zaida Ben-Yusuf
Platinum print, 1898
21.8 × 9.2 cm (8⅝ × 3⅝ in.)
National Museum of American History, Behring Center, Smithsonian Institution, Washington, D.C.

then at least to push them forward. She knew much about women's fashion, in part because of her mother, but also from her own experience as a milliner. Having published in the summer of 1898 a two-part essay, "The Making and Trimming of a Hat," in the *Ladies' Home Journal*, Ben-Yusuf was well regarded as a milliner and could perhaps have pursued this profession with great success, if she had not chosen portrait photography instead. This self-portrait makes clear how conscious she was of her public appearance and how deliberately she cast herself among those women who looked to transgress traditional boundaries of femininity.

Ben-Yusuf was pleased with this self-portrait, for it became the likeness of her that was most often reproduced and exhibited during her career. The image served not only to align her to new definitions of femininity, but also suggested an equally strong commitment to a new school of portraiture. Inspired by the work of such artists as James McNeill Whistler, John Singer Sargent, and John White Alexander, all of whom aimed to re-energize the art of portraiture by adopting new modernist strategies, Ben-Yusuf created in this self-portrait a work that announces itself as faithful to those principles. Like Whistler in his portrait *Arrangement in White and Black* (1876), she strives to remove herself from a specific context, posing instead against a dark, featureless backdrop. As a result, the figure tends to come forward, allowing the viewer to confront the subject more directly. Rather than deriving meaning from the room in which she poses, or the objects therein, this self-portrait brings to the fore Ben-Yusuf's jaunty attitude, costume, and demeanor.

In the first profile of the photographer—an article that reproduced *Portrait of Miss Ben-Yusuf*—the author Marion Barton noted her proclivity for artistically interpreting her subjects. "It is not that she merely takes portraits, but she evolves from her camera what can be described more as a work of art than a mere likeness. . . . Miss Ben-Yusef [*sic*] has but recently made herself acquainted with the uses of the camera, but her art was with her before she knew the possibilities of a lens."[2] This tendency to interpret the subject before her—and to avoid simply recording a likeness—would become a hallmark of her portraiture.

Only a year after the opening of her first photographic studio, Ben-Yusuf projects an air of self-confidence that befits her growing stature within the world of fine art photography. At the time of this self-portrait, she had much about which to feel proud. Her work was regularly being published in the leading photographic journals. Moreover, having been discovered by the editors of more than a half-dozen newspapers and magazines, she enjoyed wider public notice and a secondary income to supplement her studio profits. Yet perhaps no honor meant more to her than the recognition derived from being selected to participate in some of the premier photographic exhibitions of the moment. During the fall of 1898, she contributed work to three different exhibitions, two in New York and one in London. She was also becoming involved in the organization of these events, in one case being responsible for providing decorations in the exhibition's galleries. This involvement was surely much appreciated and led to other opportunities, including an invitation to exhibit a large selection of photographs alongside the work of Frances Benjamin Johnston at the Camera Club of New York.

Of the different self-portraits that the photographer had created to date, it was her *Portrait of Miss Ben-Yusuf* that she included at this prestigious venue. Reviewers greeted her work with enthusiasm. In Stieglitz's *Camera Notes*, William

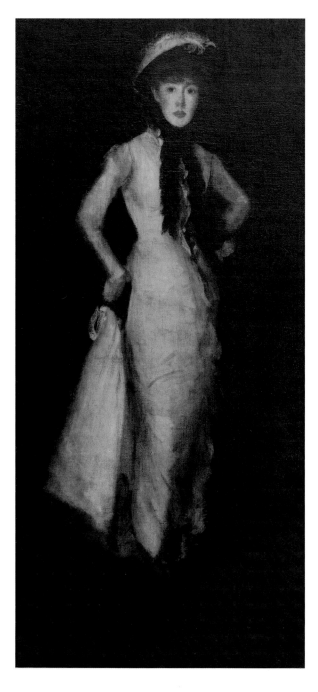

Murray, a leading New York critic, remarked that she was a "young woman of remarkable promise," who, with more experience, "will take her place in the art world in the region where it is said there is always room for one more—near the top." In discussing specific photographs, her self-portrait was one of her works that he singled out for praise. Yet it was Ben-Yusuf as much as the portrait itself that prompted Murray to comment that the subject "appears before us scintillating with all the qualities of mind and person represented by the much abused French word—chic."[3]

Twenty-eight years old when this portrait was created, Ben-Yusuf was indeed coming into her own as an independent woman and a fine art photographer. This self-portrait acts to announce her arrival in the New York art world and anticipates her engagement with the many subjects who would visit her studio in the years ahead. After several years of working to establish herself in America, Ben-Yusuf was now beginning to reap the rewards of her efforts.

FHG

1 From the outset of her career, reviewers often noted—and praised—her self-portraits. In a profile published soon after Ben-Yusuf began working as a photographer, one critic remarked that "none of Miss Ben-Yusuf's pictures surpass, if they equal, in attractiveness the portraits of herself." "People Talked About," *Leslie's Weekly*, Vol. 85, no. 2207 (December 30, 1897): 437.

2 Marion Barton, "In Woman's Realm: A Remarkable Woman Photographer," *Illustrated American*, Vol. 24, no. 456 (November 11, 1898): 377.

3 William Murray, "Miss Zaida Ben-Yusuf's Exhibition," *Camera Notes*, Vol. 2, no. 4 (April 1899): 169–70.

Portrait Against the Light
F. Holland Day (1864–1933)

Ben-Yusuf's interest in self-fashioning extended beyond her own studio. As a series of portraits by the Boston photographer F. Holland Day reveals, Ben-Yusuf also posed before the cameras of others. Like her self-portraits, these images suggest a desire to enact different identities and to experiment with ways to represent the figure—in this case, in collaboration with a photographer who shared her conviction about the medium's creative possibilities. Day and Ben-Yusuf each recognized how portrait photography could provide one with a means not simply to record one's likeness, but also to imagine and create new characters altogether. Both saw photography as an art, the potential of which was only just being discovered.

In this particular figure study—one of at least three that Day created on this occasion—Ben-Yusuf stands sideways to the camera with her hands against a door frame. She peers back toward the camera, yet her face is barely readable, given that the image's light source comes from behind her. The title of the work, *Portrait Against the Light*, indicates Day's desire to test out new compositional approaches. Ben-Yusuf wears a loose-fitting striped gown with a dark bow at the waist, and, with a strong light behind her, Day captures the curve of her back through the light fabric. Her hair is disheveled, an anomaly for the typically well-coiffed photographer. As a portrait, the image runs counter to many of the accepted tenets of this artistic genre. Rather than presenting her likeness in a clear and flattering manner, Day and Ben-Yusuf join together to experiment with the expressive possibilities of portrait photography.

Another noteworthy detail is the photograph of an unidentified middle-aged woman that hangs in a round frame on the wall at right. Despite its small size, the photograph's placement on this dark-colored wall and its proximity to Ben-Yusuf

Portrait Against the Light
F. Holland Day
Platinum print, 1899
16.4 × 10.9 cm (6⁷⁄₁₆ × 4⁵⁄₁₆ in.)
The Metropolitan Museum of Art, New York,
Alfred Stieglitz Collection, 1933 (33.43.148)

magnify its presence. Day seems to want to create a relationship between the two women. Like other elements that he has chosen in constructing this portrait, the inclusion of the photograph further animates the composition, creating a tension that complicates the viewer's understanding of the scene. This device is consistent with Day's commitment to thinking anew about fine art photography.

Rejecting conventional practices was altogether characteristic of Day. Influenced by such English aesthetes as Oscar Wilde, Aubrey Beardsley, and William Morris, Day eschewed a traditional career in favor of pursuing his interests in literature and photography. Independently wealthy, he was never overly concerned about the financial returns of the publishing house he founded in 1893 with his Harvard classmate Herbert Copeland, or his increasing investment in photography. Instead, he pursued projects that were dear to him, including the publication of the first American edition of Wilde's scandalous play *Salomé*, illustrated with Beardsley's highly erotic drawings. In the realm of photography, Day was equally controversial. Photographing male nudes, women dressed in exotic costumes, and—perhaps most shocking to Boston audiences—religious tableaux, including the subject of Christ on the cross, garnered him a reputation as a provocateur. Yet, within fine art photographic circles in America and abroad, he was increasingly seen as a leading practitioner, celebrated for his daring subject matter and his unconventional pictorial style. As a testament to his prominence, the London-based photographic group, the Brotherhood of the Linked Ring, elected him a member in 1895. Day was only the third American to be honored in this way.[4]

Portraiture especially interested Day, and he wrote repeatedly about what he perceived as the glaring absence of artistic taste in the work of most commercial portrait photographers. To improve this situation, he encouraged photographers to study the finest examples from the history of art and to abandon cheap studio props and painted backdrops. As he wrote in 1899, the same year in which he and Ben-Yusuf collaborated on this portrait series:

If one expects to produce art they must have at least a rudimentary acquaintance with examples and the history of art as a background upon which to draw in or model the subject chosen. If a most casual observer has had a sitting with Mrs. [Julia Margaret] Cameron or [Frederick] Hollyer, he will surely recollect that the studio was not completely flooded with light as, I may venture to say, nine hundred and ninety-nine out of every thousand photographers will consider an absolute necessity. If we have our portrait made by [William] Hollinger or Mrs. [Gertrude] Käsebier, we find no prepared canvas backgrounds, no painted gates, or fences, or flower pots, no vises into which our heads and shoulders are mercilessly set; which are as certainly a part of the usual photographer's apparatus as the camera itself. It is not the possession of paraphernalia which makes the portrait artist; although that is all his brother, the likeness manufacturer, can assume.[5]

In Ben-Yusuf, Day found a portrait photographer who was worth supporting. Although he had earlier worried in *Camera Notes* that the growing number of new practitioners might undermine the pictorialists' goal for the medium, he came to regard Ben-Yusuf as an artistic colleague.[6] As a member of the jury for the Philadelphia Photographic Salon of 1899, Day helped to select four works by her for inclusion in this prestigious exhibition, and a year later, while organizing the groundbreaking *New School of American Photography* exhibition at the Royal Photographic Society in London, Day again chose a selection of her work to showcase. Moreover, in articles and speeches, he

one that abandoned traditional studio conventions. Both recognized photography's artistic potential and strove to rethink their approach to representing subjects of interest. Yet, although Ben-Yusuf declared in 1901 that "we are all as yet mere experimentalists," and felt altogether comfortable in the bohemian surroundings of the artistic and literary avant-garde, she was a woman on her own for whom photography was a professional career.[8] Without the financial freedom that Day enjoyed, Ben-Yusuf was often limited in the subjects on whom she could focus and the styles that she could adopt. As her work with him suggests, though, she was a kindred spirit in the modern photography movement.

<div style="text-align: right">FHG</div>

4 Day's life and photographic career have been well chronicled in Estelle Jussim's *Slave to Beauty: The Eccentric Life and Controversial Career of F. Holland Day, Photographer, Publisher, Aesthete* (Boston: David R. Godine, 1981); and Pam Roberts's *F. Holland Day* (Amsterdam: Van Gogh Museum, 2000). For a collection of Day's writings, see also *F. Holland Day: Selected Texts and Bibliography*, ed. Verna Curtis and Jane Van Nimmen (New York: G.K. Hall & Co., 1995).
5 F. Holland Day, "Portraiture and the Camera," *The American Annual of Photography and Photographic Times Almanac*, 1899, Vol. 14 (1899): 20.
6 F. Holland Day, "Art and the Camera," *Camera Notes*, Vol. 1, no. 2 (October 1897): 27–28.
7 In particular, see F. Holland Day, "Art and the Camera," *Lippincott's Monthly Magazine*, Vol. 65 (January 1900): 85; and F. Holland Day, "Opening Address: The New School of American Photography," *Photographic Journal*, Vol. 25, no. 2 (October 1900): 75.
8 Zaida Ben-Yusuf, "The New Photography—What It Has Done and Is Doing for Modern Portraiture," *Metropolitan Magazine*, Vol. 16, no. 3 (September 1901): 397.

regularly singled her out for praise as a portraitist.[7] It is not known when they first encountered each other; however, during the summer of 1899, while Ben-Yusuf was in Boston visiting her mother, the two exchanged letters and agreed to meet. On this occasion Day created these photographs of Ben-Yusuf. In each portrait, Ben-Yusuf modifies her outfit or pose, suggesting how active this collaboration was. Her experience photographing a range of different subjects—including herself, but also, importantly, theatrical celebrities—surely influenced her engagement with Day.

Day's friendship was significant to Ben-Yusuf and greatly influenced her photography. Like Day, she was committed to a new form of photography,

3.

The Book

"The keynote of interest in modern photography is the possibility of expressing one's personal point of view," wrote Ben-Yusuf in *Metropolitan Magazine* in the fall of 1901.[9] As her self-portraits demonstrate, she created work not only for her paying clientele, but also for herself. *The Book*—alternately titled *A Study*—is representative of the non-commercial fine art photography that she created during the early years of her career. This platinum print of 1898 figures a young woman wearing a bohemian-style dress, her face darkened by shadow. Light brings into focus her bare shoulders and an outstretched hand, which rests in an exaggerated pose on a table at left. A book lies on the table, and portions of two framed prints hang on the wall in the background. As its two titles suggest, the photograph is not primarily a rendering of an individual's likeness, but rather a composition that highlights Ben-Yusuf's interest in artistic figuration. Meant for exhibition and critical review, it and other such images point to the sense of ambition she possessed as an artist. While having handled a camera for only a short time, she demonstrates in *The Book* her desire to exhibit alongside the leading pictorial photographers in America and abroad.

New York City presented Ben-Yusuf with numerous opportunities to pursue photography as a fine art. By the mid-1890s, exhibition venues, professional journals, and a host of individuals committed to such work were present there. Most important at this time were those affiliated with the Camera Club of New York, an organization formed through the consolidation of two rival camera clubs in the spring of 1896. Led by Alfred Stieglitz, the Camera Club and its journal, *Camera Notes*, became synonymous with modern photography in New York. The Camera Club was also forward-thinking in its policy of accepting

The Book
Zaida Ben-Yusuf
Platinum print, 1898
23.9 × 18.7 cm (9⁷⁄₁₆ × 7⅜ in.)
The Metropolitan Museum of Art, New York,
Alfred Stieglitz Collection, 1949 (49.55.219)

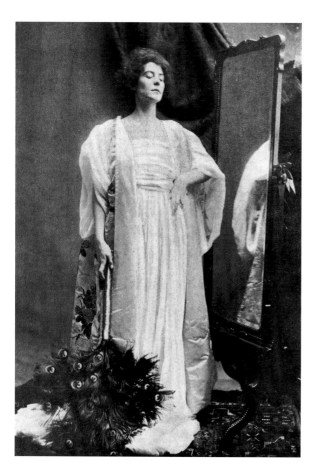

The Peacock's Plumage
Zaida Ben-Yusuf
Halftone print published in
Photo-Era, June 1898
Fine Arts Library, Harvard College Library,
Cambridge, Massachusetts

women as members, and increasingly during this period they joined in order to take advantage of the club's facilities and the network of amateur and professional photographers who belonged to it. Although Ben-Yusuf was never a member—possibly for financial reasons—she did exhibit there a large selection of her photographs, including this print, in a two-person exhibition with Frances Benjamin Johnston in the fall of 1898.

Two different critics for *Camera Notes*—William Murray and Sadakichi Hartmann—reviewed Ben-Yusuf's selection of photographs at this exhibition. In their written remarks, each praised this particular image. Invoking the painter William Morris Hunt's famous statement, "You want a picture to seize you as forcibly as if a man seized you by the shoulder," Murray concluded that "Miss Ben-Yusuf goes a step beyond this in her photographic pictures, for some of them make you feel as if you had not only been seized by the shoulder but had also received a violent blow on the proboscis or the solar plexus. . . . This may be seen even in her quietest successes, as in the picture entitled simply 'A Study.'" Hartmann, likewise, singled out this photograph as "to me one of the attractions of the exhibition."[10] Their enthusiasm derived in large part from the formal qualities of the work itself: the handling of light and shade, the rendering of the subject's outstretched hand, and the relationship of the background to the female figure.

Ben-Yusuf's ability to craft a photograph that demonstrated such technical skills was important to turn-of-the-century critics. Though Murray and Hartmann found much to praise in her work—especially given her youth and relative inexperience—they also noted less successful work from this exhibition. In *The Peacock's Plumage*, for example, both found that her headlong

desire to create a distinctly artistic photograph compromised the ultimate result. Murray remarked: "She rushes for the picturesque as if it were a five-barred gate; and when she lands on the other side, as she is quite likely to do, the top bar will be found to be badly damaged, if indeed the whole obstruction is not knocked down. If it were not for the seriousness of purpose, which is evident even in her most bizarre attempts, we might say that she preferred to embody the picturesque by presenting the grotesque." Hartmann noted similarly, "'The Peacock's Plumage' is not, in my opinion, a picture; it is ordinary, and not at all to be compared with her other work, which is generally so aristocratic, logical, and edifying."[11]

Both *The Book* and *The Peacock's Plumage* exhibit Ben-Yusuf's commitment to creating photographs that are more than mere likenesses. In these works, she aspires to transcend the recording nature of the medium to realize an image that is not only technically competent but also invested with beauty and artistic refinement. The line between success and failure in this regard was often hard to define and ever shifting. Yet this comparison does provide insight into what was valued within the fine art photographic community at the time. In *The Peacock's Plumage*, Ben-Yusuf's over-use of studio props and her subject's contrived pose compromise the image's effect. Murray categorized its "mock tragedy pose" as "stagey."[12] In *The Book*, though, Ben-Yusuf's handling of composition and light are more refined, and the result is an image that conveys poetical expression rather than false theatricality. In its subject matter and technique, *The Book* shows the influence of the leading pictorial photographers in both Europe and America—artists whose careers were themselves shaped by the artistic and literary avant-garde of this period. It is a testament to Ben-Yusuf's achievement as an emerging talent that Stieglitz acquired this particular photograph for his personal collection.

In the years ahead, Ben-Yusuf continued to experiment with the medium's artistic possibilities and to submit her best prints to photographic exhibitions in America and abroad. Yet she also faced challenges in pursuing this work. Economic circumstances compelled her increasingly to expend most of her energy on commissions or images that she could market to popular periodicals. As importantly, she found—like so many artists before and after her—that success within the artistic marketplace was not wholly a product of her own hard work and creativity. Critics, jurors, and patrons of every stripe were often as important in shaping a career. Nonetheless, at this period, photography remained for Ben-Yusuf a rich outlet for creative self-expression. Moreover, it provided her with a means to connect with the larger world of the fine arts. Having opened her photographic studio only a year earlier, she valued this sense of belonging.

FHG

9 Ben-Yusuf, "The New Photography," 390.
10 Murray, "Miss Zaida Ben-Yusuf's Exhibition," 168. Sadakichi Hartmann, "A Walk Through the Exhibition of the Photographic Section of the American Institute," *Camera Notes*, Vol. 2, no. 3 (January 1899): 87.
11 Murray, "Miss Zaida Ben-Yusuf's Exhibition," 171. Hartmann, "A Walk Through the Exhibition of the Photographic Section of the American Institute," 87.
12 Murray, "Miss Zaida Ben-Yusuf's Exhibition," 171.

4.

Miss Ben-Yusuf Announces
a Private View of Photographs

The desire for artistic acclaim and the need to earn
a living were always central to Ben-Yusuf's practice
of photography. Both required ever-wider public
notice, and in this regard she showed significant
resourcefulness and imagination. She hustled to
line up opportunities to publish her photographs
in magazines and newspapers and was not slow to
involve herself in the different photographic
exhibitions that were being organized at the time.
As this photograph indicates, she also created
exhibitions of her work at her own studio. It is
likely that she hung this photograph in a publicly
accessible case outside her studio in the days
leading up to one of these periodic exhibitions.
Yet, in taking her work and herself out in public,
she was deliberate about cultivating an aura of
high-minded artistry as a way to differentiate
herself from the many commercial photographers
employed in New York City. Cognizant of the
perception that the leading pictorial photographers
were amateurs whose work was created and
exhibited apart from the world of commerce,
Ben-Yusuf sought to position herself within this
rarefied community. This announcement of an
exhibition of her photographs—featuring a female
figure, who may possibly be Ben-Yusuf herself—
reflects an effort to find a balance between her
artistic ambition and her studio business.

In a profile of Ben-Yusuf from 1899, Sadakichi
Hartmann—a critic who consistently championed
those amateurs who were exploring photography's
creative possibilities—made special note of the
various challenges that confronted her and other
professional photographers who sought recognition
in the world of the fine arts. While praising her
innovative style as a welcome departure from more
traditional forms of commercial portraiture,
Hartmann was ultimately skeptical of the motives
of professional photographers:

*Miss Ben-Yusuf Announces a Private View
of Photographs*
Zaida Ben-Yusuf
Platinum print, 1899
17.6 × 12.1 cm (6¹⁵⁄₁₆ × 4¾ in.)
The Museum of Modern Art, New York;
gift of Mrs. Elizabeth Guy Bullock

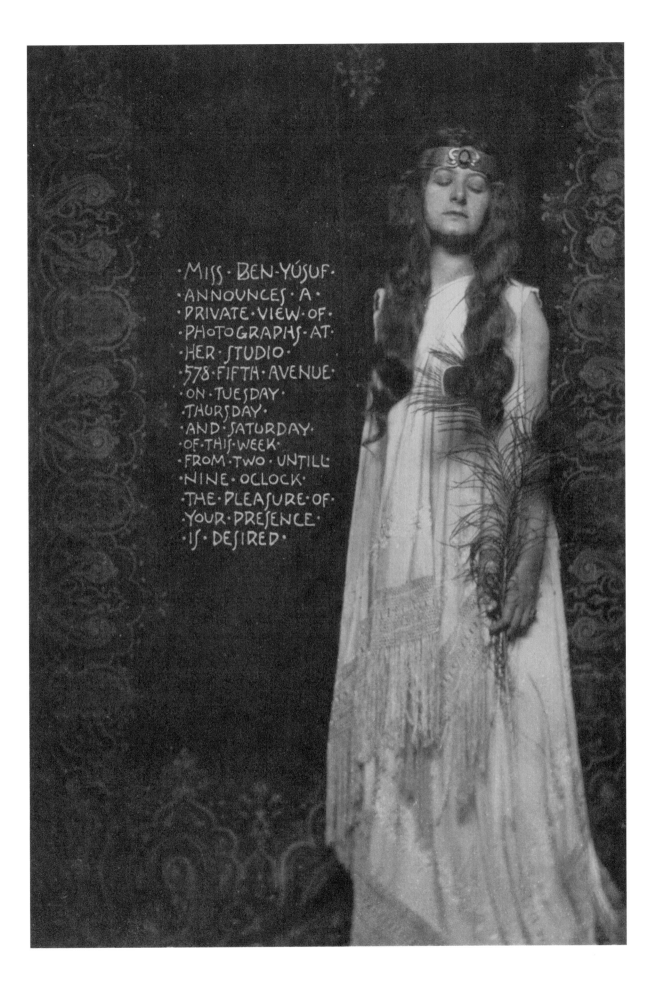

There exists in New York a clan of Bohemians who pretend they do not care a rap for money, and who only accept it for their more or less artistic services, because they have to live after all. This is merely a pose in most cases. . . . Because Miss Ben-Yusuf and Miss [Gertrude] Käsebier have found such a new way of getting customers, they do not wish to be called professionals. Besides, they claim to be superior craftsmen of their trade, they fancy limited editions of prints and exhibits in photographic salons, and understand how to surround themselves with a certain air of exclusiveness. It almost seems as if they wish to convey that they confer a special favor in photographing a person for twenty-five dollars.[13]

This photograph makes clear that Ben-Yusuf nurtured a bohemian persona. Whether or not it depicts her, the individual portrayed comes to personify the qualities associated with Ben-Yusuf's studio. Dressed in a theatrical gown with a scarab headband and holding an ostrich feather against a backdrop of a decorated tapestry, the woman suggests Ben-Yusuf's artistic flair. The photograph communicates that her studio is more than simply a place to acquire a portrait; instead, it acts as a portal into a new world. As Hartmann had observed and the photograph's written text confirms, she makes a point of her studio's exclusivity, welcoming visitors not so much to a public opening, but rather "a private view of photographs." In this way, she was similar to many late nineteenth-century artists who worked to transform their studios into exotic rooms in an effort to perform the role of the "artiste" before the public.[14]

Ben-Yusuf created this photograph most probably in the fall of 1899—around the time of her thirtieth birthday—in preparation for her first exhibition at a new studio that she had just moved into. Having spent nearly three years near Union

Square, she relocated thirty blocks north to 578 Fifth Avenue—a building that had once served as the residence of the financier Jay Gould—in order to take advantage of the increased and more fashionable commercial traffic. The block on which she sited her new studio already contained three successful photographers: Rudolph Eickemeyer, Charles Berg, and Aimé Dupont. Yet, despite this and a horrific fire the previous March at the Windsor Hotel across the street, in which ninety-two individuals perished, Ben-Yusuf recognized that business was increasingly headed uptown.

Self-portrait
Frances Benjamin Johnston
Modern gelatin silver print from
original negative, *c.* 1896
Library of Congress, Washington, D.C.,
Prints & Photographs Division

Bolstered by a number of important recent commissions, including portraits of Governor Theodore Roosevelt and Admiral William Sampson, she therefore decided to join this migration. For her inaugural exhibition, she constructed this photograph to announce her presence in the new neighborhood.

A review of the exhibition in the *New York Times* noted the relocation of Ben-Yusuf's studio and stressed how she brought to portrait photography an altogether new sensibility. The article concluded: "To characterize Miss Ben-Yusuf's work as a whole, it may be said that she puts her soul into it, and that it thereby acquires a certain indefinable but yet unmistakable quality, which lifts it above ordinary photography."[15] In one sense, this photograph was part of a larger marketing plan orchestrated to draw attention and clientele to her new studio: she believed that publicizing her bohemian persona helped to mark her out from other portrait photographers.

Like Ben-Yusuf, Frances Benjamin Johnston was a female photographer who understood the challenges faced by ambitious women trying to carve out a professional niche. In her self-portrait (opposite), Johnston provides self-mocking testimony to the perceptions that grew up around such women. Holding a beer stein in one hand and a cigarette in the other and sitting with her legs crossed so that her underskirt is visible, she makes light of the different notions that surrounded those women whose lives transgressed traditional feminine ideals. Johnston's self-portrait suggests the slippery nature of identity itself in an age when new opportunities were recasting conventional social boundaries.

Hartmann and others who favored the work of amateur fine art photographers responded with mixed feelings to the commercial element that underlay the photography of such women as Johnston, Käsebier, and Ben-Yusuf. They believed that the marketplace compromised creative expression. Yet, although the woman who figures prominently in Ben-Yusuf's photograph was performing a fictional role, her presence—like Ben-Yusuf's within the larger world of photography—was not "merely a pose," as Hartmann claimed. Unable to work without the recompense from her studio, Ben-Yusuf sought to break down the divide that existed between amateurs and professionals. As much as this portrait is about advertising, it is also representative of her desire to infuse with style, imagination, and beauty a photographic tradition that she and others perceived as artistically bankrupt. Given prevailing opinions, many writers and artists alike received Ben-Yusuf and the work that she created with some hesitation. Such was the predicament at the century's end for her and for others who sought to pursue photography for a living.

FHG

13 Sadakichi Hartmann, "A Purist," *Photographic Times*, Vol. 31, no. 10 (October 1899): 451.

14 See Sarah Burns, *Inventing the Modern Artist: Art and Culture in Gilded Age America* (New Haven, Conn.: Yale University Press, 1996); and Isabel Taube, "Rooms of Memory: The Artful Interior in American Painting, 1880 to 1920," Ph.D. Dissertation, Department of Art History, University of Pennsylvania, 2004.

15 "Some Clever Photographs," *New York Times* (December 8, 1899): 6.

5.

The Odor of Pomegranates

Ben-Yusuf's artistic explorations within the tradition of portraiture continued alongside her commercial work. One of the prints she felt was most successful was *The Odor of Pomegranates*, a work that she exhibited on at least half a dozen occasions in the years immediately after its completion in 1899. No other photograph by her was displayed or reproduced as often. This portrait shows an unidentified young woman holding a pomegranate only inches before her face. The subject is dressed in an ornately decorated garment and stands erect in profile against a similarly patterned fabric that serves as the backdrop for the photograph. A string of pearls is interwoven in her hair. As the photographer and critic Joseph Keiley observed in his review of this "especially striking" image, "the figure was posed against a darker piece of heavy oriental drapery, figured with curving lines that resembled writhing serpents, and into which the draped figure almost melted." Others, including the photographer Alvin Langdon Coburn, also commented on Ben-Yusuf's effort to meld her subject into the folds of the backdrop.[16]

The effect of this compositional strategy is a radical flattening of the picture plane so that the figure appears like a mythological personage carved on to a frieze. Capturing likeness is not the goal of the composition; instead, Ben-Yusuf is more concerned with the larger creative possibilities of photography. Although some art critics continued to dismiss the efforts of photographers who aspired to use the camera in this way, Ben-Yusuf was closely allied with those who saw photography as a medium of artistic expression. To her and other like-minded practitioners, much could be learned from the world of the fine arts and literature, and this new class of photographers went to great lengths to create prints that incorporated these lessons. As the scholar Naomi

The Odor of Pomegranates
Zaida Ben-Yusuf
Platinum print, 1899
23.7 × 12.9 cm (9⁵⁄₁₆ × 5¹⁄₁₆ in.)
Library of Congress, Washington, D.C.,
Prints & Photographs Division

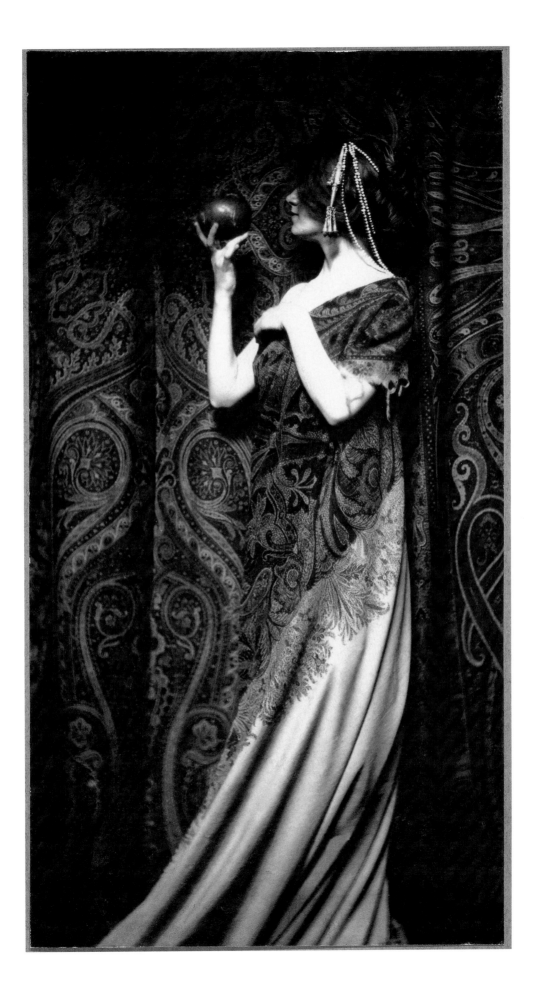

Isabella and the Pot of Basil
John White Alexander
Oil on canvas, 1897
Museum of Fine Arts, Boston;
gift of Ernest Wadsworth Longfellow

Rosenblum has shown, *The Odor of Pomegranates* owes much stylistically to such works as John White Alexander's painting, *Isabella and the Pot of Basil* (left).[17] Ben-Yusuf admired Alexander, and two years later completed a series of portraits of the artist. In its subject matter, its composition, and its presentation, Ben-Yusuf's image reveals the influence of the late nineteenth-century avant-garde.

Fine art photographers were also well aware of each other's work. Exhibitions, journals, and clubs devoted exclusively to pictorial photography were widespread in the United States and Europe during this period, and through them Ben-Yusuf acquainted herself with the latest technical and aesthetic developments. An active participant in this community, she forged relationships with a great number of its leading figures. Ben-Yusuf visited F. Holland Day in July 1899—roughly the period when *The Odor of Pomegranates* was created. Day was regarded by many at the time as the most progressive—and provocative—photographer in America. Less than a year earlier he had first exhibited his controversial *The Seven Words*, a work comprising seven close-up portraits of a model impersonating a crucified Jesus Christ. Brought together within a single frame—on which Day had transcribed biblical excerpts—this series shocked many who regarded photography as both inadequate and inappropriate for exploring sacred subjects.

Day's interest in using photography to represent the religious past impressed others with the idea that the medium should not be limited to portraying contemporary people or events. In *The Odor of Pomegranates*, Ben-Yusuf herself experiments with creating a photographic portrait that is as much about Classical mythology as it is about modern life. The pomegranate that the woman

holds before her provides a key to unlocking the work's larger symbolism. An odorless fruit, the pomegranate has long been a popular subject for artists and poets, many of whom have seen it as a symbol of the Resurrection. In Greek mythology, it figures prominently in the story of Persephone, the beautiful daughter of Zeus and Demeter, whose eating of a pomegranate given to her by Hades bound her for part of the year in the underworld over which he reigned. During those months when Persephone was forced to remain there, Demeter—the goddess of the harvest— refused to allow anything to grow, and thus winter began. Ben-Yusuf depicts her Persephone-like figure observing closely—even contemplating—the fruit before her. Its "odor" relates not to its smell, but rather the tantalizing expectation that precedes the act of consuming the pomegranate.

Ben-Yusuf's *The Odor of Pomegranates* is a departure from the professional photography that typically occupied her. Not concerned with capturing a sitter's individuality, she explores in this portrait a more universal theme: the seductiveness and potential danger of something desirable. For Ben-Yusuf, a photographer with ambitions, this subject must have resonated strongly. Only recently she had relocated her studio to a new, more fashionable space on Fifth Avenue and had devoted herself to exhibiting her work more widely. Her interest in elevating her standing in the New York photographic community was certainly worth pursuing. Yet, as a woman who needed to support herself, she would have recognized the risks involved in expanding her commitment. Despite a recent wave of encouragement for women pursuing photography, only in exceptional cases had they been able to sustain photographic careers.

Although the long hair of Ben-Yusuf's subject hides her eyes, it appears that this woman stares out at the pomegranate she holds as if pondering whether to act. Her other arm rises upward in a gesture that suggests a certain hesitation. *The Odor of Pomegranates* captures the tense moment of decision. An example of the creative possibilities in fine art photography, this image also signals much about Ben-Yusuf's hopes and anxieties as a professional photographer in New York at the turn of the century.

FHG

16 Joseph Keiley, "The Salon," *Camera Notes*, Vol. 3, no. 3 (January 1900): 147–48. Alvin Langdon Coburn, "American Photographs in London," *Photo Era*, Vol. 6, no. 1 (January 1901): 211.
17 Naomi Rosenblum, *A History of Women Photographers* (New York: Abbeville Press, 1994): 75–77.

6.

Ekai Kawaguchi

Buddhist scholar
Born Sakai, Japan
1866–1945

Ben-Yusuf's photography was not limited to subjects that she captured in her New York studio. When she traveled to Japan and China in 1903, she took with her three cameras, which she used to photograph various subjects, including the region's landscape, architecture, and historic landmarks. She also used her trip as an opportunity to continue collecting portraits of prominent figures. As in New York, photography permitted her access to individuals of note, and despite being in a foreign land, she was not reluctant to pursue new subjects. Most significantly, Ben-Yusuf created at least two portraits of the famous Buddhist scholar Ekai Kawaguchi, whom she photographed at the Oriental Hotel in Kobe, Japan. Details about how she met him and the nature of their interaction are not known; however, from the resulting photographs, it is apparent that Ben-Yusuf was permitted the time to create images consistent with her previous work.

Few individuals were as celebrated in Japan as Kawaguchi in the summer of 1903. In May, he arrived back in Kobe after six years abroad, during which he became the first Japanese person to enter Nepal and Tibet, then both closed to outsiders. His safe return and the story of his journey prompted celebrations throughout Japan.[18] As Kawaguchi explained in an article he wrote for *Century Magazine*, for which Ben-Yusuf supplied a variant of this portrait: "my sole object in going to Tibet was to complete my studies of Buddhism. Complete editions of the Buddhist Scriptures were brought to Japan in the early centuries, but being in Chinese, the texts in many places admit of different interpretations according to the individual writers." As the "Chinese translations are less trustworthy than the Tibetan texts," he longed to study the scriptures in the authoritative Sanskrit edition, a task that no Japanese scholar had ever

Ekai Kawaguchi
Zaida Ben-Yusuf
Platinum print, 1903
24.1 × 18.7 cm (9½ × 7⅜ in.)
Philadelphia Museum of Art, purchased with the Lola Downin Peck Fund, the Alice Newton Osborn Fund, and with funds contributed by The Judith Rothschild Foundation, in honor of the 125th anniversary of the Museum, 2002

Musicians in Ceremonial Costume
John La Farge
Watercolor and gouache over
graphite, 1887
Worcester Art Museum, Massachusetts;
gift of Samuel B. Woodward

had an opportunity to pursue. He also hoped
to visit several sacred Buddhist landmarks.[19]

In order to achieve his goal, Kawaguchi
orchestrated an extraordinary journey that required
tremendous patience, ingenuity, and physical
stamina. Leaving Japan in June 1897, he first
traveled to Darjeeling, India, where he spent a year
and a half studying the Tibetan language. Crossing
the border into Nepal disguised as a Chinese
student on a pilgrimage through Tibet, he made
his way to the capital, Kathmandu, and then to
the village of Tsadang, the home of a Buddhist
scholar who agreed to assist his studies and to aid
him across the border into Tibet. As the Tibetan
authorities closely watched the established routes of
entry, Kawaguchi was forced to take an alternative
route through the Himalaya mountains near
Dhaulagiri, whose summit rises to more than 7500
meters (25,000 feet). Almost dying of cold and
starvation, he made it across the border in July
1900 and began his two-year exploration of the
country. The following spring found Kawaguchi in
Lhasa, Tibet's capital and the home of the Dalai
Lama. In the guise of a Chinese doctor, he gained
admittance to Sera Monastic University, the most
prestigious center for Buddhist studies, during
which time he had the occasion to be blessed by
the Dalai Lama at his palace.

A year later, Kawaguchi's pilgrimage came to an
abrupt halt when his true identity was uncovered.
Knowing that the authorities had killed previous
outsiders who had entered Tibet, he fled back to
Darjeeling before he could be caught. Yet news
soon came that those who had protected him in
Lhasa had been imprisoned and were facing severe
punishment. Although ill with malaria for a time,
he began an effort to seek pardon for them,
traveling to Calcutta and Delhi to talk with
Japanese and Indian officials. Kawaguchi returned

to Nepal in January 1903 to meet the prime minister, who forwarded to the Dalai Lama his letter of apology. Ultimately, the Dalai Lama granted the release of these individuals.[20]

Ben-Yusuf's portrait of Kawaguchi shows the recently returned scholar kneeling on a mat in a pose characteristic of a formal meeting between two people in Japanese society. In one hand he holds a folded fan—a common element in a formal costume—and in the other, Buddhist prayer beads. The kimono and surplice that he wears are typical of a Buddhist monk's robes in Japan. Ben-Yusuf's focus on a traditionally dressed man holding objects that speak to his culture's heritage follows closely the example of many artists who visited Japan, including such Americans as John La Farge, Robert Blum, and Helen Hyde. She and others were interested in discovering a timeless Japanese past, and as a result avoided scenes or figures suggesting the rapid industrialization that the nation was experiencing at this point.

Nevertheless, there are elements in Ben-Yusuf's portrait that suggest a modern sensibility—one that breaks with conventional representations of Japanese figures. In this close-up, she captures the individuality of her sitter, a rare feat for most Western artists in Japan. The photograph of Kawaguchi is neither an ethnographic document nor a postcard portrait. Instead, through her use of light and composition, Ben-Yusuf has attempted to capture his dignity and purposefulness. While his achievements in Nepal and Tibet might have merited special attention, she has not sensationalized the thirty-seven-year-old scholar, but has presented him as a participant in a formal exchange.

In the years that followed his return to Japan, Kawaguchi worked hard to promote relations between his own country and Nepal. In addition to writing a lengthy account of his landmark journey, he revisited Nepal on two other occasions, one of them in 1905, when he presented the prime minister in Kathmandu with a hundred-volume set of the *Tripitaka*, a Buddhist canon of scriptures. He also promised, in the first such gesture from a Japanese official, to lend his advice and support to Nepalese efforts to modernize the country's socio-economic infrastructure. In return, he received a valuable collection of Sanskrit manuscripts, together with various Buddhist paintings and religious objects. In Kawaguchi, Ben-Yusuf met one whose ambition and sense of purpose were clearly worth marveling over. Taken at the time of his most celebrated achievement, her portrait conveys that sense of respect and honor that she surely felt in meeting and photographing him. Her encounter also suggests how photography continued to serve as a vehicle for personal self-fulfillment.

FHG

18 Eliza Scidmore, "Japanese Priest a Year in Tibet," *Chicago Daily Tribune* (January 23, 1904): 1.

19 Ekai Kawaguchi, "The Latest News from Lhasa: A Narrative of Personal Adventure in Tibet," *Century Magazine*, Vol. 67, no. 3 (January 1904): 385. For a study of Kawaguchi's life and travels, see Abhi Subedi, *Ekai Kawaguchi: The Trespassing Insider* (Kathmandu, Nepal: Mandala Book Point, 1999).

20 With the encouragement of Annie Besant, the president of the Theosophical Society in London, Kawaguchi's writings about his travels in Nepal and Tibet were translated into English in 1909. The resulting publication, *Three Years in Tibet* (London: Theosophical Publishing Society, 1909), provides a detailed account of his experience and first-hand observations of the practice of Tibetan Buddhism.

7.

The Dancer and *The Piano of Nippon*

In addition to meeting Ekai Kawaguchi while in
Kobe, Ben-Yusuf also had occasion to meet and
photograph a geisha dancer. Upon her return
to New York, she wrote about this unnamed
woman—and her manner and costume—in the
first of four *Saturday Evening Post* articles about her
travels in Asia. "She was a perfectly charming little
girl about fourteen years old, prettier than most of
them, and always careful to follow the etiquette
of her profession, bowing politely to the singers
who accompanied her as well as to her audience at
the end of each dance. The costume she wore was
of heavy black crepe, the flowers formed in the
dyeing process and not embroidered. Keeping her
hands hidden in the kimono sleeves is a souvenir
of old-fashioned elegance."[21]

It was "old-fashioned elegance" that Ben-Yusuf
sought out during her time in Japan and that she
tried to capture in her portraits of this woman,
two examples of which are pictured here. Like
many Western tourists who traveled to Japan
during the period, Ben-Yusuf gravitated to those
places where she could encounter aspects of
Japanese culture that were seemingly unchanged
by time. Her trip during the summer of 1903 to
Nikko—a village in the mountains north of
Tokyo that is famous for its natural and historic
landmarks—was like those of many who longed
to experience something of Japan's medieval past.
There, amid dramatic waterfalls and mountain
lakes, she encountered and photographed such
picturesque sites as the Toshogu, the lavishly
decorated shrine and mausoleum of an important
seventeenth-century shogun.

Such landmarks were not the only subject that
captured tourists' attention. Westerners also gazed
upon Japanese men, women, and children from all
walks of life, but most especially those who
dressed and performed functions consistent with

The Dancer and *The Piano of Nippon*
Zaida Ben-Yusuf
Halftone prints published in *Leslie's
Monthly Magazine*, February 1905
Firestone Library, Princeton University,
New Jersey

popular notions of traditional Japanese society. Samurai warriors attracted great notice, not surprisingly given their legendary status and exotic costume. In looking at Japanese women, visitors particularly sought out the geisha, a figure around whom a variety of associations swirled. While a geisha during this era was typically a young woman who provided light entertainment, many saw her also as a courtesan offering amusements that extended beyond music and dancing. Adding to the aura around the geisha were popular stories suggesting that this class of women had existed for centuries. In fact, geisha-type women date back to the earliest history of Japan, and during a certain period geisha did indeed work as prostitutes. By the time Japan was opened up to the West in the mid-nineteenth century, however, new regulations limited the extent of this sex trade.

Nevertheless, popular perceptions remained, and geisha were invested with special significance by foreigners. Photographers recognized that there was a market for geisha portraits, and their images both added to the attention that grew up around these women and helped to conventionalize the manner in which they were perceived. Such Western photographers as Felice Beato and Baron Raimund von Stillfried, and such Japanese photographers as Kimbei Kusakabe, created great quantities of these images for the commercial tourist trade during the latter half of the nineteenth century. Beato, a photojournalist from England who established a successful studio in Yokohama in 1863, was especially instrumental in popularizing portraits of geisha, and his photograph *Playing Koto* (below) is representative of this type. It highlights the geisha's colorful dress and the traditional instrument she plays. Lacking individuality, his subject instead represents a timeless archetype.[22]

Ben-Yusuf's series of geisha portraits follows in the same tradition. Fixating on the exotic, she casts

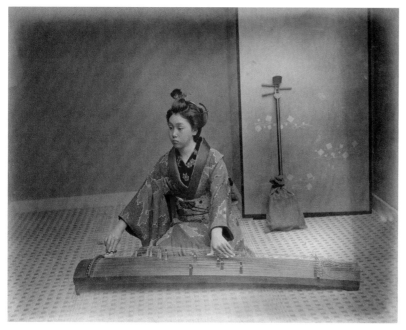

Playing Koto
Felice Beato
Hand-colored albumen silver print,
c. 1875
Rosin Collection of Early Photography
of Japan, Freer Gallery of Art and
Arthur M. Sackler Gallery Archives,
Smithsonian Institution, Washington, D.C.

Japanese culture as having changed little from its medieval past. What Ben-Yusuf most wants to capture are her subject's ornate kimono and the performance that she presents—one that she characterized as "dignified" in an article published in *Leslie's Monthly Magazine* in 1905.[23] By enfolding her within the decorated screen that serves as a backdrop, Ben-Yusuf adds to the sense that this woman lives wholly in the realm of art and that the realities of modern Japan do not impinge on her life. Like the photographer Edward Curtis, whose turn-of-the-century images of Native Americans cloaked tribal communities in a warm, yet distant light, she has focused on traditional customs and costumes rather than on the circumstances in which Japanese women more commonly lived at this time.

Photographing such figures as Kawaguchi and a geisha appealed to Ben-Yusuf's interest in the extraordinary. In traveling to Japan, she brought with her not simply the dreams of a Western tourist, but also her particular eye for the unique and beautiful. Although during her trip she became acquainted with modern Japan—its growing industrialism and openness to new peoples and new ways—Ben-Yusuf preferred to focus on those aspects that were consistent with the nation's historic identity. Partly a product of her imagination and partly based on fact, this world allowed her the type of escape that photography itself had at times afforded her.

FHG

21 Zaida Ben-Yusuf, "Japan Through My Camera," *Saturday Evening Post*, Vol. 176, no. 43 (April 23, 1904): 6.
22 For studies of the Western photographic tradition in nineteenth-century Japan and China, see Eleanor Hight, "Japan as Artefact and Archive: Nineteenth-Century Photographic Collections in Boston," *History of Photography*, Vol. 28, no. 2 (Summer 2004): 102–22; Melissa Banta and Susan Taylor, eds., *A Timely Encounter: Nineteenth-Century Photographs of Japan* (Cambridge, Mass.: Peabody Museum Press, 1988); and David Harris, *Of Battle and Beauty: Felice Beato's Photographs of China* (Santa Barbara, Calif.: Santa Barbara Museum of Art, 1999).
23 Zaida Ben-Yusuf, "Women of Japan," *Leslie's Monthly Magazine*, Vol. 59, no. 4 (February 1905): 420.

Roosevelt
Men

No other figure towered over American life at the turn of the century as Theodore Roosevelt did. Even before he assumed the office of the presidency following William McKinley's assassination in September 1901, Roosevelt was widely regarded as a national hero, in large part on account of his leadership during the Spanish–American War of 1898, but also because of his success as a reform-minded New York governor. Once in the White House, he proved exceptionally energetic, fighting to break up corporate trusts, leading the attempt to build the Panama Canal, and pushing efforts to conserve America's natural resources. Yet Roosevelt was as important for the manner in which he utilized his position as he was for his political agenda. His strident belief in the power of the executive branch to serve as a "bully pulpit" in promoting change transformed the institution of the presidency and won him lasting fame. Although the figures represented in this section come from different walks of life, all were fervent supporters of Roosevelt. Some knew him from the world of New York politics, others from his days as the leader of the Rough Riders, and others still from the many books, articles, and speeches he wrote. In addition to sharing Roosevelt's political vision, these individuals admired the public persona he projected. They warmed to his belief in the so-called "strenuous life" and to his reassertion of an older form of American masculinity—one best characterized by his favorite proverb, "Speak softly and carry a big stick." Ben-Yusuf photographed Roosevelt during his tenure as governor. She also depicted many other figures whose careers intersected with America's twenty-sixth president.

8.

Theodore Roosevelt
Governor of New York
Born New York City
October 27, 1858–January 6, 1919

In the early spring of 1899, *McClure's Magazine* commissioned Ben-Yusuf to travel to Albany to photograph New York's governor, Theodore Roosevelt, for a forthcoming profile. She later described her trip: "On my arrival [I] was met by some one who was to take me direct to his private office. I found him one of the most nervous subjects I had ever had."[1] It is difficult to imagine a nervous Teddy Roosevelt; "ebullient," "ferocious," even "despondent" are distinct possibilities, but "nervous" seems unlikely—especially in 1899.[2]

Theodore Roosevelt's story is American legend. He was the asthmatic child healed by vigorous exercise and steely will; the college dandy torn between a life of scholarship and one of public service; the stubborn state legislator who earned his party's nomination for speaker when he was only twenty-four. He was the triumphant young lover who, upon winning the hand of pretty Alice Lee, exulted, "I do not think ever a man loved a woman more than I love her." And then, when his adored mother and his young wife died within hours of each other, he was the grieving son and husband, driven to proclaim, "The light has gone out of my life." He was the cattle rancher who tracked down outlaws, the failed but flamboyant candidate for mayor of New York City, and the chairman of the U.S. Civil Service Commission, where he fought to reward merit over patronage in the appointment process. And in March 1899, when Ben-Yusuf photographed him, he was the forty-year-old governor of New York.

Although all of these incidents helped to build the legend, it was Roosevelt's role as co-organizer of the First U.S. Volunteer Cavalry Regiment, the Rough Riders, whose charge up San Juan Hill in Cuba during the Spanish–American War the previous summer had thrilled the country, that was particularly significant in making him governor.

Theodore Roosevelt
Zaida Ben-Yusuf
Platinum print, 1899
20.2 × 16 cm (7¹⁵⁄₁₆ × 6⁵⁄₁₆ in.)
Library of Congress, Washington, D.C.,
Prints & Photographs Division

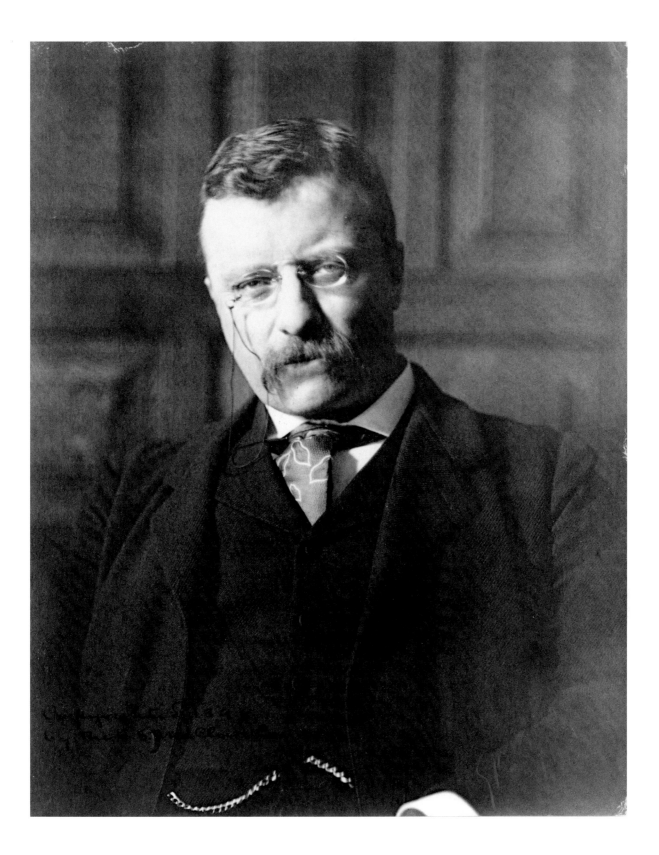

The regiment—his hand-picked band of cowboys and Ivy Leaguers—reasserted national faith in a particular brand of American manliness, while stories of his personal heroism earned him national admiration.

But being governor seldom requires raw physical courage. It was Roosevelt's behavior after the battle that persuaded voters of his fitness for office. Major General William Shafter, commander of the troops in Cuba, announced that the army, exhausted from battle and sickening quickly in the tropical heat, would be moved inland in hopes of cooler weather. Roosevelt wrote to Shafter explaining that such a move would be disastrous

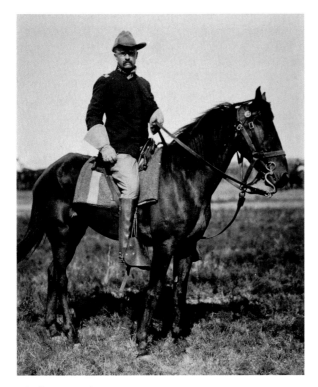

Theodore Roosevelt
Pach Brothers Studio
Platinum print, 1898
National Portrait Gallery, Smithsonian Institution,
Washington, D.C.; gift of Joanna Sturm

and demanding that his forces be removed to "the North Maine coast, for instance, or elsewhere where the yellow fever germ cannot possibly propagate."[3] Other commanders signed up to the letter's proposal, and the disposition of the troops was played out in the newspapers as a personal struggle between Roosevelt and Secretary of War Russell Alger. The outcome was typically Rooseveltian: Alger was castigated as an uncaring political hack, while Colonel Roosevelt, leading the Rough Riders to camp on Montauk, Long Island, was extolled as risking his career for the welfare of his men.

Back in New York, the Republican Party was mired in charges of corruption. In 1895, the people of New York had authorized $9 million to be spent dredging and repairing the Erie Canal, but recent audits revealed that all but $25,000 had been spent and only one-third of the work completed. The party leaders needed a candidate of unquestioned integrity. They needed Roosevelt, but they did not want him. They suspected, quite rightly, that such a maverick might be more than they could control. Only when it became obvious that the alternative would be to give the election to the Democrats did the party boss, Senator Thomas C. Platt, rally his forces behind the young colonel.

Within days of the election in November 1898, Senator Platt must have wondered if he would have been better off with a Democrat. Platt would put forward nominees, and Roosevelt would refuse them until he was offered someone he believed to be worthy of the post. When Roosevelt proposed legislation, the state legislature simply ignored it. When this happened, the governor reintroduced it until the legislature backed down. Known for his combative nature and given to tirades, Roosevelt relied on stubborn doggedness in dealing with his fellow Republicans. He simply wore them down.

That spirit of weary determination is clear in Ben-Yusuf's photograph, although the right shot did not come easily. Ben-Yusuf wrote of the sitting: "His face seemed to get tied up in knots, then he tried to look pleasant, and the result was so funny that we all laughed, and decided that he had better be serious. 'I'll imagine I'm discussing embalmed beef,' he said with a rather vicious emphasis on the last two words." Finally she "told him to 'brace up' or something equally dreadful," and she got the photograph she wanted. Far from the optimistic Roosevelt of so many portraits, this image shows a somber governor, his head inclined slightly, his brow furrowed, and his mouth held in a tight line. Most compelling is his direct gaze, as though he were taking the measure of the photographer, and of the viewer. Skilled at framing his public persona, Roosevelt seems to offer another side of himself. Beyond the exuberant Rough Rider and the insistently protective commander, he becomes the unwavering reformer, resolutely taking on the New York political establishment. Roosevelt was clearly pleased with the results. Ben-Yusuf reported that "later he sent me a very cordial note after receiving the prints."[4] And she was satisfied as well, choosing to display the portrait at a photography exhibition in New York later that fall.

Faced with at least two more years of dealing with Roosevelt, Senator Platt worked to draft the governor as William McKinley's vice-president. Despite Roosevelt's qualms that such a move would cause him to lose a powerful position and gain an impotent one, he accepted the nomination and helped McKinley to victory in the presidential election of 1900. Six months after the inauguration he was thrust into the White House when the anarchist Leon Czolgosz assassinated the new president. Roosevelt fulfilled McKinley's term and went on to one of his own. Later he won the Nobel Peace Prize, ran for president again on the third-party candidate Bull Moose ticket, and lent his name to the Teddy bear.

With the help of the popular press and such photographers as Ben-Yusuf, Theodore Roosevelt initiated a revolution in the American presidency. Where previous presidents had lived quietly, he and his family became beloved public figures and their lives were documented in both words and pictures. His daughter Alice inspired a fashionable song, and affectionate stories of the boisterous Roosevelt children filled the papers. Always conscious of his national audience, Roosevelt used his position— his "bully pulpit"—to further much more than a political agenda. His beliefs about nature and conservation, about marriage and motherhood, and about manliness were pronounced with such conviction that they had the weight of truth. Throughout his presidency and after, Roosevelt defined and promoted a particular kind of American culture: one that valued fair play and mutual respect, hard work and a square deal, and, above all, a zeal for life. In doing so, he provided a model for national leadership.

EOW

1 Zaida Ben-Yusuf, "Celebrities Under the Camera," *Saturday Evening Post*, Vol. 173, no. 48 (June 1, 1901): 14.
2 Biographies of Roosevelt include Kathleen Dalton, *Theodore Roosevelt: A Strenuous Life* (New York: Alfred A. Knopf, 2002); William Henry Harbaugh, *Power and Responsibility: The Life and Times of Theodore Roosevelt* (New York: Farrar, Straus, and Cudahy, 1961); and Edmund Morris's two-part study, *The Rise of Theodore Roosevelt* (New York: Coward, McCann & Geoghegan, 1979) and *Theodore Rex* (New York: Random House, 2001).
3 "Nine Men Out of Ten Sick," *New York Times* (August, 5, 1898): 7.
4 Ben-Yusuf, "Celebrities Under the Camera," 14.

9.

Leonard Wood

Army general, colonial administrator
Born Winchester, New Hampshire
October 9, 1860–August 7, 1927

In assessing the state of affairs in Cuba six months after the signing of a peace treaty between the United States and Spain, Roosevelt, the governor of New York, singled out Leonard Wood, then the military governor of the Cuban province of Santiago, for special praise. In a glowing profile of Wood published in January 1899, Roosevelt exclaimed: "All conditions were ripe for a period of utter anarchy, and under a weak, a foolish, or a violent man this anarchy would certainly have come. General Wood, by his energy, his firmness, his common sense, and his moderation, has succeeded in working as great an improvement as was possible in so short a time."[5] Roosevelt knew his subject well, having organized with him the First U.S. Volunteer Cavalry Regiment—popularly known as the Rough Riders—which had served with distinction in Cuba the previous spring. While Roosevelt returned to the United States to pursue his candidacy for governor, Wood chose to remain in Cuba to oversee affairs in Santiago and to address some of the problems that plagued the war-stricken nation.[6]

Roosevelt's public remarks reflected his sincere respect for Wood's achievements as a colonial administrator. Wielding absolute authority, he had implemented a sweeping program to care for the residents and the refugees who struggled in the aftermath of the war. His efforts at distributing meals, rebuilding the water supply, and sanitizing the city had helped to avert a major humanitarian crisis. In praising his friend, Roosevelt was also inserting himself into a larger political debate about America's Cuban policy. In particular, questions regarding the administration of the island's affairs and its current and future relationship with the United States were unresolved. Roosevelt's profile was intended to bolster Wood's position in the eyes of American

Leonard Wood
Zaida Ben-Yusuf
Platinum print, 1899
19.9 × 15.1 cm (7¹³⁄₁₆ × 5¹⁵⁄₁₆ in.)
Library of Congress, Washington, D.C.,
Prints & Photographs Division

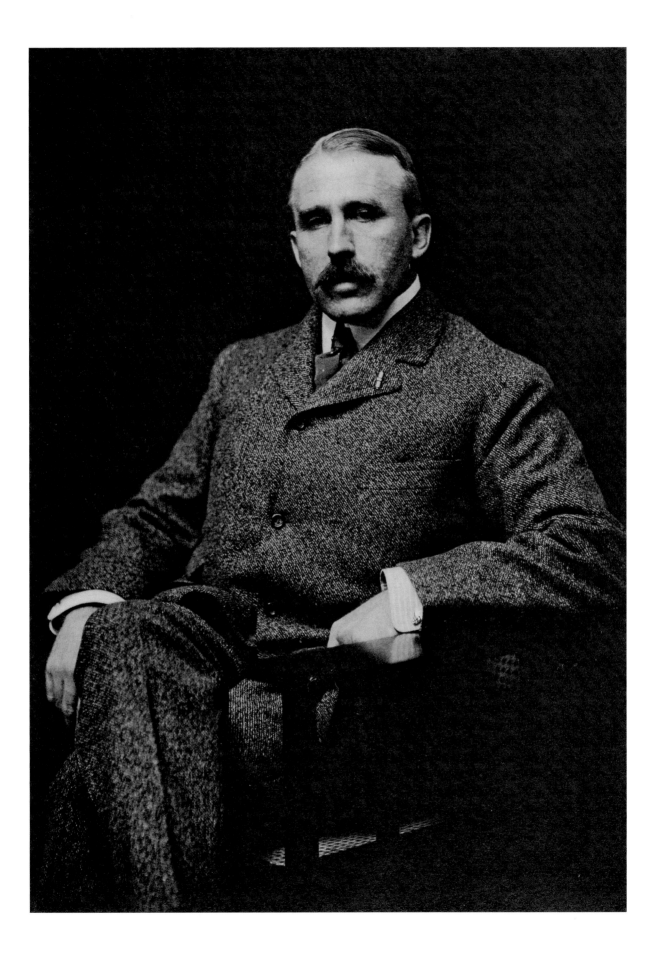

officials in Washington at a time when Wood was feuding over money and authority with John R. Brooke, the newly designated provisional governor of Cuba.

While Brooke was his superior in both military rank and political position, Wood continued throughout the next year to maintain that he, Wood, was the man most able to restore peace and stability to the nation. Such self-assertiveness had been a hallmark of Wood's character since his youth. It revealed itself in his impulsive decision in 1885 to leave a private medical practice in Boston to join the Army Medical Department as a contract surgeon and to become a part of the campaign in Arizona to track down a band of renegade Apaches under the leadership of Geronimo. His heroism in this effort led to his being awarded a Congressional Medal of Honor and a succession of increasingly prominent military positions. Wood's leadership of the Rough Riders and his success in Santiago convinced him and other noteworthy supporters—including President William McKinley, who had earlier enlisted Wood as his private physician—that he should take

Leonard Wood
Unidentified photographer
Albumen silver print, 1898
National Portrait Gallery,
Smithsonian Institution, Washington, D.C.

charge of affairs in Cuba. Although the military favored Brooke, the more senior officer, by the year's end officials handed over the reins of the provisional government to the newly promoted thirty-nine-year-old major general.

Ben-Yusuf's portrait of Wood was taken in her studio on December 16, 1899, only three days after the announcement of his new appointment. Wood was scheduled to sail for Cuba later that afternoon, but before doing so he sat for her. This session was in part orchestrated by editors at *McClure's Magazine*, who were preparing a lengthy profile of Wood for the February issue.[7] In this portrait, Wood wears a finely tailored wool suit, altogether appropriate for New York in December, though a marked departure from the lightweight khaki uniform that he sported throughout his four years of service in Cuba. He sits rather formally, with his legs crossed and his hands at his sides. Famous for his physical fitness and his embrace of the so-called "strenuous life" popularized by Roosevelt, Wood projects on this occasion a persona consistent with his new position of authority. Ben-Yusuf later recalled that he was a relatively quiet subject, though his "lionlike strength" was readily evident.[8]

While Wood ruled Cuba with an iron fist, effectively disenfranchising the vast majority of Cuban citizens, he initiated a number of vital projects, including the dredging of Havana harbor and a successful campaign to eradicate the deadly yellow-fever epidemic that annually ravaged the population. Many resented what they perceived to be a heavy-handed attempt to remake Cuban society, and some harbored the belief that Wood was laying the foundation for America's eventual annexation of the island nation. Yet, by the spring of 1902, he was able to return control of the government to a newly installed national assembly. Having presided over the adoption of a new

constitution and the peaceful handover of authority, Wood left Cuba a hero in the eyes of most Americans and Cubans.

Wood's success in Cuba propelled him to national prominence and led to new assignments and further promotions. In 1903, Roosevelt—now at home in the White House—asked his friend to take charge of affairs in the unsettled province of Moro in the Philippines, an opportunity that Wood accepted and that eventually led to his selection as the Army chief of staff. Wood was an ambitious and opinionated man who often shunned bureaucratic hierarchies in his efforts to effect what he regarded as constructive change. During the years after the Spanish–American War, he was one of the foremost proponents of a strong military and an increased American presence abroad. Many shared these views, and in 1920 Wood—ever eager to lead—became a candidate for the Republican presidential nomination. Although he lost to Warren Harding, he was offered and accepted the position of governor general of the Philippines, an office that he held until his death.

FHG

5 Theodore Roosevelt, "General Leonard Wood: A Model American Military Administrator," *Outlook*, Vol. 61, no. 1 (January 7, 1899): 22.

6 Wood's tenure in Cuba is recounted in several biographies, including Jack Lane, *Armed Progressive: General Leonard Wood* (San Rafael, Calif.: Presidio Press, 1978); and Jack McCallum, *Leonard Wood: Rough Rider, Surgeon, Architect of American Imperialism* (New York: New York University Press, 2006).

7 Ray Stannard Baker, "General Leonard Wood: A Character Sketch," *McClure's Magazine*, Vol. 14, no. 4 (February 1900): 368–79.

8 Ben-Yusuf, "Celebrities Under the Camera," 13.

10.

Jacob A. Riis

Journalist, photographer
Born Ribe, Denmark
May 3, 1849–May 26, 1914

In her *Saturday Evening Post* article "Celebrities Under the Camera," Ben-Yusuf related the following tale about the social reformer Jacob Riis, which she had heard shortly after his visit to her studio in the fall of 1899:

It seems that for months, even years, Mr. Riis had been trying to get a certain spot in the Mulberry Bend district turned into a park for the poor people of that vicinity, and when he finally succeeded in accomplishing this he was so pleased that the day it was opened he went in and just rolled on the grass with delight. Then, along came a policeman, who considered it his duty to hale Mr. Riis off to the station house, and the more he protested the worse it was. Strange to say, the policeman did not know him, but on the way they met some one who did, and the disorderly Mr. Riis was kindly allowed to go free.

Although Ben-Yusuf admitted that she could not "vouch for its accuracy," the story represented for her not only Riis's characteristic exuberance in addressing the plight of the urban poor, but also the often callous conduct of law-enforcement officials who patrolled New York's impoverished and overcrowded Lower East Side.[9]

Like many New Yorkers who came to know Riis through either his popular writings or his community-based activism, Ben-Yusuf was an admirer of his relentless efforts on behalf of the disenfranchised. When the opportunity presented itself, she seized the chance to photograph him. The resulting portrait suggests the ease that each felt in the other's company. Sitting sideways on a chair with his legs crossed and holding a magazine loosely in his hand, Riis projects the sense of warmth and compassion for which he was well known. Despite his seeming good humor, the fifty-year-old Riis was not comfortable at having his portrait made for publicity's sake. As he professed earlier that year in a letter to his friend Silas McBee, the editor of *The Churchman*, he thought

Jacob A. Riis
Zaida Ben-Yusuf
Halftone print published in
The Outlook, March 2, 1901
Print Collection, Miriam and Ira D. Wallach Division of Art, Prints, and Photographs, New York Public Library, Astor, Lenox, and Tilden Foundations

little of "this celebration business," whereby reformers upstaged the subjects whose lives they were working to better, and denied McBee's request to publish his photographic likeness.[10] Yet, while the exact circumstance of this portrait sitting is unclear, Riis did permit Ben-Yusuf to photograph him. He was pleased with her work and used this image as the frontispiece for his autobiography of 1901.

In this work—titled *The Making of an American*—Riis drew a lively portrait of his experience as an immigrant to the United States. Given the reform campaign to which he had dedicated more than twenty years, he hoped also to call attention through his example to the larger issues that immigrants and the poor faced. Indeed, Riis's arrival in the United States from his native Denmark in 1870 coincided with a period of explosive immigration. Especially in such urban centers as New York City, the population of which increased more than sixfold between the censuses of 1850 and 1900, the newly arrived often struggled to make ends meet. Riis experienced at first hand

many of the difficulties that were associated with immigration. Despite having trained as a carpenter in Copenhagen, he had trouble finding employment that would support him. Although he worked in a series of menial jobs, he was often hungry and homeless, and, on repeated occasions, fell into deep depression. These experiences during his first years in America shaped the rest of his career. Once established as a police reporter for the *New York Tribune*—and later the *Evening Sun*—Riis focused attention on the various problems that plagued the city's poor, many of whom were recent immigrants living in squalor on the Lower East Side. All aspects of their living and working conditions were subject to his probing pen, and before long city officials were forced to come out from behind their curtain of neglect to confront these growing problems.[11]

Riis's so-called "warfare against wretchedness" took a dramatic turn with his decision in 1888 to begin using photography to cast light on this previously invisible world. Although published at the time in poor halftone reproductions or as

Home of an Italian Ragpicker, Jersey Street
Jacob A. Riis
Gelatin silver print, 1888
(printed later)
Museum of the City of New York,
The Jacob A. Riis Collection

drawn woodcuts—forms that compromised the works' stark immediacy—such photographs as *Home of an Italian Ragpicker, Jersey Street* contributed greatly to his reform efforts. In his writings and lectures, Riis had always preferred colorful anecdotes rather than cold statistics or larger systematic interpretations. As a documentary form of expression, photography furthered his ability to personalize such issues as tenement overcrowding, sweatshop labor, and police corruption. The publication in 1890 of *How the Other Half Lives*—based in part on an earlier series of newspaper and magazine articles—transformed Riis into a national spokesman for the urban poor. The book's popularity also allowed him to give up his job as a police reporter in order to concentrate on writing books, delivering lectures, and assisting politicians and other officials who were in a position to effect substantive change.

One such figure was Theodore Roosevelt, who, as president of the New York City Police Board from 1895 and as New York governor from 1899, saw Riis as an ally in his campaign to clean up the corruption pervasive in state and local governments. Although Riis turned down Roosevelt's offer to become the Commissioner of Immigration, the two men collaborated on various initiatives, including the creation of new housing standards, new workplace rules, and a series of new public parks and playgrounds. Riis campaigned for Roosevelt—both when he was running for governor and later for president—and in 1903 wrote a glowing biography of his friend. In his autobiography, Riis said about their relationship: "I was his umpire with the tailors, with the drug clerks, in the enforcement of the Factory Law against sweaters, and I know that early and late he had no other thought than how best to serve the people who trusted him."[12] Roosevelt, in turn,

declared that Riis was "the most useful citizen in New York" and, on another occasion, "the ideal American."[13]

Ben-Yusuf's portrait of Riis coincides with the period in which the two men worked most energetically. Together with other activists, they succeeded in addressing some of modern New York's most pressing problems. This period marked a transition in Riis's life as well as in the future of urban reform. In the years after 1900, in part because of Roosevelt's accession to the presidency and in part because of his feeling that fellow "muck-rakers" had become too negative, Riis increasingly focused his efforts on the national stage. While his crusade against poverty continued, he was no longer making his regular walking tours around the city's most overcrowded neighborhoods. The movement for better housing, working conditions, and schools was becoming ever more professionalized in the new century, and Riis believed he had more to contribute by moving away from his grass-roots campaigns. In Riis, Ben-Yusuf encountered an important turn-of-the-century pioneer—one whose writing, lecturing, and photography brought to light and helped to improve the lives of New York's disenfranchised.

FHG

9 Ben-Yusuf, "Celebrities Under the Camera," 14.
10 Jacob Riis to Silas McBee, letter in the Silas McBee Papers, January 12, 1899, Southern Historical Collection, University of North Carolina Library, Chapel Hill.
11 Jacob Riis's life and photographic career have been the subject of several works, including, most importantly, James B. Lane, *Jacob A. Riis and the American City* (Port Washington, NY: Kennikat Press, 1974); and Alexander Alland, *Jacob A. Riis, Photographer and Citizen* (Millerton, NY: Aperture, 1974).
12 Jacob Riis, *The Making of an American* (New York: The Macmillan Company, 1901): 382.
13 See the following obituaries: "Riis Called by Death," *Washington Post* (May 27, 1914): 12; and "Jacob A. Riis, Reformer, Dead," *New York Times* (May 27, 1914): 11.

Lincoln Steffens

Journalist
Born San Francisco, California
April 6, 1866–August 9, 1936

"Do we Americans really want good government? Do we know it when we see it? Are we capable of that sustained good citizenship which alone can make democracy a success?"[14] By November 1903, on the eve of a pivotal mayoral election in New York City between the incumbent reformer Seth Low and Charles Murphy, the candidate who represented the historically corrupt Tammany Hall political machine, Lincoln Steffens had exposed enough abuse and graft in American politics to pose such provocative questions. Nothing less than the integrity of the democratic system and the future of New York were at stake in this election, argued Steffens in an extended exposé, "New York: Good Government in Danger," published in *McClure's Magazine*. As a journalist, Steffens measured success by the ability to search out the facts about society and to use them to bring about change for the common good. To Steffens and other "muck-rakers"—President Roosevelt's term for those writers dedicated to unmasking wrongdoing—the truth was at the bedrock of a properly functioning democracy. Regarded at his death as "one of the best reporters and one of the most relentless searchers after truth in his generation," Steffens pursued investigative journalism with unequaled purpose and dedication, and, in the process, became one of progressivism's champions at the dawn of the new century.[15]

Ben-Yusuf photographed Steffens only a short time before the publication of his essay on New York politics. Her portrait reveals his characteristic intensity and alertness, while suggesting a sense of his quiet elegance. Having spent three years in Germany undertaking postgraduate study, he cultivated the persona of an intellectual and an artist. Ben-Yusuf's image hints at elements of this public face. As Steffens and *McClure's*, the magazine for which he wrote, sought to build a national

Lincoln Steffens
Zaida Ben-Yusuf
Halftone print published in
The Bookman, November 1903
Firestone Library, Princeton University,
New Jersey

profile, this portrait was probably created to help publicize his recent series of attention-grabbing essays on corruption in various American cities—published as a collection in March 1904 under the title *The Shame of the Cities*.[16] These essays revealed what many had long suspected regarding the workings of city governments: namely, that "the professional politician is but a tool in the hands of and a feeble imitator of the man of business."[17] The writings of Steffens and other "muck-rakers"—in particular, Ida Tarbell and Ray Stannard Baker—in *McClure's* struck a chord with readers and helped to bring such concerns as the power of concentrated wealth and the rising tide of misgovernment into the mainstream of American politics. Inspired in part by the findings of these journalists, Roosevelt initiated his so-called Square Deal—a campaign of "trust-busting" and government reform that sought to reverse decades of bad government.

The Shame of the Cities not only represented a decisive moment in political thought; it also marked an important transition in Steffens's own

career. Since 1892, he had worked at a succession of jobs as a reporter and then an editor at three different New York newspapers. These experiences exposed him to the manner in which New York's city government operated, and resulted in several high-profile stories, including a series of reports on police corruption that led to the defeat of Tammany's candidate in the 1894 mayoral election and the naming of Theodore Roosevelt as New York's new police commissioner. Steffens and his mentor Jacob Riis built a close working relationship with Roosevelt, undertaking investigations of such matters as the plight of immigrants and the "system" that kept dishonest politicians in power. About Steffens, Roosevelt exclaimed in 1895, "He is a personal friend of mine, and he has seen all of our work at close quarters. . . . He and Mr. Jacob Riis have been the two members of the Press who have most intimately seen all that went on here in the Police Department."[18]

Yet, while during the 1890s Steffens had attained a level of success in the world of New

Sweatshop of Mr. Goldstein, 30 Suffolk Street, New York
Lewis Hine
Gelatin silver print, 1908
Library of Congress, Washington, D.C., Prints & Photographs Division

York journalism, he yearned to write for a larger audience and perhaps to write a novel. When novel-writing proved more difficult than he imagined, he accepted Samuel McClure's invitation to become the managing editor of his monthly magazine, a position he assumed in September 1901—the same month as McKinley's assassination and Roosevelt's accession to the White House. In this new position, Steffens soon came to understand that "a man can not be a successful editor who sits forever in his office."[19] Encouraged by McClure to get out from behind his desk, he undertook a series of trips to investigate the state of local governments in big cities across the nation. It was these eye-opening reports—first in St. Louis and later in half a dozen other cities—that catapulted him into the national spotlight and lifted the cause of progressive reform into the larger political debate. As Jacob Riis explained at the time, "Mr. Steffens turned on the lime-light and showed crime which hides in dark places."[20]

By exposing "corruption from corruptionists, [and] bribery from those who bribed and were bribed,"[21] Steffens pioneered the scientific study of governments and inspired like-minded reformers—including the writer Upton Sinclair and the photographer Lewis Hine—to look behind other façades in American life. His "muck-raking" continued at a frenetic pace through the first decade of the new century and resulted at times in substantive changes both nationally and locally. Yet, following his wife's untimely death in 1911 and his increasing frustration with the pace of reform, Steffens decided to redirect his energies. He traveled widely during this later period, with a special interest in observing revolutionary change in such foreign nations as Mexico and Russia. In writing about these events, he believed that there were important lessons for America, though

ultimately most were either uninterested or regarded his reports as anti-American. For his last decade, he retired to Carmel, California, to write his autobiography. Throughout his life, Steffens saw writing as a powerful tool for bringing forward the type of information that would lead to a more vibrant and democratic society. As he later exclaimed, "mankind is well meaning, and what the world needs is not so much more goodness as more intelligence."[22]

FHG

14 Lincoln Steffens, "New York: Good Government in Danger," *McClure's Magazine*, Vol. 22, no. 1 (November 1903): 85.

15 "Lincoln Steffens, Author, Dies at 70," *New York Times* (August 10, 1936): 19. About Steffens, see Lincoln Steffens, *The Autobiography of Lincoln Steffens* (New York: Harcourt, Brace and Company, 1931); and Justin Kaplan, *Lincoln Steffens: A Biography* (New York: Simon and Schuster, 1974).

16 Ben-Yusuf's portrait of Steffens was published on at least two occasions during this period. In both instances, it accompanied a profile of the journalist. See "An Exposer of Municipal Corruption," *The Bookman*, Vol. 18, no. 3 (November 1903): 247–51; and "The Exposer of Graft," *Booklover's Magazine*, Vol. 2, no. 6 (December 1903): 700–702.

17 Alfred Hodder, "Nine Books of the Day," *The Bookman*, Vol. 19, no. 3 (May 1904): 302.

18 Theodore Roosevelt to Horace E. Scudder, August 6, 1895, letter in Lincoln Steffens Papers, Columbia University Libraries. Steffens wrote newspaper and magazine profiles of Roosevelt both before and after his rise to the presidency. Their relationship was more complicated, though, than some have characterized. They did enjoy a friendship for a period and were often political allies. Yet, while Steffens admired Roosevelt's personal qualities and his concern for substantive reform in the arenas of business and government, he was also disappointed at times by Roosevelt's tendency to compromise and his inability to think broadly and critically about the existing order. For his part, Roosevelt grew tired of the stridency of Steffens and other "muck-rakers," and later distanced himself from their politics.

19 "An Exposer of Municipal Corruption," 251.

20 *Ibid.*, 250.

21 *Ibid.*, 251.

22 "Lincoln Steffens, Author, Dies at 70," 19.

12.

George Horace Lorimer

Publisher
Born Louisville, Kentucky
October 6, 1867–October 22, 1937

For thirty-eight years the editor George Lorimer
published the *Saturday Evening Post*, a weekly that
entertained, informed, and inspired readers in
numbers significantly greater than those achieved
by any previous magazine in America. Before the
popularization of radio, film, and television, weekly
periodicals with national circulations served as the
primary vehicle of mass culture in America. Few
grew to be as successful and influential as the *Post*.
A fervent supporter of Theodore Roosevelt's
progressive Republicanism, Lorimer built a
magazine that proclaimed itself as representative
of the nation's ideals. Under his leadership, the *Post*
did not simply reflect the attitudes of its time;
instead, it hoped to shape the beliefs of its readers.
Lorimer's target audience was broadly defined as
the American businessman, and through both
fiction and non-fiction he sought to instruct
readers in the importance of such values as hard
work, selflessness, and frugality. The magazine's
extraordinary popularity suggests how compelling
his vision of America was.[23]

Ben-Yusuf's portrait of Lorimer was created
during the first years of his involvement with
the *Post* and its Philadelphia parent, the Curtis
Company. Here in his mid-thirties, Lorimer
presents himself as the epitome of the audience he
hopes to reach. Rather than assuming the air of
an effete intellectual, he strikes an egalitarian and
businesslike pose. This image was altogether fitting,
given both his notion of the *Post* and his personal
background. Unlike most literary editors at this
time, Lorimer had dropped out of college after
only a year of study to take a job with the Chicago
meat-packer Philip D. Armour. As a writer for
The Critic remarked in a profile of Lorimer in 1903,
"the pork-packing business, however, did not
appeal to the aesthetic side of his nature, and he
threw down an unusually well-paid position to get

George Horace Lorimer
Zaida Ben-Yusuf
Halftone print published in
The Critic, June 1903
Morris Library, University of Delaware,
Newark

into journalism, without any definite prospects before him."[24] After less than two years working as a reporter in Boston, he landed in 1898 at the *Post*, a magazine that the publisher Cyrus Curtis had recently purchased for a mere $1000. With less than 2000 subscribers, the *Post*'s only marketable asset was its tenuous connection to Benjamin Franklin, whose long-defunct *Pennsylvania Gazette* had been produced in the same printing shop as the *Post* had once been.

Within a year of arriving at the *Post*, Lorimer was promoted to editor, and the transformation of the weekly began in earnest. Understanding that Curtis's most significant publication at the time, the *Ladies' Home Journal*, was built around a clearly defined middle-class audience, Lorimer worked to

attract a male readership from a similar stratum of society. Articles that highlighted developments in the world of business and included lessons in how to succeed took center stage in Lorimer's *Post*. Likewise, he frequently ran stories about and by self-made men that might serve as inspiration for readers. The magazine's reinvention extended beyond content. In particular, the new editor—hoping to solicit material from established writers—worked to restructure the relationship between freelance authors and the *Post*. By making decisions on potential articles within three days of receipt and offering payment on acceptance, Lorimer created more appealing circumstances for would-be writers. In part because of such changes, he had great success in recruiting well-known

"A good many salesmen have an idea that buyers are only interested in funny stories."
Illustration in George Lorimer, *Letters from a Self-Made Merchant to His Son*, 1902
Library of Congress, Washington, D.C.

" *A good many salesmen have an idea that buyers are only interested in funny stories.*"

figures, including, importantly, Grover Cleveland, the first of seven presidents to contribute while Lorimer served as editor. During his early years at the *Post*, Lorimer also published the work of such younger talents as Frank Norris, Theodore Dreiser, and Stephen Crane.

Ben-Yusuf benefited too from Lorimer's interest in attracting noteworthy outside contributors. Having sold an article with accompanying pictures to Curtis's *Ladies' Home Journal* in 1898, she was one of the first people to begin regularly supplying the *Post* with photographs. The magazine initially did not publish photographs or illustrations, and Lorimer's commitment to doing so represented an important turn in its reconfiguration. While Ben-Yusuf contributed photographs to more than two dozen different newspapers and magazines during her career, her work for the *Post* was her most sustained collaboration and included articles together with commissioned photographic assignments. In addition to connecting her with Grover Cleveland, it was Lorimer who published her four-part essay "Japan Through My Camera," and who commissioned her six-part survey, "Advanced Photography for Amateurs."

Ben-Yusuf's portrait was not simply a photograph of a colleague, but was probably created to publicize *Letters from a Self-Made Merchant to His Son*, published in the fall of 1902. During the previous year Lorimer had begun writing and publishing in the *Post* fictitious letters purportedly from John "Old Gorgon" Graham, a loving, yet gruff meat-packer in Chicago, to his son Pierrepont, an unfocused undergraduate at Harvard University. The humorous letters offered real-world advice to Pierrepont, facetiously known as "Piggy" to fellow students. So popular was the series that Lorimer packaged the twenty letters together and published them as a single volume. A sequel was produced two years later. In *Letters*, Lorimer tried to impart the virtues of hard work and common sense, and railed against anything that reeked of elitism. Through easy-to-digest anecdotes and bromides, he reframed age-old principles for a modern readership. The result was predictably positive. "There is always need of iteration of these plain, hard facts for the benefit of the rising generation," proclaimed a *Wall Street Journal* reviewer, who added that "the book can be unqualifiedly recommended as likely to do good for young men just facing a business career, especially if they are lacking in ambition or self-reliance."[25]

Letters was representative of the down-to-earth philosophy that Lorimer introduced into the pages of the *Post*. Like the book, the *Saturday Evening Post* rapidly became one of the bestsellers of the new century. By appealing to readers' desire for practical advice and by couching that wisdom in a quintessentially American package, the magazine's circulation by 1908 reached the unprecedented one million mark; by the late 1920s, more than three million people bought the *Post* each week. As a writer for *The Critic* put it in 1903, summing up Lorimer's work-in-progress, "he has given his paper a unique position. It is American to the backbone,—not the rampant, spread-eagle American; it is a solid, sensible American spirit that pervades its pages."[26]

FHG

23 The best work on George Lorimer is found in two biographies: John Tebbel, *George Horace Lorimer and the "Saturday Evening Post"* (Garden City, NJ: Doubleday, 1948); and Jan Cohn, *Creating America: George Horace Lorimer and the "Saturday Evening Post"* (Pittsburgh: University of Pittsburgh Press, 1989).
24 "The Lounger," *The Critic*, Vol. 42, no. 6 (June 1903): 489.
25 "New Publications," *Wall Street Journal* (December 22, 1902): 8.
26 "The Lounger": 490.

13.

Cleveland Moffett

Journalist, novelist
Born Boonville, New York
April 27, 1863–October 14, 1926

At the turn of the century, journalism was
changing rapidly as a result of increased newspaper
and magazine circulation and the introduction of
professional news photography. Also contributing
to the field's transformation was the popularization
of the celebrity journalist, an individual who did
more than simply report the news, instead often
becoming involved in the events of the day. These
figures offered up opinionated commentary about
topical issues and in the process became identified
with the subjects they wrote about. Although not
the first, Cleveland Moffett became one of the
leading representatives of this new school of
journalists. Initially associated with the *New York
Herald* and then the *New York Recorder*, Moffett was
successful enough to sever his association with a
single newspaper by the mid-1890s in order to
write independently. Over the next two decades
he became a frequent contributor to more than a
dozen different magazines, reporting principally on
new advances from the world of science, industry,
and technology. While he also wrote fiction, plays,
and accounts of his travels, he was most highly
regarded as a journalist chronicling the scientific
and material progress of the age.

No journalist was as effective as Moffett at
introducing to the wider public the extraordinary
developments pioneered during this period. In
writing about such topics as the gramophone,
Guglielmo Marconi's wireless telegraph, and
Arthur Wright's experiments with the X-ray,
Moffett presented American readers with the
first popular accounts of these breakthrough
technologies. Invariably his reports celebrated such
inventions as evidence of civilization's progress, and
lionized the figures responsible for realizing them.
In his essay "The Edge of the Future," published
in *McClure's Magazine* in 1896—the year that Henry
Ford constructed his first automobile—Moffett

Cleveland Moffett
Zaida Ben-Yusuf
Platinum print, *c.* 1901
19.9 × 10.3 cm (7$\frac{13}{16}$ × 4$\frac{1}{16}$ in.)
Print Collection, Miriam and Ira D. Wallach
Division of Art, Prints, and Photographs,
New York Public Library, Astor, Lenox, and
Tilden Foundations

The Author After His First Dive
Unidentified photographer
Halftone print published
in Cleveland Moffett,
Careers of Danger and Daring, 1901
Library of Congress, Washington, D.C.

extolled the virtues of the "horseless carriage," explaining that "manufacturers all over the country are already making active arrangements ... with a view to being among the first to supply what is already a growing, and will soon be an enormous, demand." The age of the "motor vehicle has at last arrived," he exclaimed jubilantly.[27]

Ben-Yusuf's portrait presents Moffett as robust, self-confident, and thoroughly modern. Standing with his shoulders pulled back and with both hands in his trouser pockets, he looks toward Ben-Yusuf's camera with an expression of firm purpose. To Moffett, journalism was not a parlor literary activity. Instead, it required one to go out into the world. "The new notion is to get things at first hand, not second, from the men who do them," Moffett wrote about this new school.[28] Ben-Yusuf's portrait captures a man who showed up at the scene of the day's significant events and at times even participated in them.

Moffett admired the bravery displayed by certain types of workers as much as he did the ingenuity of the inventors and engineers whom he documented. In 1901, during the period when Ben-Yusuf created this portrait, he wrote a series of ten essays about men involved in industries that required feats of courage. Published individually and then together under the title *Careers of Danger and Daring,* these profiles demonstrated that "it is not alone on the battlefield that heroism is to be encountered," and celebrated those who "are constantly risking their lives for small wages in many of the every-day occupations which contribute to our modern well-being."[29] Moffett's subjects included such figures as a dynamite worker, a bridge-builder, a locomotive engineer, and a fireman. In his pursuit of these stories, he was not hesitant in demonstrating his own bravery. In researching a profile of divers who worked in New

York harbor to salvage sunken ships and their cargo, he took part in an effort to raise coal from a sunken barge. In addition to assisting the crew aboard the salvage vessel, he went so far as to don the cumbersome diving equipment, and to experience for himself the sensation of working twenty feet under water. The resulting story described this personal episode in detail and exhorted his readers to pay attention to the lives of such men: "Oh, bored folk, idle folk, go to the wreckers, say I, if you want a new sensation; watch the big pontoons put forth their strength, watch the divers, and (if you can) set the crew of the *Dunderberg* to telling stories."[30] The public flocked to these essays, prompting one reviewer to comment that Moffett "writes with a vigor and picturesqueness that holds one spellbound."[31]

Moffett moved with his family to Paris in 1907, yet he returned to New York and California often to pursue new projects. He continued to write on an eclectic range of subjects, from the importance of exercise and a good diet to the historic antagonism between labor and capital. He also worked with individuals in the burgeoning motion-picture industry, adapting his stories for the screen. With the outbreak of the Great War, he returned to New York for an extended period. During this time Moffett became one of the most outspoken advocates of American preparedness, even going so far as to draft an article that envisioned a coming German invasion of America. A fierce patriot, he was troubled by those who protested at America's entrance into the war, serving for a time on the Vigilantes Committee of the American Defense Society, a group organized to combat what some regarded as the seditious activities of anti-war demonstrators. In this campaign, Moffett used his status as a celebrated journalist to write to President Wilson, asking him to define treason. His letter—meant "to serve America and to further the great work of world regeneration toward which you are so ably and fearlessly leading us"[32]—and his subsequent arrest for harassing a "soap box" orator on a Broadway street corner only consolidated his reputation as a vigorous promoter of an America strong in foreign affairs and industrious in business.

In his politics and his beliefs about American society, Moffett was very much a staunch Roosevelt supporter. He and other journalists like him promoted the goals of Roosevelt's presidency not so much by writing generously about him, but rather by articulating further Roosevelt's vision of a modern and robust nation. In doing so, Moffett also contributed to the rise of a new, more vigorous press. Opinionated, and at times jingoistic, this school helped to shape many aspects of American life at the turn of the century.

FHG

27 Cleveland Moffett, "The Edge of the Future," *McClure's Magazine*, Vol. 7, no. 2 (July 1896): 153.

28 Cleveland Moffett, "Winning the Seven-Day Fight," *Century Magazine*, Vol. 61, no. 6 (April 1901): 23.

29 Cleveland Moffett, "Encountering Danger While Doing Their Duty," *Current Literature*, Vol. 32, no. 1 (January 1902): 22.

30 Cleveland Moffett, *Careers of Danger and Daring* (New York: The Century Co., 1901): 53.

31 "Miscellaneous," *The Critic*, Vol. 40, no. 3 (March 1902): 282.

32 Cleveland Moffett, quoted in "Asks the President to Define Treason," *New York Times* (August 17, 1917): 7.

14.

John Fox, Jr.

Author
Born Stony Point, Kentucky
December 16, 1862–July 8, 1919

Ben-Yusuf's portrait of John Fox, Jr. coincided
with the publication in 1903 of *The Little Shepherd
of Kingdom Come*, a novel the popularity of which
propelled Fox to the forefront of American
literary circles. Although Fox's fame is now largely
forgotten, this historical romance set in the
mountainous region of eastern Kentucky during
the Civil War was one of the first American novels
to sell a million copies, thereby rescuing the author
from debt and establishing him as the authority on
this region and its people. Fox had written about
the Southern mountaineer previously; this novel,
however, captured a national audience, in part
because of its sweet sentimentality, but also on
account of its expansive investigation of the Civil
War's impact on the inhabitants of this border
state. While the war itself had concluded nearly
forty years earlier, a younger generation of
writers—none of whom had witnessed it at first
hand—found here rich material for their prose.
Like Stephen Crane and Thomas Nelson Page, Fox
made a name for himself in this literary genre.

Ben-Yusuf's portrait pictures the author as a
cosmopolitan figure. Dressed in a dark suit and
seated casually on a chair, he appears comfortable
before the camera. Having graduated from Harvard
in 1883 and worked for a time as a journalist in
New York City, Fox was hardly an outsider in the
East. His success as a novelist, though, was directly
related to his upbringing in the world about which
he wrote. A native Kentuckian, Fox knew well
the often rough-and-tumble towns that dotted the
Cumberland Mountains, and understood the role
played by race and class—not to mention the
lingering memory of the Civil War—in the lives
of these communities. After a brief stint in New
York, he relocated in 1889 to Big Stone Gap in
western Virginia, where he became involved in a
real-estate business with two brothers. The land

John Fox, Jr.
Zaida Ben-Yusuf
Platinum print, 1902
17.8 × 11.1 cm (7 × 4⅜ in.)
Print Collection, Miriam and Ira D. Wallach
Division of Art, Prints, and Photographs,
New York Public Library, Astor, Lenox, and
Tilden Foundations

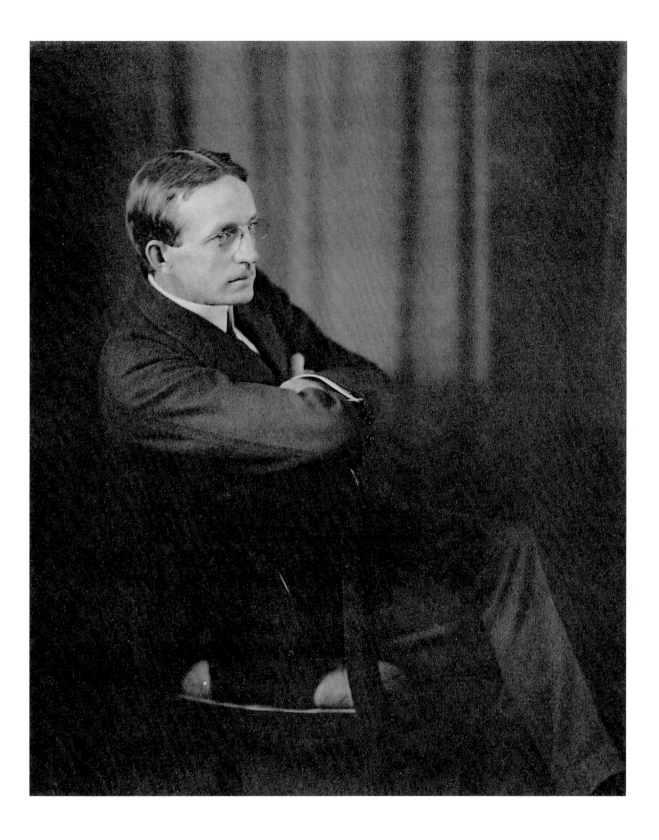

John Fox, Jr.
Edward Penfield
Print published on the cover of
Scribner's Magazine, January 1903
Art and Architecture Collection,
Miriam and Ira D. Wallach Division of Art,
Prints, and Photographs, New York Public
Library, Astor, Lenox, and Tilden
Foundations

around Big Stone Gap was reputed to have
abundant mineral deposits, and Fox joined many
who came looking to strike it rich. What he
discovered, though, was a town where violence and
alcoholism flourished. To assist the effort to bring
order to this community, he joined the Home
Guard, a local volunteer police force; however,
although he would make Big Stone
Gap his permanent residence, he and his family
lost large sums of money in the speculative real-
estate market.[33]

In the early 1890s, Fox began to pursue his
interest in fiction writing. Drawing upon his early
years in Kentucky and his time in Big Stone Gap,
he wrote stories that explored—often in regional
dialect—conflicts between those who were on the
inside and those from outside this region. Local
and family feuds were particularly noteworthy
material, as Fox later admitted in a *Scribner's*
article: "nowhere is the feud so common, so old,
so persistent, so deadly, as in the Kentucky
mountains."[34] An outgrowth of this new work was
his participation on the lyceum circuit. In addition
to reading his own fiction and the work of others,
he played the guitar and sang regionally inspired
songs. The lecture promoter James Burton Pond
managed his travels and helped to raise the young
writer's national profile. Pond was probably the
individual who brought Fox to Ben-Yusuf's
photography studio in the winter of 1902.

Fox attracted considerable attention on
the lyceum circuit, and his mountain fiction
increasingly garnered critical and popular praise.
One influential supporter was his fellow Harvard
graduate Theodore Roosevelt, who met and
befriended him in 1894. Fox admired Roosevelt
greatly, and during the Spanish–American War was
moved to join his voluntary cavalry regiment, the
Rough Riders. Although ill health prevented him

from fighting in the war, Fox did travel to Cuba and worked there as a correspondent for *Harper's Weekly*. His dispatches were highly supportive of the American cause and did much to enhance the heroic mystique surrounding the Rough Riders. Roosevelt was deeply appreciative, and when Fox developed typhoid fever while in Cuba, Roosevelt invited the writer to recuperate at his family home, Sagamore Hill. In later years, Roosevelt was host to Fox on repeated occasions at the White House.

Roosevelt's support was a great boon to Fox, yet it was the success of *The Little Shepherd of Kingdom Come* that transformed him from a regional writer into one of the nation's literary elite. Centered on the life of Chad Buford, a virtuous orphan who rises to respectability only to watch the family that has adopted him being torn apart by war, the novel highlights the many strains that affected Kentuckians during the Civil War. Like many American households, Fox's family was similarly divided by the war. His novel allowed the reader to reflect upon the difficulties experienced by many during this period. This type of historical fiction enjoyed wide popularity at the turn of the century, and Fox gained a reputation as more than simply a local colorist. As the reviewer for the *New York Times* wrote, "Mr. Fox treats of the civil war with the large comprehension more and more apparent in Southern writers, hence his book makes for that sectional harmony which only a complete understanding of each other's point of view can achieve."[35]

Ben-Yusuf's portrait served to mark the publication of this breakthrough novel. Often reproduced in literary journals of the day, the photograph served also as the basis of a print by Edward Penfield, the celebrated American illustrator and graphic designer. Artists often used photographs in this way, and Ben-Yusuf seemed happy to collaborate on repeated occasions. Penfield's print ran on the cover of *Scribner's* in January 1903 (opposite), to publicize the serialized version of *The Little Shepherd of Kingdom Come*. Fox had worked for several years on the novel and had high hopes for its success. The decision by *Scribner's* to publish it and to include Penfield's print alongside the first installment must certainly have pleased the forty-year-old author. Although scarcely remembered today, the novel marked a turning point in his professional career and played a significant role in attracting a new generation of writers and artists to the subject of the South.

FHG

33 For a fuller account of Fox's life and literary career, see Warren Titus, *John Fox, Jr.* (New York: Twayne Publishers, 1971).

34 "Kentucky, the Home of the Feud," *New York Times* (June 2, 1901): 23.

35 "Mr. Fox's Excellent Novel," *New York Times* (September 19, 1903): 13.

15.

Ernest Thompson Seton

Naturalist, author, artist
Born South Shields, England
August 14, 1860–October 23, 1946

In an era of rapid industrialization and urbanization, when the number of residents in American cities came to surpass the number living in the country, the natural environment and man's relationship to it received much attention in popular and scientific circles. A leading voice in shaping perceptions about nature-related issues was the British-born naturalist Ernest Thompson Seton. As a writer of more than forty books, a prolific illustrator and artist, and a popular lecturer, Seton contributed in significant ways to the public's understanding of and respect for the natural world. He was especially known for his study and portrayal of wildlife and for his embrace of Native American traditions. Living in New York at the turn of the century, Seton became a strong advocate of Roosevelt's belief in the "strenuous life" as an antidote to the ills of civilization. These different interests led him in 1902 to establish the Woodcraft Indians—a popular youth program that incorporated elements drawn from Native American culture—and to play a leading role in the founding of the Boy Scouts of America eight years later.[36]

Ben-Yusuf's portrait of Seton was created in 1899, at a time when he was first gaining an international reputation. The previous year he had published *Wild Animals I Have Known*, a bestselling collection of animal stories accompanied by his own illustrations. In this volume he gave names to his wildlife subjects and crafted dramatic narratives in which they served as the principal characters. Despite the obvious anthropomorphism, Seton asserted that he drew widely from his own studies as a field researcher in Canada and the United States. He had in fact extensive experience in this realm, having served as a government-appointed naturalist in the province of Manitoba and as a contributing member of the prestigious American

Ernest Thompson Seton
Zaida Ben-Yusuf
Platinum print, 1899
20 × 9.2 cm (7⅞ × 3⅝ in.)
Print Collection, Miriam and Ira D. Wallach Division of Art, Prints, and Photographs, New York Public Library, Astor, Lenox, and Tilden Foundations

Ernest Thompson Seton
Zaida Ben-Yusuf
Halftone print published on the cover
of the *Home Journal,* May 1900
Library of Congress, Washington, D.C.

Ornithologists' Union. He had also lived in New Mexico, where he first became interested in the wolf, an animal that he portrayed often in his writing and art. For the most part, young and old alike enjoyed these and other tales published by Seton during this period. As one reviewer wrote in 1900, "These chapters come the nearest to animal autobiographies of anything that has been written or is likely to be written, until the dumb creatures themselves learn the art of self-expression."[37]

Yet there were those among the scientific community—beginning with the well-known conservationist William Burroughs—who found Seton's animal stories problematic. As Burroughs wrote in the *Atlantic Monthly* in 1903, the "line between fact and fiction is repeatedly crossed … and a deliberate attempt is made to induce the reader to cross too. . . . Seton says in capital letters that his stories are true and it is this emphatic assertion that makes the judicious grieve."[38] Seton's eccentric and egotistical personality contributed to this and other disagreements that arose during his career as a naturalist. The two men ultimately reconciled their differences—and Seton was later awarded the Burroughs Prize for his epic four-volume study *Lives of Game Animals*—but not before the issue of "nature fakers" became a public controversy.[39]

Seton's popularity as a writer and an artist during this period led to invitations to present public lectures, a forum in which he excelled. Illustrated with lantern slides, these lectures combined natural science, dramatic storytelling, and calls to protect wildlife and the environment. Although they began as single events, the response to them prompted more ambitious speaking tours. James Burton Pond, the lecture manager who orchestrated many of Seton's speaking engagements, was ecstatic about his success,

exclaiming in 1901 that "at the present time there are more engagements booked for him at high prices than for any other platform attraction in the country."[40] By the decade's end, Seton was earning up to $12,000 annually for this work.

Seton most probably visited Ben-Yusuf's studio to satisfy the demand by magazines for his portrait. As with other subjects, Ben-Yusuf created several images, yet she and Seton liked best the one in which he has a drawing board before him. She recalled the occasion later: "Evidently he could not resist the paper and pencil. I left him for a few minutes while I went to attend to my plate holders, and when I returned he had drawn a most amusing sketch of a nice comfortable pig, with its head on one side, and just that suggestion of humanity about it that it takes Mr. Thompson [Seton] to give. Of course I kept it."[41] Their mutual regard for this portrait suggests something about both subject and photographer. Being pictured as though he has just turned his attention away from his art is consistent with Seton's desire to be understood as one who was immersed in his studies. He is no armchair naturalist in this portrait, but rather one committed to his work. Such an unorthodox pose also reflects Ben-Yusuf's recurring inclination to experiment with the composition and format of her portraits.

Like others of the burgeoning conservation movement, including Roosevelt, Seton saw nature as an essentially positive element that deserved protection. In his books, art, and public lectures, he conveyed the wonder and beauty of the natural environment to audiences who increasingly lived apart from wilderness. It was in nature, he believed, that civilization was reborn.

FHG

36 Although born Ernest Evan Thompson, he legally adopted the surname Seton in 1901. Reports at the time suggested that the name Thompson "grates on his nerves," though it is more likely that he wished to recall his supposed aristocratic Scottish heritage by using "Seton." "A Line-O'-Type of Two," *Chicago Daily Tribune* (October 31, 1901): 12. For an extensive study of his life and naturalist career, see John Henry Wadland, *Ernest Thompson Seton: Man in Nature and the Progressive Era, 1880–1915* (New York: Arno Press, 1978).

37 John Wright Buckham, "The Modern School of Nature Interpretation," *Book Buyer*, Vol. 20, no. 2 (March 1900): 111.

38 William Burroughs, "Real and Sham Natural History," *Atlantic Monthly*, Vol. 91, no. 545 (March 1903): 299.

39 For more about this controversy, see Ralph Lutts, *The Nature Fakers: Wildlife, Science and Sentiment* (New York: Fulcrum, 1990).

40 James Burton Pond, *Eccentricities of Genius* (New York: G.W. Dillingham, 1901): 516.

41 Ben-Yusuf, "Celebrities Under the Camera," 14.

The
Old Guard

Despite its importance as a place of change and innovation, turn-of-the-century New York was also a city where tradition cast a long shadow. In the fields of art and literature especially, New York boasted age-old institutions that dominated the cultural landscape, including, for example, the National Academy of Design and the publishing house of Harper & Brothers. Although often supportive of the work of a new generation, many leading figures were committed first and foremost to excellence in an established mode of expression. Some in this "Old Guard"—uncomfortable about the implications of the rise of modernism—saw it as their responsibility to uphold time-honored conventions and to guard against what they perceived as declining standards. Each of the individuals represented in this section was born before the Civil War and took center stage in the extraordinary changes that reshaped New York and the larger nation during the last three decades of the nineteenth century. Yet, by the century's end, they were also the group against which many of a new generation rebelled. While they continued to be regarded as key figures in the public's eye—and their portraits continued to be in demand—these writers and artists represented a cultural tradition that was gradually losing ground to those who embraced a new, modernist aesthetic. Much younger than any of these men, Ben-Yusuf was nonetheless successful in creating contemporary portraits that revealed their distinct character.

16.

William Dean Howells

Author
Born Martin's Ferry, Ohio
March 1, 1837–May 11, 1920

William Dean Howells visited Ben-Yusuf's studio in the fall of 1899, just weeks before embarking on a lengthy North American lecture tour. He explained his motivations for the tour in a letter to Samuel Clemens, better known as Mark Twain: "Naturally, I don't want to pull up at 62 and start out on a scamper to Winnipeg and back; but it will be a relief from writing, and I must boil the pot somehow." Six months later, he would lament to his friend that it was "worse, far worse, than you ever said in your least credible moments The worst of it was that I was meeting nice, kind, intelligent people all the time, whom I liked and respected, and who wished to be good to me; but it was killing me, and I was a wretched ghost before them. For a whole month, I had not one night's natural sleep."[1] Despite his agony, Howells's lectures on "Novel-Writing and Novel-Reading" were a triumph with both critics and audiences and another professional coup for one of American literature's most celebrated writers.[2]

It must have been a gratifying success for a man with such uncertain beginnings. The son of an abolitionist newspaper editor from Ohio, Howells learned to read by setting type for his father's paper. He became familiar with politics by reading his father's anti-slavery diatribes, editorials so hard-hitting that the family was once forced to relocate to a new community. These experiences in small-town journalism would shape his writing life.

An enormously prolific author from the beginning, Howells was twenty-three when, in 1860, he wrote Abraham Lincoln's campaign biography. A year later, he was rewarded by being appointed consul to Venice, a post that kept him out of the war, while providing him with the settings and characters for many of his books. Upon his return to the States, he was recruited by James Fields to serve as the assistant editor of the *Atlantic Monthly*,

William Dean Howells
Zaida Ben-Yusuf
Platinum print, 1899
21.3 × 16.3 cm (8⅜ × 6⁷⁄₁₆ in.)
National Portrait Gallery,
Smithsonian Institution, Washington, D.C.

where he first encountered and later became close friends with Henry James and Samuel Clemens. Howells shared with these authors a fascination with the American character; he doted on mavericks, seeing them as validations of democracy, and detested what he saw as overly conventional, Europeanized Americans. Not surprisingly, his novels often confronted the forthright and naïve with the sophisticated and corrupt. In *The Rise of Silas Lapham* (1885), for example, he depicts an honest farmer turned paint manufacturer who chooses to return to the farm rather than adopt shady practices.

The lone campaigner for the good cause was a recurrent theme in Howells's life and writings. A noteworthy example of his commitment to social justice occurred in 1886, when authorities in Chicago arrested eight anarchists for inciting bombers in the Haymarket riots and—despite little evidence—sentenced seven of them to death.

Howells protested in both editorials and in letters to the governor of Illinois, a stand that was castigated by the press and the public, many of whom celebrated the eventual hangings as a blow to Howells's reputation.

If Howells saw it as such, it did not slow him down. He was an early advocate for women's suffrage, arguing that "there is altogether too much talk about the inborn differences of men and women. . . . The differences are chiefly owing to habit and environment, I think."[3] Howells would have been sympathetic to Ben-Yusuf's efforts to establish an independent career. His novel *The Coast of Bohemia* (1893) centers on the struggles of Cornelia Saunders, a young female artist who travels to New York to study at "the Synthesis of Art Studies," a thinly disguised Art Students League. Before she leaves Ohio, she is warned, "It's a hard road for a man, and it's doubly hard for a woman. It means work that breaks the back and

William Dean Howells
Zaida Ben-Yusuf
Platinum print, 1899
Library of Congress, Washington, D.C.,
Prints & Photographs Division

wrings the brain. It means for a woman, tears and hysterics, and nervous prostration, and insanity—some of them go wild over it. . . . For men the profession is hazardous, arduous; for women it's a slow anguish of endeavor and disappointment."[4]

Ben-Yusuf created at least two portraits of Howells at this sitting. In the first, he sits in a cane chair before the photographer's familiar paisley backdrop. He holds a journal before him—possibly one of the *Harper's* publications—and appears to be reading intently. Of it, Ben-Yusuf wrote that "Mr. Howells . . . is much more slender than his portraits would lead one to suppose; when I first saw him I made up my mind that I would try to make his new one different in this regard; but I found that, after, like the picture Mr. Howells has used for so many years, I had to allow mine also to give the same impression."[5]

Howells seems so natural, so absorbed in reading, that it is tempting to assume that Ben-Yusuf allowed her subject to pose himself. In the first portrait, he almost hunches over his pages. In the other, he squints at the work, his right elbow thrown over the back of the chair. Howells's stocky frame, white walrus mustache, and pince-nez are not heroic, but his substantial presence, reinforced by his complete absorption, seems to attest to his significance. As the photographs were intended to publicize his speaking tour, they convey a clear message: this is a man who knows reading and writing.

Unlike many who comprised the New York literary world at the turn of the century, Howells has not been lost in obscurity, yet the scope of his influence is still little understood. In addition to writing over seventy books and supporting numerous political and social causes—including the founding of the National Association for the Advancement of Colored People in 1909—Howells

was a leading champion of literary realism. As he explained in a profile by Stephen Crane, whereas for some writers "life began when the hero saw a certain girl, and it ended abruptly when he married her," Howells wished "to see the novelists treating some of the other important things of life—the relation of mother and son, of husband and wife, in fact all those things that we live in continually."[6] Howells not only developed the precepts of literary realism, but he also fostered it among such younger writers as Crane, Frank Norris, and Harold Frederic. Although succeeding generations of writers have disparaged his clout, his contemporaries declared him a literary giant. In 1899, in a poll to select the ten best living writers for an American Academy, Howells ranked first. His friend Samuel Clemens finished second.

EOW

1 William Dean Howells, quoted in Henry Nash Smith and William M. Gibson, eds., *Mark Twain–Howells Letters: The Correspondence of Samuel L. Clemens and William D. Howells, 1872–1910* (Cambridge, Mass.: The Belknap Press, 1960): 700, 712.

2 Biographies about William Dean Howells include Susan Goodman and Carl Dawson, *William Dean Howells: A Writer's Life* (Berkeley: University of California Press, 2005); Kenneth S. Lynn, *William Dean Howells: An American Life* (New York: Harcourt, Brace, Jovanovich, 1971); and Edward Wagenknecht, *William Dean Howells: The Friendly Eye* (New York: Oxford University Press, 1969).

3 "Politics, But a Good Thing," *New York Times* (October 13, 1894): 9.

4 William Dean Howells, *The Coast of Bohemia* (New York: Harper & Brothers, 1893): 17–18.

5 Zaida Ben-Yusuf, "Celebrities Under the Camera," *Saturday Evening Post*, Vol. 173, no. 48 (June 1, 1901): 13.

6 Stephen Crane, "Fears Realists Must Wait: An Interesting Talk With William Dean Howells," *New York Times* (October 28, 1894): 20.

17.

Thomas Nast

Political cartoonist
Born Landau, Bavaria
September 30, 1840–December 7, 1902

Thomas Nast's cartoons shaped American politics from the Civil War to the century's end, arguably to a degree unmatched by any single artist or writer of this period. Described at his death as the "Father of American Caricature" by *Harper's Weekly*—the journal to which he contributed for more than forty years—Nast was relentless in satirizing those whom he perceived as threatening the nation and its core principles.[7] He became famous for exposing glaring examples of incompetence, corruption, greed, and bigotry in American society. While his drawings addressed many topics, he is best remembered for redirecting American thought regarding the major issues of the day. In particular, Nast's cartoons influenced perceptions of the Civil War and Reconstruction, helped to bring down the notoriously abusive Tweed Ring in New York City, and colored every presidential contest from Abraham Lincoln's re-election in 1864 to Grover Cleveland's triumph in 1884.[8]

Nast was not the first artist to draw political cartoons in America, yet he came to be regarded as the progenitor of this tradition, in part because of the timing of his emergence. Coming of age at the dawn of the illustrated press, Nast was among the first generation of graphic artists to supply drawings to large-circulation periodicals that reached a national market. Whereas the work of earlier caricaturists circulated in limited quantities, his cartoons in *Harper's Weekly* were seen by a readership that numbered no fewer than 100,000 and at times more than double that.[9] Nast's reimagining of what an editorial cartoon could be was also influential. His decision to favor imagery over dialogue—in a break with tradition—appealed to a wide audience, as did the memorable symbols he devised to represent specific people or groups, including the donkey for the Democratic party, the elephant for the Republican

Thomas Nast
Zaida Ben-Yusuf
Halftone print published in
The Critic, July 1902
Morris Library, University of Delaware, Newark

party, and the tiger for William "Boss" Tweed and his Tammany Hall political machine. While political cartoons were his chief passion, he also gained widespread acclaim for popularizing other important characters in American life, most notably Santa Claus, who first appeared in 1862 wearing a pro-Union stars-and-stripes costume.

From the start of his career, Nast created work that made its impact felt. Only eighteen when he began contributing to *Harper's Weekly*, he helped to transform that young New York-based journal into a powerful national voice. His Civil War images— drawings that explored the lives of common soldiers and dealt with the larger issues of the war—first brought him to national attention. Described later as "military assaults" by his lecture manager, James Burton Pond, these drawings

"stirred the patriotic blood in the North, and sent battalions of youth to rally round the flag."[10] Lincoln praised Nast for inspiring readers to support the war effort, and Ulysses S. Grant declared that "he did as much as any man to preserve the Union and bring the war to an end."[11] Although peace between the North and the South was declared in 1865, Nast remained focused on the often disappointing turn of events associated with Reconstruction, ridiculing Andrew Johnson for his failure in both leadership and ethics.

Nast's reputation as a champion of fairness and democracy was secured with his protracted campaign against the corrupt activities of the New York political boss William Tweed and his Tammany Hall cronies. As the local Democratic leader, "Boss" Tweed controlled the nomination

THE TAMMANY TIGER LOOSE.—" What are you going to do about it?"

The Tammany Tiger Loose
Thomas Nast
Wood engraving, 1871
National Portrait Gallery, Smithsonian Institution, Washington, D.C.

process for those who sought elected office, and used his authority to hand-pick candidates who would support his machine. In addition to controlling the city government, he grew rich from kickbacks and bribes. Beginning in 1869, Nast began his assault, portraying the politician as a ruthless tiger destroying the virtuous republic. Tweed responded by intimidating Nast's publisher and eventually by trying to bribe Nast himself, yet the young artist would not back down. "Can't you stop his pictures," said Tweed to an associate at the time. "I don't care what they write about me, but those terrible pictures hurt."[12] Ultimately, such cartoons as "The Tammany Tiger Loose—'What are you going to do about it?'" (opposite) exposed Tweed for the abusive official that he was. Published on the eve of a city election in the fall of 1871, this drawing and others that preceded it contributed to the Tweed Ring's defeat.

Yet, well regarded and influential though Nast became, his popularity did not shield him from professional and financial difficulties at the end of his life. Ben-Yusuf's portrait shows him during this period. Taken to publicize a forthcoming biography of him by Albert Bigelow Paine, this photograph reveals how he had grayed over time. Nast's problems stemmed from bad investments and the decision to sever his long-standing relationship with *Harper's Weekly* in 1886. Although he continued to contribute drawings to other periodicals and at one time tried to establish his own weekly, his creative energy flagged noticeably. While his reputation—especially among a new generation of progressive reformers—remained high, he was having trouble making ends meet. So severe was his situation at the beginning of the new century that old friends who now occupied posts in the Roosevelt administration helped to secure a diplomatic appointment for him. In the spring of 1902—shortly before this photograph was probably taken—Nast was named U.S. consul-general at Guayaquil, Ecuador, a posting that he had not requested, but one that he felt compelled to accept. Leaving New York in July, he would never return, succumbing to yellow fever before the year's end.

By 1902, Nast was far removed from his glory days when as a young artist in his twenties he had created work that shaped the national discourse. Although he failed to regain that significance during the last decade of his life, many continued to revere what he had earlier achieved. Roosevelt was among those who celebrated his legacy. He wrote to the famous caricaturist, acknowledging that "I learned my politics from your cartoons." He went on to add that "I have always felt that in the fight for civic honesty you played as great a part as any soldier could possibly play in the fight for the Union."[13] Strong in his convictions and dedicated to revealing the truth, Nast played an important role in laying the foundation for the rise of Progressivism.

FHG

7 "The Great American Cartoonist," *Harper's Weekly*, Vol. 46, no. 2400 (December 20, 1902): 1972.

8 Several biographies have chronicled Nast's career. Published not long after his death, Albert Bigelow Paine's *Thomas Nast: His Period and His Pictures* (New York: The Macmillan Company, 1904) provides a thorough assessment of his life and work. See also J. Chal Vinson, *Thomas Nast: Political Cartoonist* (Athens: University of Georgia Press, 1967); and Morton Keller, *The Art and Politics of Thomas Nast* (New York: Oxford University Press, 1968).

9 Frank Luther Mott, *The History of American Magazines*, Vol. 2 (Cambridge, Mass.: Harvard University Press, 1968), 475–76.

10 James Burton Pond, *Eccentricities of Genius* (New York: G.W. Dillingham, 1901): 188.

11 Keller, 13.

12 "The Late Thomas Nast," *The Bookman*, Vol. 16, no. 5 (January 1903): 434.

13 Paine, 553.

18.

Grover Cleveland

Former U.S. president
Born Caldwell, New Jersey
March 18, 1837–June 24, 1908

In these sad and ominous days of mad fortune-chasing, every patriotic, thoughtful citizen, whether he fishes or not, should lament that we have not among our countrymen more fishermen. There can be no doubt that the promise of industrial peace, of contented labor and of healthful moderation in the pursuit of wealth, in this democratic country of ours, would be infinitely improved if a large share of the time which has been devoted to the concoction of trust and business combinations, had been spent in fishing.[14]

So wrote Grover Cleveland in his essay of 1901, "A Defense of Fishermen," for the *Saturday Evening Post*. Few men—and certainly no previous United States president—were as passionate about fishing, and outdoor recreation in general, as the former New York governor and two-term Democratic president. Ben-Yusuf learned as much after spending a day on a fishing excursion with Cleveland in the summer of 1901. Along Hop Brook outside the resort town of Tyringham, Massachusetts, Ben-Yusuf documented the former president engaged in his favorite pastime. A selection of these portraits was reproduced alongside his article.

Four years after leaving the White House, Cleveland had relocated to Princeton, New Jersey, where he spent his time writing, lecturing, and involving himself in the affairs of Princeton University. However, what he did more than anything else was to pursue his lifelong interest in fishing and hunting. Following his retirement from political life, Cleveland traveled frequently throughout the nation to join friends and former colleagues in outdoor adventures. He hunted duck in the Carolinas and Virginia, fished for salmon on the St. Lawrence River, and stole away for weeks at a time to residences on Buzzard's Bay and in Tyringham. The press chronicled his successes and shortcomings as an outdoorsman, often on its

Grover Cleveland
Zaida Ben-Yusuf
Platinum print, 1901
23.7 × 19 cm (9⁵/₁₆ × 7½ in.)
Print Collection, Miriam and Ira D. Wallach Division of Art, Prints, and Photographs, New York Public Library, Astor, Lenox, and Tilden Foundations

Grover Cleveland
Anders Zorn
Oil on canvas, 1899
National Portrait Gallery,
Smithsonian Institution, Washington, D.C.;
gift of the Reverend Thomas G. Cleveland

front page. Several months prior to the publication of "A Defense of Fishermen," reporters covered in detail an incident in which the sixty-three-year-old former president almost drowned when his boat was swamped during a storm at the end of a highly successful day of hunting duck in Virginia. While some praised Cleveland for his skills as a hunter and his heroism in escaping a near-tragic incident, others sharply criticized him for killing so many birds during the mating season. As a writer for *Outing* editorialized, "To kill upwards of seventy-five ducks in a single day is not the work of a sportsman at any season; at this time of the year it is the work of a pot-hunter."[15] Later that summer, a similarly heated controversy erupted when a game warden in Massachusetts caught Cleveland's fishing party with a bass that was smaller than the legal limit. Although Cleveland initially confessed to the offense, another member of the group ultimately admitted his guilt and paid the two-dollar fine.[16]

Such incidents—while annoying—did little to dampen Cleveland's enthusiasm. For him, fishing and hunting were more than simply recreational pursuits to while away retirement. Instead, as he suggested in his *Saturday Evening Post* article, they were antidotes to a society he perceived with dismay as increasingly fast-paced and cut-throat. He was not alone in pointing to the redemptive qualities of the rugged outdoor life. For more than a generation, a host of individuals, from medical doctors to politicians, championed a return to nature as a means of preventing or curing the ills of society. Theodore Roosevelt's outspoken advocacy of the "strenuous life" had made such pursuits *de rigueur* to an entire class of men. Cleveland's interest in fishing and hunting sat squarely in a larger campaign to promote a renewed American manliness.[17]

Cleveland's writings in the years after his presidency extended beyond outdoor recreation. Yet, like "A Defense of Fishermen," his essays tended to convey regret about what he perceived as an assault on certain values and institutions that he held dear. A frequent contributor to *Century* and the *Saturday Evening Post*, he often expressed during this period grave concern about such subjects as American foreign policy and divisions within the Democratic Party. Despite his opposition to the Republican administration of William McKinley, Cleveland refused to support William Jennings Bryan, McKinley's Democratic challenger, in the presidential election of 1900. Bryan's populist politics—his support of free silver and an income tax—ran counter to Cleveland's belief in a limited and fiscally conservative federal government. The split that existed within the Democratic Party assured McKinley's re-election in November and prompted some Democrats to consider drafting Cleveland for the nomination of 1904.[18]

Yet, as Ben-Yusuf's photograph and the painting by Anders Zorn of Cleveland in 1899 (opposite) seem to make clear, the former president no longer possessed the same energy as he had in his youth. Two tumultuous terms in the White House and the disintegration of the political party to which he had long been allied led him to embark on a new course. Unlike Ulysses S. Grant and others who wrote their memoirs in these later years, Cleveland had neither the passion nor the stamina to commit to such a project. The past held less appeal than the present company of his family and many friends. As Ben-Yusuf has pictured, Cleveland's retirement was focused on getting back to the simpler pleasures of life. He confided as such to a correspondent two years after leaving political office. In reply to a speaking invitation, he wrote: "I am not the sort of man people want to hear in these days. My beliefs and opinions are unsuited to the times. No word that I could speak would do the least good. . . . I am content in my retirement."[19]

FHG

14 Grover Cleveland, *Fishing and Shooting Sketches* (New York: The Outing Publishing Company, 1906): 20–21.
15 "Grover Cleveland in Peril," *Chicago Daily Tribune* (March 10, 1901): 1; and Caspar Whitney, "The Sportman's Viewpoint," *Outing* (April 1901): 98.
16 "Mr. Cleveland's 'Short' Fish," *New York Times* (August 31, 1901): 1.
17 Kathleen Dalton, *Theodore Roosevelt: A Strenuous Life* (New York: Alfred A. Knopf, 2002); and Gail Bederman, *Manliness & Civilization: A Cultural History of Gender and Race in the United States, 1880–1917* (Chicago: University of Chicago Press, 1995).
18 For a good political biography of Cleveland, see Allan Nevins, *Grover Cleveland: A Study in Courage* (New York: Dodd, Mead & Company, 1964).
19 Grover Cleveland to Judson Harmon, April 17, 1899, letter in Allan Nevins, ed., *Letters of Grover Cleveland, 1850–1908* (Boston: Houghton Mifflin Company, 1933): 515.

19.

John White Alexander

Artist
Born Allegheny City, Pennsylvania
October 7, 1856–May 31, 1915

Ben-Yusuf photographed the painter John White Alexander at her Fifth Avenue studio shortly after his return from Paris in the fall of 1901, in what was arguably the period of the painter's greatest creative and critical triumph. After eleven years in Paris, he arrived back in New York trailing honors and awards, culminating in the gold medal at the Paris Exposition of 1900 and his selection as a *chevalier* of the Légion d'honneur. His stature as an artist is suggested in the lead to a profile of 1903: "When one thinks of American art in Paris one thinks of four names: of Sargent, Whistler, Abbey, and Alexander. Of these four but one has returned to make his residence in his home country—Alexander."[20]

In Ben-Yusuf's photograph, Alexander stands upon bare floorboards before a long drape. As with many of her portraits, the image is cropped to accentuate its verticality. Although Alexander's hips and feet face the camera, his shoulders and head turn slightly to his right, and his eyes turn back to stare directly into the lens. His wool suit and tweed overcoat peg him as practical and down-to-earth, while his sweeping mustache and trim Van Dyck beard give a hint of European flair. The overcoat and wrinkled pants suggest a traveler just recently arrived. Given Ben-Yusuf's desire to portray subjects in natural positions, it is probable that she was going for just this effect. Alexander was indeed recently arrived, and much was being made of his return. His posture—simultaneously relaxed and resolute—suggests a likeable, yet determined man.

Alexander's rise to such an influential position would have seemed possible only in a nation raised on Horatio Alger stories. Orphaned when he was five and raised by his grandparents, Alexander was twelve when he went to work at the Atlantic and Pacific Telegraph Company in Pittsburgh. Constantly sketching, he captured the interest

John White Alexander
Zaida Ben-Yusuf
Platinum print, 1901
23.8 × 10.2 cm (9⅜ × 4 in.)
John White Alexander Papers, Archives of American Art, Smithsonian Institution, Washington, D.C.

John White Alexander
Zaida Ben-Yusuf
Platinum print, 1901
John White Alexander Papers,
Archives of American Art,
Smithsonian Institution, Washington, D.C.

of the company's president, Colonel Edward Jay Allen, who subsequently agreed to become his young employee's official guardian. When Alexander was eighteen, he left Pittsburgh for New York and a job as an office boy at the publishing house of Harper & Brothers; within a year he was providing his first illustrations for *Harper's Weekly*. His sweeping sketches of Pittsburgh, devastated by the railroad riots in 1877, reveal his skill at portraying both space and action, but his real love was portrait painting. Later that same year he traveled, first to study at the Royal Academy of Munich, and then to Pölling, Germany, to work less formally with Frank Duveneck and "Duveneck's boys," young American expatriates eager to adopt their leader's *alla prima* technique, with its sweeping brushstrokes and clarity of color.

Back in Pittsburgh in 1881, Alexander resumed work for *Harper's*, where, with rare exceptions, he concentrated on formal portraits of great men, including Daniel Webster, Henry Wadsworth Longfellow, and Ralph Waldo Emerson. More and more he painted, rather than sketched, the portraits that were used to model these engravings, and he slowly began to gather portrait commissions. Having married, in 1891 he traveled with his new bride to Paris for what was supposed to be a short visit. They stayed eleven years. Admired for his flowing lines and his clear but subtle colors, Alexander was immediately embraced by the French art world, and his success echoed in the United States. Despite being in Paris, he was commissioned to paint six murals—eventually titled *The Evolution of the Book*—to be installed in the new Jefferson Building of the Library of Congress, and in 1896 he visited Washington, D.C., to oversee their installation. The generosity of his welcome may have influenced his decision to return to the United States permanently in late 1901.

Alexander did not move to New York simply to capitalize on his European success. A new nationalism in American art was gaining ground, based on the dual presumption that there was something uniquely American and clearly identifiable in native work and that such work could hold its own in comparison with more traditionally celebrated European art. By leaving Paris, Alexander was declaring his allegiance to this new "American-ness." He came back to great acclaim, and in the winter of 1902 he mounted his first solo exhibition, at New York's Durand-Ruel Gallery. Many reviewers celebrated his return: "[This exhibition of paintings] will be gratifying to the lovers of and believers in American art, for they reveal Mr. Alexander as a portraitist and figure painter of whom any country might be proud."[21] However, the New York to which he returned was not as harmonious as he perhaps expected. Increasingly, the terms "decorative" and "*beaux arts*"—long associated with his portraits— were being used derisively, and soon critics were dwelling on his shortcomings. As the critic Harriet Monroe related about a new exhibition in 1904, "these later pictures do not show so fine an advance as we expected ... and so our pleasure in the retention of so much of the grace and dash of youth is alloyed by regret for the lack of sounder qualities, which we are forced to admit will always lie too deep for his searching."[22]

Alexander continued to be fashionable and successful, but he was more and more regarded as part of an older generation. Elected to the National Academy of Design upon his return in 1901, he devoted his attention to advancing its fortunes in the face of diminishing support and a cadre of younger artists who no longer revered such institutions. Alexander marked a transition in modern American art. His portraits of women,

in particular, show a new appreciation of line and abstract form, but his allegiance to traditional portraiture never allowed him to push beyond customary limits. He arrived in New York—and in Ben-Yusuf's studio—as the promise of a newly emergent American art. If he were the harbinger of change, it was a change that he could not sustain. However, his work remained popular and he never lacked for commissions. For the rest of his career, he would continue to blend realism with aestheticism to create lovely, even fascinating, glimpses into a world of privilege and elegance.

EOW

20 "An American Artist of Note," *Current Literature*, Vol. 34, no. 2 (February 1903): 148. For more about John White Alexander, see Sarah J. Moore, *John White Alexander and the Construction of National Identity* (Newark: University of Delaware Press, 2002).
21 "Portraits by John W. Alexander," *New York Herald* (November 28, 1902): 7.
22 Harriet Monroe, "John W. Alexander, His Paintings," *The House Beautiful*, Vol. 15, no. 2 (January 1904): 73.

20.

William Merritt Chase

Artist, teacher
Born Nineveh, Indiana
November 1, 1849–October 25, 1916

During the last two decades of his life, William Merritt Chase received numerous honors for his contributions as a painter and as an art teacher. None, though, moved him as greatly as the gesture made by a group of his former students in 1902. In that year, they commissioned his long-standing friend John Singer Sargent to paint Chase's portrait and arranged to donate the finished work to the Metropolitan Museum of Art in New York. The painting's unveiling at the Met in 1905 elicited a fresh round of appreciations and tributes, including a profile in the pages of the *American Art News*. Observing that critics and patrons in the late 1870s greeted Chase and several other young American artists returning from their European studies as "cranks, madmen, etc.," the writer for the *American Art News* went on to declare that Chase had done "more to alter the conditions then prevailing in American art circles than anyone else. He may in fact be said to have been the founder with his fellows of the American Art Renaissance."[23]

Ben-Yusuf's portrait of Chase accompanied this article. In most respects, her photograph captures Chase well, showing off his carefully cultivated bohemian elegance. By this period the silk top hat, pince-nez eyeglasses, bushy mustache, and the carnation he wore on his lapel had become hallmarks of the artist.[24] His Tenth Street studio—famously decorated with a large collection of paintings and *objets d'art* amassed during his travels—further complemented his reputation as America's most cosmopolitan artist. He was the "perfect model of fashion," his friend Harrison Morris later recalled, conveying a feeling shared by many in the art world.[25]

As successful a likeness as it is, Ben-Yusuf's photograph can only hint at the degree to which Chase had become a staunch defender of

William Merritt Chase
Zaida Ben-Yusuf
Halftone print published in
American Art News, November 4, 1905
Art and Architecture Collection,
Miriam and Ira D. Wallach Division of
Art, Prints, and Photographs, New York
Public Library, Astor, Lenox, and Tilden
Foundations

William Merritt Chase
John Singer Sargent
Oil on canvas, 1902
The Metropolitan Museum of Art, New York;
gift of the pupils of Mr. Chase, 1905 (05.33)

established artistic conventions. Such had not always been the case. Having settled in New York in 1878 after six years of study in Europe, Chase became well known for standing apart from the conservative National Academy of Design and for promoting a new, less academic approach to painting. In his Impressionist-inspired portraits and landscapes, he introduced a Continental style that pushed American painting away from its parochial roots. His popularity as a teacher—first at the Art Students League and later at the schools he founded at Shinnecock on Long Island and on Fifty-seventh Street in New York—helped to consolidate his central role during this period in the progress of art in America. Yet, by the new century, Chase had become increasingly apprehensive about what he perceived as an erosion in the quality of contemporary painting. Pessimistic about the direction in which modern art was headed, he accused many artists of employing poor techniques and of mistreating their subjects.[26]

This concern revealed itself quite dramatically during a now-famous encounter with Alfred Stieglitz at the photographer's 291 Fifth Avenue gallery in 1908. Chase had frequented the gallery before, sometimes in the company of his students. In general, he admired Stieglitz's photography and the exhibitions he presented there. On this occasion, though, a collection of nude drawings by the French sculptor Auguste Rodin set Chase off. The journalist Herbert J. Seligmann later described the episode: "But when the Rodin drawings were shown Mr. Chase had become enraged, because of their possible effect on his students ... , and had banged his silk hat down so hard that it had smashed. Stieglitz replied that it was just because of the students that the Rodin drawings were shown, and that Chase was really not thinking of

his students at all. Chase ... departed, unpacified, declaring he would never again set foot in 291."[27]

Despite harboring deeply negative feelings about such modernist artists as Rodin, Chase continued to engage in those pursuits he most enjoyed: namely, painting, traveling, and teaching. At times he combined all three. For several summers, beginning in 1903, he traveled abroad—often with his students—to visit the artistic capitals of Europe. There he found inspiration in the well-trodden temples of high art and only reluctantly frequented those galleries where the seeds of a new art were being sown. Yet, while he deplored such movements as Cubism, Futurism, and Fauvism—once referring to the artist Paul Cézanne as an "idiot"—his distress about the status of modern art was as much a result of the slights directed at him by a new generation of progressive artists and critics.[28] Indeed, his critical remarks about the Independents Exhibition of 1910 and the Armory Show of 1913—two landmark exhibitions of modern art in New York—were in part prompted by successful efforts to exclude him from these shows.

At once honored for his contributions to American art and marginalized for his outdated opinions, Chase spent the last years of his life defending the artistic tenets he had long cherished. Some in the New York art world remained wedded to these ideas, including his contemporary James Carroll Beckwith, who wrote at his death: "The loyalty with which Chase has always stood by the higher principles of his profession has been an encouragement to all American painters. Never stooping to the commercial or the cheap, he has held high the banner of courage and integrity, striving ceaselessly to 'paint the thing as he saw it, for the God of things as they are.'"[29]

Others, though, were less inclined to follow Chase's example. Although willing to acknowledge his influence, this new generation now embraced new subjects and new approaches to art-making. Ironically, many of the leading modern artists in America were Chase's former students, including such figures as Marsden Hartley, Charles Demuth, Joseph Stella, and Charles Sheeler. It was Georgia O'Keeffe, however, who perhaps best captured the relationship between Chase and the artists of this new age. Reflecting on her time under his tutelage, she explained: "I think that Chase as a personality encouraged individuality and gave a sense of style and freedom to his students. . . . I thought that he was a very good teacher. I had no desire to follow him, but he taught me a great deal."[30] Ben-Yusuf's elegant portrait represents a once-dominant figure in American art at a time when the field was rapidly moving beyond the principles he espoused.

FHG

23 "Among the Artists," *American Art News*, Vol. 4, no. 4 (November 4, 1905): 3.

24 For a descriptive portrait of the flamboyant Chase, see Walter Pach, *Queer Thing, Painting: Forty Years in the World of Art* (New York: Harper & Brothers, 1938): 31.

25 Harrison Morris, *Confessions in Art* (New York: Sears Publishing Company, 1930): 73.

26 Several studies are noteworthy in chronicling Chase's life and appraising his art. In particular, see Ronald Pisano, *A Leading Spirit in American Art: William Merritt Chase, 1849–1916* (Seattle: Henry Art Gallery, 1983); and Keith Bryant, *William Merritt Chase: A Genteel Bohemian* (Columbia: University of Missouri Press, 1991).

27 Herbert J. Seligmann, *Alfred Stieglitz Talking: Notes on Some of His Conversations, 1925–1931* (New Haven, Conn.: Yale University Press, 1966): 111.

28 Pach, 36.

29 James Carroll Beckwith, "A Great American Painter," *New York Times* (October 29, 1916): 2.

30 Georgia O'Keeffe to Ronald Pisano, September 18, 1972, letter in the Papers of Ronald G. Pisano, Archives of American Art, Smithsonian Institution.

21.

James Carroll Beckwith

Artist, teacher
Born Hannibal, Missouri
September 23, 1852–October 24, 1917

Amid the changing currents that characterized the fine arts in America at the turn of the century, James Carroll Beckwith was a well-grounded rock. Whereas other artists of his generation embraced a host of new influences, Beckwith remained true to the formal academic training he had received as a young man in Paris. A highly regarded art teacher for almost two decades at the National Academy of Design, he was unwavering in his commitment to Europe's Old Masters and directed his students to imitate them in terms of both style and subject matter. This attitude won him praise in the years immediately following his return to New York in 1878; however, during the latter half of his career, he was increasingly seen as out of touch with the contemporary art world. Beckwith was cognizant of his growing irrelevance, and wrote despairingly at the end of his life about his own situation and the status of the arts in American society.[31]

American Art News, a weekly journal devoted to the fine arts, commissioned Ben-Yusuf to create Beckwith's portrait in the fall of 1905 as part of its series of illustrated profiles of important figures in the New York art world. This portrait was one of seven published that fall, a sign of the respect that many continued to accord Beckwith.[32] Ben-Yusuf's photograph suggests something of the artist's formal elegance and his conservative nature. Dressed in a fashionable suit and sporting his trademark Van Dyck beard, he sits in a comfortable armchair with his hands interlocked before his chest and his legs crossed. He is most assuredly a man of refinement and respectability, qualities that the fifty-three-year-old artist took pains to cultivate both in himself and in the world of American art.

From an early age, Beckwith worked hard to distinguish himself as an artist of the first order. Though he mentioned repeatedly to reporters and others that he was born in the same small

Midwestern town as Samuel Clemens, he went to great lengths to distance himself from that world. Having won the reluctant agreement of his father, a wholesale grocer, to pursue his interest in the fine arts, he enrolled in art school, first in Chicago and then in New York City at the National Academy of Design. Yet it was France toward which career-oriented artists gravitated during this period in order to acquire the skills and credentials that would assure future success. Following the path of other American artists of his generation, Beckwith traveled to Paris in 1873 and remained there for the next five years, working, most significantly, in the atelier of the painter Émile-Auguste Carolus-Duran. In Paris, he learned the importance of being a good draftsman and of aspiring to the high ideals of Europe's historic masters. He became a part of the American expatriate community then living there, befriending such emerging talents as John Singer Sargent and William Merritt Chase.

Returning to New York, Beckwith was well received and soon secured teaching posts at the Art Students League and later at the National Academy of Design. He also joined a host of different arts organizations that were then being set up in America to promote a new, more international artistic outlook. One such group was the Free Art League, which sought to lift the high tariffs being imposed on imported artworks. Beckwith was a prime figure in its campaign to ensure that the world's best art would reach American shores.[33] Well respected as a portrait painter, he undertook numerous commissions, the proceeds from which gave him a certain degree of financial independence. His self-portrait of 1898 (page 132) exudes the sense of self-confidence that he felt as an artist. Yet, while his work continued to be widely exhibited and much praised, he was growing increasingly wary of new artistic

James Carroll Beckwith
Zaida Ben-Yusuf
Platinum print, 1905
22.2 × 18.5 cm (8¾ × 7⁵⁄₁₆ in.)
National Academy Museum, New York

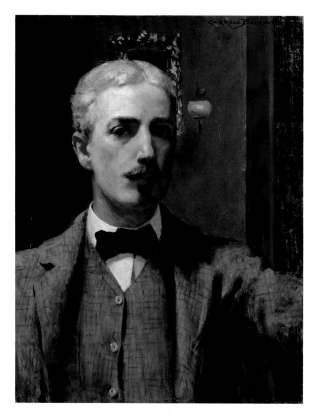

Self-portrait
James Carroll Beckwith
Oil on canvas, 1898
The Detroit Institute of Arts;
gift of the artist

Art Students League who encouraged students to paint the world around them in an expressionistic manner—Beckwith's remarks were surely directed at those such as Henri who sought to move fine arts education away from its conservative tenets.[35]

Ben-Yusuf's portrait depicts a proud lion who felt besieged by the arrival of modernism. To the end of his life, Beckwith continued to paint in a style consistent with his training. Most appropriately, his last sustained series of paintings was executed in Paris. As his obituarist commented, Beckwith "was particularly happy in his paintings of historic monuments, such as the fountains and old buildings at Versailles. He reconstructed their original importance … and managed to convey the sense of their ancient splendors without sacrificing their actual aspect of semi-dilapidation."[36]

FHG

developments. Beckwith spent many summers in Europe, and he looked on with skepticism at the work of Claude Monet and others. Both their loose technique and their prosaic subject matter troubled him.

This concern found expression not only in Beckwith's journals and private correspondence, but also in his lectures and published letters to various newspaper editors. Beckwith directed his most pointed criticism toward what he perceived were declining standards in fine arts education. As he later wrote in a letter published in the *New York Times*, "authoritative guidance is unquestionably lacking in all of our art schools. The dignity of the Royal Academy, and the high respect in which the Directors of the Ecole Nationale des Beaux-Arts are held, [have] a restraining influence upon the student, which saves him from being led astray into the hopeless paths of so-called 'Modernism' or 'Art Nouveau' that have shipwrecked so many men of talent." Beckwith recommended that schools ought to develop required courses in "aesthetics … where good and bad taste should be demonstrated, where beauty and grace should be defined, in contradistinction to the ugly."[34] Although he did not mention by name Robert Henri—a much-admired instructor at the

31 The best work to date on Beckwith's career is Pepi Marchetti Franchi and Bruce Weber's *Intimate Revelations: The Art of Carroll Beckwith (1852–1917)* (New York: Berry-Hill Galleries, 1999).

32 "Among the Artists," *American Art News*, Vol. 4, no. 5 (November 11, 1905): 3.

33 Beckwith later reversed his position on this issue, arguing that American art patrons should be encouraged to purchase the work of native artists. The timing of this change coincided with a period when sales of his own work were declining.

34 James Carroll Beckwith, "The Worship of Ugliness," *New York Times* (October 4, 1915): 8.

35 Beckwith's frustration was also grounded in the fact that his beloved institution, the National Academy of Design, was finding it increasingly difficult to recruit the city's best art students. Since selling its landmark building on Twenty-third Street to the Metropolitan Life Insurance Company in 1894 in order to build a new, larger space uptown in Harlem—a structure that was never completed and ultimately abandoned—the National Academy was no longer the most favored art school in New York City. John Davis, "Real Estate and Artistic Identity in Turn-of-the-Century New York," *American Art*, Vol. 20, no. 2 (Summer 2006): 56–75.

36 "Carroll Beckwith, Noted Painter, Dies," *New York Times* (October 25, 1917): 15.

22.

Daniel Chester French

Sculptor
Born Exeter, New Hampshire
April 20, 1850–October 7, 1931

Whereas most artists of his generation wore well-tailored suits in public and cultivated a cosmopolitan air, the sculptor Daniel Chester French preferred—at least on this occasion at Ben-Yusuf's studio—to be depicted in an artist's smock. This garment falls in almost sculptural folds from his body; the hems hang with the weight and weave of heavy linen. French's features and the creases in the smock are sharply rendered, but the depth of field leaves his hands slightly out of focus and effectively roughens them. Ben-Yusuf's photograph conveys that these are the working hands of an actively engaged artist.

While French worked in New York at this time, he was very much a New Englander. Born in New Hampshire, he was ten when his family settled in Concord, Massachusetts. Louisa May Alcott, a family friend, was the first to encourage his artistic interests, providing him with early lessons in sculpture. It was a relationship that established a pattern. Although French studied drawing for a year at the Massachusetts Institute of Technology, he would spend most of his life learning from friends and gathering mentors.[37]

French's first success was his statue of a Revolutionary War icon, the Massachusetts Minute Man. In 1871, the town of Concord was looking for ways to commemorate the hundredth anniversary of "the shot heard round the world," and the twenty-one-year-old artist responded with a model of a citizen soldier tamping shot into his long rifle. Those who saw it were intrigued, but the commission was not secured until a year later, when a city patron left the town $1000 to proceed with a memorial. French was promised the job provided that his final model met with the commissioners' approval. His finished design shows a young farmer stepping forward, his left hand resting on a plow handle, while his right holds a rifle. Although the statue was well received, French initially gained no compensation for his efforts. The commissioners felt that they were generous enough in simply paying for the expensive casting and installation of the work, and that such an inexperienced artist would have to be satisfied with the recognition he had earned. In the face of such logic, Ralph Waldo Emerson, a Concord resident, argued that "if I ask an artist to make me a silver bowl and he gives me one of gold I cannot refuse to pay him for it if I accept it."[38] The committee ultimately sent French $1000.

French's career advanced quickly after that first commission. In 1893, he earned a special honor for being selected to provide a monumental work for the centrally located Court of Honor at the World's Columbian Exposition in Chicago. The result was a 20-meter (65-foot) plaster statue, *The Republic*, a classically draped woman standing with her arms raised. Her right hand held an orb with an eagle perched on it. In her left she gripped a staff. Covered in gold leaf and beaming electric lights from its laurel-leaf crown, the statue was the allegorical exclamation point to a national celebration.

After the exposition, commissions rolled in at such a rate that French was able to be selective, but he could never resist a tempting project. In 1901, the year when Ben-Yusuf photographed him, he was in the process of finishing the Richard Morris Hunt Memorial in New York, a marble colonnade to celebrate the life of America's most celebrated beaux arts architect (page 135). At the time he was also working on the Francis Parkman Memorial in Boston and finalizing the design of an allegorical *Alma Mater* for Columbia University. Given his popularity, it is perhaps appropriate that Ben-Yusuf photographed French in his smock instead of a tailored suit.

Daniel Chester French
Zaida Ben-Yusuf
Platinum print, 1901
19.1 × 14.8 cm (7½ × 5¹³⁄₁₆ in.)
ARTnews Collection, New York

Ben-Yusuf was pleased with the resulting image and exhibited it—alongside other photographic works selected by Alfred Stieglitz—at the Glasgow International Exhibition in May 1901. The portrait also played a role four years later in a new relationship that Ben-Yusuf negotiated with *American Art News.* The publication of the image in that art journal represented the first in a regular series of illustrated profiles of prominent American artists. Whether this idea was hers or someone else's at the magazine is not known; yet Ben-Yusuf supplied the images for the first seven articles. French was a natural choice to inaugurate this series, given his position at the pinnacle of the art world. In choosing Ben-Yusuf as their first photographer in the series, *American Art News* was endorsing her work as well.

French's career coincided with an unprecedented rise in the construction of public buildings and civic spaces in New York and other major cities in America. The demand for public art accompanied this boom, and French built a prestigious career fulfilling this need. His popularity as a sculptor stemmed in part from the fact that much of his work was a throwback to a familiar nineteenth-century decorative aesthetic. Yet French can also be seen as a transitional figure between the beaux arts movement and the increasing realism of modern sculpture. His statue of Abraham Lincoln for the *Lincoln Memorial* in Washington, D.C., consumed the bulk of his energy from its commissioning in 1911 to its dedication eleven years later. Unlike the idealized allegorical figure for the Columbian Exposition, this statue portrayed a tired leader, staring straight ahead with dogged resolve. Its sculptural humanism gestures toward an emergent modernism. French's *Lincoln* is one of the most recognized and admired sculptures in America. Taken alone, it would secure his reputation as a great sculptor, but taken as the capstone of his prolific career, it illuminates his larger influence in shaping public space at the dawn of the new century.

EOW

37 Biographies of French include Margaret French Cresson, *Journey into Fame: The Life of Daniel Chester French* (Cambridge, Mass.: Harvard University Press, 1947); and Michael Richman, *Daniel Chester French: An American Sculptor* (New York: The Metropolitan Museum of Art, 1976).
38 Ralph Waldo Emerson to Daniel Chester French, March 5, 1876, letter in the French Family Papers, Library of Congress.

Richard Morris Hunt Memorial,
Central Park, New York
Daniel Chester French
Marble and bronze, 1901
Courtesy Smithsonian Institution Libraries, Washington, D.C.

Young Moderns

While an "Old Guard" elite played a prominent role in the cultural life of the city, it was increasingly a new generation that was responsible for the period's most significant developments in the arts, literature, music, and fashion. With New York City having become by the century's end the nation's capital for those wishing to pursue careers in these fields, young men and women with ambition flocked to it. Like Ben-Yusuf, they found there not simply opportunities, but an extensive network of individuals and groups who were experimenting with ideas of creative expression. These "Young Moderns" often carried with them groundbreaking possibilities from their previous lives, and in New York, the concentration of talent and the availability of venues to bring forth their work made the city the center for a burgeoning American modernism. To a degree far greater than in earlier eras, New York also proved to be relatively tolerant of the idea that women could participate in such cultural pursuits. Not every woman enjoyed these new freedoms, and often there was resistance to women who strove to make their mark; however, New York sustained, to a degree beyond any other American city, the careers of independent-minded women. The individuals pictured in this section represent a sample of those young men and women who were a part of the movement to remake America at the dawn of the twentieth century.

23.

Edith Wharton

Author
Born New York City
January 24, 1862–August 11, 1937

Raised in a prominent old New York family, Edith Wharton was well attuned to the broad changes occurring in American society at the beginning of the twentieth century. In her novels and short stories—many of which were set in New York City—Wharton explored the effects of modernity on the lives of the urban elite, paying particular attention to the challenges women faced. Although she was often critical of the tradition-bound past, she was likewise wary of the disruptions brought forth by realignments in social mores and expectations. Her probing fiction derived much of its power from this tension between old and new.

Ben-Yusuf's portrait shows Wharton in her late thirties during an important transitional moment in her life—a period marked by a new sense of self-confidence as a writer and an independent woman. It had not always been so. Despite a privileged childhood, she received little encouragement from her parents to pursue her interest in writing. Instead, they pushed her toward marriage and a life consistent with her upbringing. Her marriage to the socially proper Edward Wharton in 1885 only exacerbated her growing unease. While the couple shared an interest in dogs and outdoor activities, Edith felt uncomfortable performing the role of a woman of leisure. Furthermore, her affable husband understood little of her desire for wider intellectual stimulus. As the two grew increasingly further apart, both her physical and emotional health suffered.[1]

New friendships gained during travels to Europe—together with the publication of Wharton's first book, *The Decoration of Houses* (1897), written with the architect Ogden Codman—helped to compensate for the problems in Wharton's marriage, and before long she had entered into the first fruitful period of her literary career. The publisher Scribner's brought out her first collection

Edith Wharton
Zaida Ben-Yusuf
Platinum print, *c.* 1901
7.5 × 7.3 cm (2¹⁵⁄₁₆ × 2⅞ in.)
Yale Collection of American Literature,
Beinecke Rare Book and Manuscript
Library, Yale University, New Haven,
Connecticut

138

Edith Wharton

Edith Wharton
Edward Harrison May
Oil on canvas, 1870
National Portrait Gallery,
Smithsonian Institution, Washington, D.C.

of short stories in 1899; a second set, *Crucial Instances*, was produced two years later. Ben-Yusuf's photograph coincides with the publication of this second volume. Reviewers found much to praise in these short stories. As the critic for the London *Times* noted, "It is because her work is full of freshness and observation that her stories have won her a faithful following among those who appreciate the finer qualities of fiction in an age when blatancy and over-emphasis are too frequently mistaken for sincerity and power." While "clearly a disciple of Mr. Henry James," she wrote in a manner that was deemed less "overweighted" than that of the famed American expatriate.[2]

James was indeed an important influence, and his encouragement at the turn of the century was another factor in Wharton's growing self-confidence as a professional writer. In the fall of 1900, desirous of his critical feedback and support, Wharton had sent him a copy of a short story that she had recently published in *Lippincott's* magazine. In response, James remarked that the ambitious nature of her literary inquiry could not be captured in a story so short. Nonetheless, he concluded, "I egg you on, in your study of the American life that surrounds you. Let yourself go in it & *at* it. It's an untouched field, really."[3] James's advice to consider writing longer works and to investigate contemporary life around her spurred Wharton on in that direction.

This period also saw Wharton establishing herself anew in another way. Although she and her husband continued to share a residence on Park Avenue, she began to conceive of a plan to purchase a new home in Lenox, Massachusetts. Her mother-in-law owned a house there, and from visits Wharton had grown to enjoy the quiet and peace of the surrounding Berkshires. In the spring of 1901 she traveled alone to Lenox to find a site

where she might build a home. By June she had signed the deed for the property, using her own money to underwrite the purchase. "The Mount"—the grand home that her friend Ogden Codman designed—would ultimately reflect the design philosophy that she and Codman had set out in *The Decoration of Houses*. Although Wharton moved permanently to France in 1907, the period during which she lived in Lenox represented a critical moment in her literary career. There, surrounded by friends, she found the space where she could mature as a writer. It was in Lenox that she would complete her first novel, *The House of Mirth* (1905), a tragic tale of a young woman's fall from grace within elite New York society.

In Wharton, Ben-Yusuf seems to have encountered a kindred spirit—an independent woman working at developing a career. As the great majority of Ben-Yusuf's portraits are vertical studies, her decision to create a square-format, bust-length portrait is noteworthy. Rather than showing her subject's whole body, she captures, with great intimacy, Wharton's facial expression. The author neither smiles nor frowns, but instead looks directly into the camera's lens. Conveying neither great confidence nor youthful innocence, she seems to stare back at Ben-Yusuf, possibly taking the measure of her female peer. Her attire—a choker necklace and an open-front shirtwaist with lace trimming—is suggestive of a fashionable and somewhat daring woman, qualities that Ben-Yusuf also possessed. Little is known about the occasion on which this portrait was created or the relationship between these two women. Yet the portrait itself hints that there existed a certain bond—perhaps even understanding—that united them. As Ben-Yusuf had previously photographed Wharton's sister-in-law and close friend Mary Cadwalader Jones, it is

interesting to speculate about connections within this circle of accomplished New York women.

In the years that followed this sitting, Wharton went on to achieve literary immortality. Building on the success of *The House of Mirth*, she published over the next three decades more than two dozen novels, collections of short stories, and non-fiction works. In 1921, she won the Pulitzer Prize for *The Age of Innocence*; two years later, she became the first woman to be awarded an honorary doctorate from Yale University. Although she divorced her husband in 1913 and never remarried, she had many close friends within the Parisian intellectual community. To the end of her life Wharton was active as both an observer of and a participant in a rapidly changing world. Her writings speak eloquently of the social conflicts that arose from these grand upheavals.

FHG

1 Many scholars have studied Wharton's life and literary career. Important biographies include R.W .B. Lewis's *Edith Wharton: A Biography* (New York: Harper & Row, 1975); Cynthia Griffin Wolff's *A Feast of Words: The Triumph of Edith Wharton* (New York: Oxford University Press, 1977); Shari Benstock's *No Gifts from Chance: A Biography of Edith Wharton* (New York: Charles Scribner's Sons, 1994); and Hermione Lee's *Edith Wharton* (New York: Alfred A. Knopf, 2007).

2 Untitled clipping in the Edith Wharton Collection. YCAL MSS 42, Box 4, Folder 100, Yale Collection of American Literature, Beinecke Rare Book and Manuscript Library.

3 Lyall H. Powers, ed., *Henry James and Edith Wharton: Letters, 1900–1915* (New York: Scribner's, 1990): 32.

Lucia Chamberlain
Zaida Ben-Yusuf
Halftone print published in
The Bookman, June 1908
Firestone Library,
Princeton University, New Jersey

celebrities in New York literary circles. The *New York Times* effusively praised this romantic tale set at a country house in Monterey, California, suggesting that it "indicates the influence of fresh air, and sky, and sea, among people who reflect the class we call the 'smart set.'" While the reviewer noted that the novel featured characters similar to those in Edith Wharton's recently published *The House of Mirth*, "they are not exasperating in their long speeches of pessimism, and they do not find the world a place of disheveled ambitions."

Asked by the same critic why the "smart people you have written about ... [aren't] always unhappy," Esther responded: "We are a naïve lot out there on the coast. They have as much money as they want, many of them are quite as rich as the Newport millionaires, and we don't mistrust people because they appreciate art or literature more than money. The wealthiest smart women in society in California entertain artists and writers just as well as they do society people."4 With *Miss Essington*, the Chamberlain sisters became in New Yorkers' eyes the refreshingly modern voice of the West Coast.

Ben-Yusuf created a portrait of each sister some time prior to the publication of their second joint novel, *The Coast of Chance*, in 1908. Both wear light-colored dresses typical of the Belle Epoque style then fashionable. In Esther's portrait, Ben-Yusuf has posed her standing with eyes downcast against a neutral wall. She wears a stylish hat and holds a

fur muff at her waist. The portrait suggests a woman of refined taste who is both demure and strikingly self-confident. In her dress and bearing, she is exemplary of one school of modern femininity.

In announcing the appearance of their new novel, *The Bookman* published Ben-Yusuf's portraits of the two sisters. Although neither sister achieved lasting acclaim, their work resonated with audiences at the beginning of the new century. At some time not long after the publication of *The Coast of Chance*, both sisters left New York for undetermined reasons to resettle in northern California. While Esther relocated to San Francisco, Lucia became part of an artists' colony in Carmel that included Jack London, Upton Sinclair, and Mary Austin. Both continued to write, though little is known of their lives during this later period. Like so many who have moved to New York from elsewhere, the Chamberlain sisters were transformed by their time there. In marking their presence and contributing to their increased fame, Ben-Yusuf's portraits played a role in those changes.

FHG

4 "Do Our Story Writers Misuse the 'Smart Set?'" *New York Times* (July 9, 1905): 7.

Robert Herrick

Author
Born Cambridge, Massachusetts
April 26, 1868–December 23, 1938

Robert Herrick was neither from New York City, nor did he live there during his lifetime. Yet his novels—many of which were set in his adopted hometown of Chicago—reveal perhaps better than the work of any other fiction writer of his generation the hopes and tensions of those who inhabited America's booming cities at the turn of the century. While Herrick preferred to examine the dark underbelly of progress, immersing his characters in the corruption and greed of city life, he did not think of himself as a "muck-raker," exposing wrongdoing like his contemporaries Lincoln Steffens and Ray Stannard Baker. Instead, he hoped to explore through fiction what he later called the "American sickness," a spiritual malaise brought about by the headlong pursuit of material success and power. In his best novels, he demonstrated that rapid urban growth invariably forced individuals to confront a larger set of ethical questions, including, importantly, one's civic obligations in a capitalistic society.[5]

Herrick saw the American city as a rich subject for writers. Arriving at the newly founded University of Chicago in the fall of 1893 to develop a program in composition, he discovered a place that differed in many respects from Cambridge, Massachusetts, where he had been born and raised. Although the excitement of the World's Columbian Exposition, held in Chicago that summer, seemed to promise that the city was at the beginning of a new era, Herrick found it a crude and barren wasteland, lacking history and marked by a sharp contrast between rich and poor. These feelings revealed themselves throughout his writing career, but in no place more directly than in an essay that he published in 1914 on the novel's status in contemporary American letters. While he acknowledged a preference for "the simpler virtues, the plainer life, of the old unprosperous America,"

he declared that novelists had a responsibility to examine urban life, for it was here that the great events of the age were being enacted. Yet he understood that such work was messy, professing that "our intensely modern cities are, at least externally and in mass, undeniably ugly—sprawling, uncomposed, dirty, and noisy. With their slovenly approaches, their needless crowding, they express the industrial greed and uncoordinated social necessities of a rapidly multiplying and heterogeneous people One and all, our great cities are—at least superficially—convincing proofs of the terrible power of uncontrolled selfishness."[6]

Herrick's novels attracted wide public notice, but often angered readers, especially Chicagoans, who railed against his characterization of their hometown as an industrial jungle. Yet, to others, including the pragmatist philosopher William James and William Dean Howells, the leading realist writer of the day, Herrick's work deserved high praise. Commenting on the publication of *The Common Lot* (1904) and *The Memoirs of an American Citizen* (1905), two of Herrick's most critically successful urban dramas, Howells exclaimed: "You have attempted and accomplished great things in these books, and it is nothing against you that their lesson of not struggling for mere success, financial or social, will be for the most part lost. You have asked in that too much of our generation, but it is high and brave in you to have asked it."[7] Herrick's reflections on the double-sided nature of success—the theme of these two novels—were consistent with Howells's belief that American writers should delve deeper into the moral complexities that confronted individuals in contemporary society.

Ben-Yusuf photographed Herrick in New York not long before the publication of *The Common Lot*, described by one critic as a "searching analysis of the subtle deterioration of character in a young

Robert Herrick
Zaida Ben-Yusuf
Halftone print published in
The Critic, February 1904
Morris Library, University of Delaware, Newark

Policeman Leading a Man away during the 1904
Chicago Stockyards Strike
Unidentified photographer
Gelatin silver print, 1904 (printed later)
Chicago History Museum

architect of good impulses and training, who not only sells his skill and time, but gradually, and almost unconsciously, also sells himself in order to secure the amount of money which he regards as the one and only evidence of success."[8] Herrick traveled periodically back east to meet with publishers and to conduct other business. This portrait was created on one such trip, most probably to publicize the forthcoming novel. Shown at age thirty-five, Herrick appears polished and assured, qualities that he hoped to convey to eastern readers. Literary magazines often included the photograph in their reviews of the book.

While Herrick cultivated the persona of a stylish man of letters, he was never far from the often troubling episodes that unfolded with regularity in big cities. At times, his novels seemed to comment on the very events that were transpiring on the streets of Chicago. At others, he incorporated elements of these incidents into his fiction. For example, a massive strike by Chicago meat-packers that made national headlines during the summer of 1904—one that led to widespread rioting and subsequent police intervention—shaped Herrick's portrayal of Van Harrington, the lead protagonist in *The Memoirs of an American Citizen*, published the following year. In chronicling Harrington's rise from homelessness to a seat in the U.S. Senate, Herrick portrays him as an underhanded operator in a Chicago meat-packing plant, cutting shady deals and bribing city officials. A critic of the American gospel of success, Herrick created characters that were products of the modern world and its values.

Although Herrick never came to embrace Chicago and the Midwest, he remained at the University of Chicago for thirty years, publishing new work with great regularity, but also traveling widely in Europe and the Caribbean, and setting

up a new home in Maine. Somewhat unpredictably, in 1935 he accepted an offer to serve as the government secretary of the Virgin Islands, a post he held until his sudden death three years later. Far from Chicago, he enjoyed his work and the people he met there. "He was sympathetic with the underprivileged," recalled Harold Ickes, the secretary of the interior under whom he served, and "early won the confidence of the people of the Virgin Islands."[9] Under the warm Caribbean sun, Herrick found a sanctuary from the urban problems that he had chronicled for much of his literary career.

FHG

5 For a good biography, see Blake Nevius, *Robert Herrick: The Development of a Novelist* (Berkeley: University of California Press, 1962).
6 Robert Herrick, "The Background of the American Novel," *Yale Review*, Vol. 3 (January 1914): 224, 228.
7 Quoted in Nevius, 140.
8 Hamilton Mabie, "Some Books of the Season," *Ladies' Home Journal*, Vol. 22, no. 1 (December 1904): 19.
9 "Robert Herrick, 70, Aide of Ickes, Dead," *New York Times* (December 24, 1938): 15.

Sadakichi Hartmann

Art critic
Born Nagasaki, Japan
November 8, 1867–November 21, 1944

"Hartmann may be capricious and malicious and rather careless at times, but he is, after all, the only art critic we have who knows a good picture when he sees it, and who is not afraid of expressing his opinion."[10] At the turn of the century, most artists agreed—some perhaps reluctantly—with this assessment by the American painter Edward Simmons. There were, of course, other critics during this period who regularly wrote about the arts, but it was Sadakichi Hartmann whose erudite prose most influenced the rise of modernism in American painting, sculpture, and photography. While his frank opinions at times upset those about whom he wrote, he maintained a catholic mindset toward the arts, writing about famous and less well-known artists alike. His interest in photography was especially noteworthy, and he did much to encourage the legitimization of photography as a fine art medium.[11]

Ben-Yusuf's own career was greatly bolstered by the attention Hartmann paid her. Indeed, no other writer captured the subtlety of her photography or the unique individuality of her character as well as Hartmann. Having first reviewed her work in *Camera Notes* in January 1899, he remained alert to the prints she submitted to exhibitions in New York and to the career she was fashioning for herself. Hartmann posed for this portrait in the fall of 1898, and thought well enough of it to reproduce it in an essay he wrote on the relationship between portrait painting and photography. About this "fair likeness," he commented, "she got the swing of my body,

although she knew me scarcely an hour then." Ben-Yusuf's ability to capture an individual's likeness "with the simplest means, without applying any special artistic arrangement" was noteworthy to Hartmann, who repeatedly bemoaned the inclination by professional photographers to augment their portraits with hackneyed backdrops and studio props.[12]

Born in Japan, Hartmann was the son of a German government official. He admired photography for, among other reasons, its relative ease and its moderate expense. He believed in the medium's potential as a graphic fine art, yet he also advised that photographers study the principles of composition and cultivate a personal style—preferably one that avoided the overt manipulation of the subject or the resulting negative. This concern for "straight photography" was in part a product of certain relationships he had forged as a young man. His friendships with the poets Walt Whitman, whom he met at age seventeen while living in Philadelphia, and Stéphane Mallarmé, whom he encountered in Paris while working as a newspaper correspondent, instilled in him a respect for direct observation and a style that avoided Victorian excess.

It was Alfred Stieglitz, though, who was most important in cultivating Hartmann's interest in the artistic possibilities of photography. Hartmann met Stieglitz in 1898 and within months began submitting essays to his *Camera Notes*. Hartmann had tried to establish his own art journal on two previous occasions, but both

Sadakichi Hartmann
Zaida Ben-Yusuf
Halftone print from an original of 1898
Special Collections, University of California, Riverside Libraries, Riverside

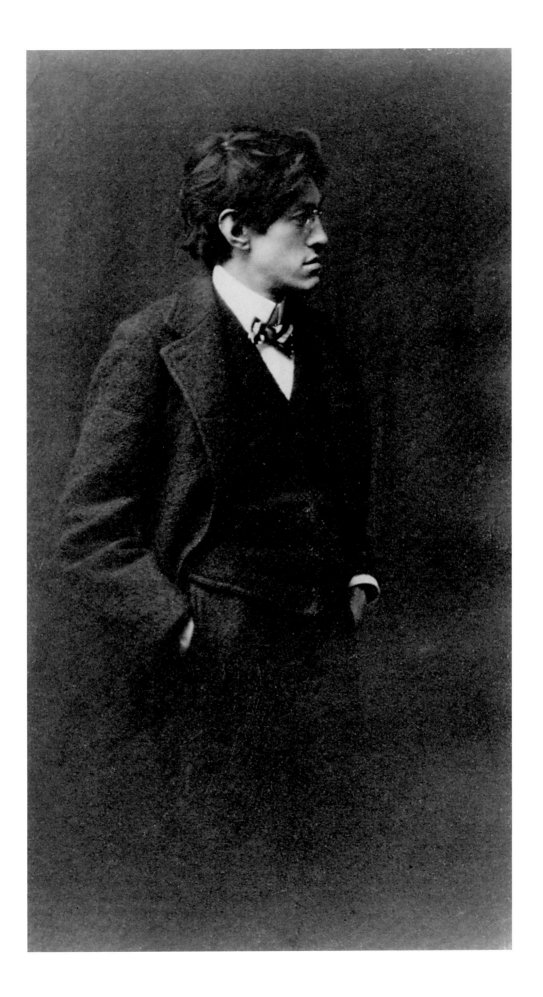

Sadakichi Hartmann
Zaida Ben-Yusuf
Halftone print published in
Photographic Times, October 1899
University of Illinois Library at
Urbana-Champaign

attempts had failed after only a few months. Although the combination of Stieglitz's autocratic manner and Hartmann's sensitive personality precipitated a brief falling-out between the two men in 1904, Hartmann greatly respected Stieglitz's commitment to the fine arts and contributed regularly over a period of fifteen years to *Camera Notes* and later *Camera Work*.

Like Stieglitz, Hartmann encouraged women to involve themselves in the arts. However, believing that women too often imitated men, both longed for female artists to "throw a new radiance over art by the psycho-physiological elements of their sex," as Hartmann declared in 1897. Only by working as a "woman" would a female artist attain "the laurel leaf of fame."[13] What exactly that meant in terms of style and subject matter, Hartmann never explored in detail. Yet, in Ben-Yusuf, Hartmann believed he had encountered one who aspired in that direction. In a profile of her entitled "A Purist," he praised
her prints, describing them as "infused with her personality." While he thought her work uneven at times, "it is doubtful if there is in the entire United States a more interesting exponent of portrait photography than she is." Her "artistic temperament" made her ideally suited to excel in portraiture, Hartmann explained: "She is somewhat a psychologist, ever on the alert, ever

seeking to grasp and to express in material form the characteristics of her subjects."[14] Hartmann and Ben-Yusuf remained in contact with each other years after their initial meeting in 1898.

Until poor health forced him in 1911 to resettle away from the city, Hartmann was the most prolific and wide-ranging author in the New York art world. Such books as his two-volume *A History of American Art* (1902), *Modern American Sculpture* (1902), and *Japanese Art* (1904) consolidated his position of authority as a critic. Yet Hartmann was more than simply an observer of the often radical transformations occurring in the fine arts during this period. In championing many of the era's most progressive artists, and such new artistic media as photography and, later, film, he helped to shape important developments in modernist aesthetics. His interest in promoting a uniquely national art also contributed to the growing acceptance of American artists on an international stage. New York's centrality as a twentieth-century art capital owed much to Hartmann and his spirit of creative possibility.

FHG

10 Quoted in Alexander Horr, "Sadakichi Hartmann as a Photographic Writer," *The Photo-Beacon* (1904): 304–308.
11 For an overview of Hartmann's career and a rich collection of his writings, see Jane Calhoun Weaver, ed., *Sadakichi Hartmann: Critical Modernist* (Berkeley: University of California Press, 1991).
12 Sadakichi Hartmann, "Portrait Painting and Portrait Photography," *Camera Notes*, Vol. 3, no. 1 (July 1899): 19.
13 Sadakichi Hartmann, "Nineteenth Exhibition of the Society of American Artists," *Art News*, Vol. 1, no. 3 (May 1897): 3.
14 Sadakichi Hartmann, "A Purist," *Photographic Times*, Vol. 31, no. 10 (October 1899): 449, 451–52. Hartmann was less enthusiastic about the second photograph that Ben-Yusuf created of him on this occasion, declaring, "the position of the head, bending forward, was so peculiar that nine out of ten of my acquaintances asked me if I had lately become a bicycle fiend, for the picture looked very much as if it had been taken by a snapshot when I was scorching away from some picture exhibition which had done its best to make me melancholy." Hartmann, "Portrait Painting and Portrait Photography," 14.

Robert Henri

Artist, teacher
Born Cincinnati, Ohio
June 24, 1865–July 12, 1929

George Bellows, a fellow Ashcan School artist, once explained Robert Henri's influence on his own work: "No one who has not felt the magnetic power of Henri, when he had before him an audience of ambitious students hungry for the master's moving words, can appreciate the emotional devotion to art which he could inspire as could no other teacher."[15] Robert Henri was an accomplished artist and a revolutionary iconoclast, but his most lasting contribution to American art was as a teacher. Through his classes, he inspired a generation of artists to turn from the meticulous mannerism of the nineteenth century to the exuberant realism of the twentieth.[16]

Robert Henri was perfectly suited to an age that spurned Victorian refinement for a celebration of authentic experience and rugged masculinity. Born Robert Henry Cozad, he moved as a child from Cincinnati to Cozad, Nebraska, a town founded by his land-speculating father. After his father shot an employee over a gambling debt, the family fled to Atlantic City, changing their names along the way. Robert simply dropped Cozad and changed the spelling of his middle name, although he insisted that the proper American pronunciation was "Hen-rye."

In 1886, Henri was admitted to the Pennsylvania Academy of the Fine Arts in Philadelphia, only a semester after Thomas Eakins's retirement from the faculty. He studied with Thomas Hovenden and Thomas Anshutz, but Eakins's influence, with its emphasis on the study of anatomy, persisted. Henri's brother, Frank Southrn, was also in Philadelphia, studying to be a doctor. Southrn allowed the young painter to observe operations and autopsies, deepening his understanding of the human form. Henri remained fascinated with the human figure throughout his career and would eventually devote himself to portrait work.

For the next few years Henri moved between studying in Paris and teaching in Philadelphia, but in 1900 he and his wife, Linda Craige, settled in New York, where his work attracted critical attention and earned him repeated solo exhibitions. However, teaching remained a more reliable source of support, so in 1902 he joined the faculty of William Merritt Chase's New York School of Art. His classes brought to New York the former Philadelphia students John Sloan, George Luks, William Glackens, and Everett Shinn, all of whom had worked previously as newspaper illustrators. There they met and befriended such new classmates as Rockwell Kent, George Bellows, and Edward Hopper. So much talent in one studio was bound to result in rivalry, even jealousy, but all that was suspended when Robert Henri taught. Rockwell Kent later remarked: "As an inspirational influence in American art, [Henri] is possibly the most important figure of our cultural history."[17]

Henri urged his students to explore their neighborhoods, their city, and their country, and to translate that experience into their work: "The object, which is back of every true work of art, is the attainment of a state of being, a state of high functioning, a more than ordinary moment of existence."[18] He exhorted them to turn from the conventionally beautiful and to paint scenes of city life. Critics who found these subjects dreary and depressing missed the point: Henri's students sought to celebrate the vitality of the city, not to expose its seediness.

Ben-Yusuf's photograph of Robert Henri was published in the journal *American Art News* only two weeks before Linda Henri's death.[19] She had not been well for several years, but her loss devastated Henri. He collapsed and was taken in by his former student John Sloan, who taught his classes, while Sloan's wife, Dolly, nursed him back to

health. Ben-Yusuf's photograph does not hint at the grief to come. Henri's hair is neatly combed, and he wears a well-cut tweed jacket. Ben-Yusuf suggests his artistic nature by having him gaze dreamily to the right—an effect deepened by the almond-shaped eyes that lend an exotic touch to his appearance. Although Henri figures himself as a wild-haired and disheveled terror in his self-portrait of 1904 (page 154), Ben-Yusuf presents him as a respectable man of vision and action.

Henri would have approved of the portrait's minimal background. He advised students that "from my point of view the simpler a background is the better the figure in front of it will be, and also I will add, the better the figure is the less the observer will need entertainment in the background."[20] He would have endorsed Ben-Yusuf's professional ambitions. He had taught at the Philadelphia School of Design for Women and continued to teach women's classes in New York. His second wife, Marjorie Organ, was a popular comic artist. Although his classes for men were bastions of masculinity—students competed to see who could hook their fingers over the door frame and do the most pull-ups—Henri urged both men and women to become artists.

In spite of Henri's innovative theories, his essentially conservative subjects—he was painting mostly portraits and seascapes—earned him the endorsement of the established art world. In 1903, he was elected to the Society of American Artists, and in 1906 he accepted membership at the National Academy of Design, where he became a juror for its annual exhibition a year later. When his fellow jurors refused to accept submissions from some of his most talented students, he withdrew his own work and organized a separate show. The exhibition of The Eight—Henri, Shinn, Luks, Glackens, Sloan, as well as Ernest Lawson,

Robert Henri
Zaida Ben-Yusuf
Platinum print, *c.* 1905
20 × 14.9 cm (7⅞ × 5⅞ in.)
Delaware Art Museum, Wilmington

Arthur B. Davies, and Maurice Prendergast—opened in May 1908. Although some of the artists had little in common and never exhibited as a group again, the show was seen as an important disruption of the artistic *status quo*, and its participants as avant-garde.

The impetus for change was clearly part of the American art scene at the turn of the century. Robert Henri did not create it, yet his influence reverberated through others' lives. Hopper, celebrated for his American scenes, later said of Henri: "No single figure in recent American art has been so instrumental in setting free the hidden forces that can make of the art of this country a living expression of its character and its people."[21]

EOW

15 Quoted in Bennard B. Perlman, *Robert Henri: His Life and Art* (New York: Dover Publications, 1991): 64.

16 Important writings about and by Henri include Robert Henri, *The Art Spirit* (New York: J.B. Lippincott Company, 1923); William Inness Homer, *Robert Henri and His Circle* (Ithaca, NY: Cornell University Press, 1969); and Perlman.

17 Rockwell Kent, *It's Me O Lord* (New York: Da Capo Press, 1977): 81.

18 Henri, 159.

19 "Among the Artists," *American Art News*, Vol. 4, no. 7 (November 25, 1905): 3.

20 Henri, 41.

21 Edward Hopper, "John Sloan and the Philadelphians," *The Arts* (April 1927): 174.

Self-portrait
Robert Henri
Crayon drawing, 1904
National Portrait Gallery,
Smithsonian Institution,
Washington, D.C.

Everett Shinn

Artist
Born Woodstown, New Jersey
November 6, 1876–May 1, 1953

For more than fifty years, Everett Shinn drew inspiration from the extraordinary energy and tensions of New York City. His art was about the changing face of the city—the rise of the built environment, the emergence of new transportation systems and leisure activities, and the changing fortunes of the city's rich and poor. In his paintings and pastels, the streets, city parks, markets, and theaters of the bulging metropolis teem with activity. The modern city was noteworthy to him for its public spaces and the individuals who did not simply traverse them, but brought them to life. The literal movement of people served as a metaphor for the larger transformations that characterized turn-of-the-century New York.

Ben-Yusuf's evocative portrait of Shinn pictures the artist in his mid-twenties, during the period when he was first emerging as an important figure in the New York art world. A variant of this photograph was published in *The Critic* in March 1901 to accompany a review of Shinn's exhibition of pastels at the Fifth Avenue gallery of Boussod, Valadon & Co. Proclaiming that Shinn was "fast gaining vogue," this magazine writer noted that "his delicate and somewhat fanciful art is clearly to be reckoned with."[22] Such praise helped to catapult Shinn—despite his young age—into the ranks of New York's artistic elite.

Only four years earlier, Shinn had been working as a newspaper illustrator in Philadelphia and attending classes periodically at the Pennsylvania Academy of the Fine Arts. The son of a bank teller, he initially held a design job at the Thackeray Gas Fixture Works in Philadelphia, where he reputedly drew one of the first plans for a rotary engine.[23] After being fired from this position for sketching street scenes while at work, he devoted himself to his interest in art. Shinn enjoyed the lively company of a group of young artists then in Philadelphia, including Robert Henri, George Luks, and John Sloan, each of whom also supplied illustrations to the city's papers. As one could earn more money drawing for the press in New York, Shinn moved there in late 1897. Several months later, he married the Philadelphia artist Florence Scovel, a member of the socially prominent Biddle family. Relocating to New York also allowed him to move further from her family, many of whom thought little of him.[24]

In New York, Shinn thrived, supplying a steady stream of illustrations to various newspapers and magazines, and executing an independent series of pastel and watercolor cityscapes entitled *New York by Night*. By 1899, he had mounted his first one-man exhibition at Boussod, Valadon & Co., and had risen to the position of art editor at *Ainslee's Magazine*. His career was aided by support from members of the cultural elite, such as playwright Clyde Fitch, actress Elsie de Wolfe, and architect Stanford White, each of whom purchased examples of his work. It was White's recommendation that confirmed Shinn's relationship with the owners of Boussod, Valadon & Co. and prompted the gallery to underwrite a portion of the expenses associated with the artist's first trip to Europe in 1900. There Shinn created a substantial new body of work, the highlights of which were featured at the gallery the following year.

Ben-Yusuf photographed Shinn some time soon after his return from Europe in the fall of 1900. This image demonstrates her commitment to thinking anew about the genre of portrait photography. Not only has she done away with a decorative backdrop and minimized the number of studio props, but she has also posed her subject in a decidedly unconventional manner. Shinn has his left elbow on the surface of a table. He leans

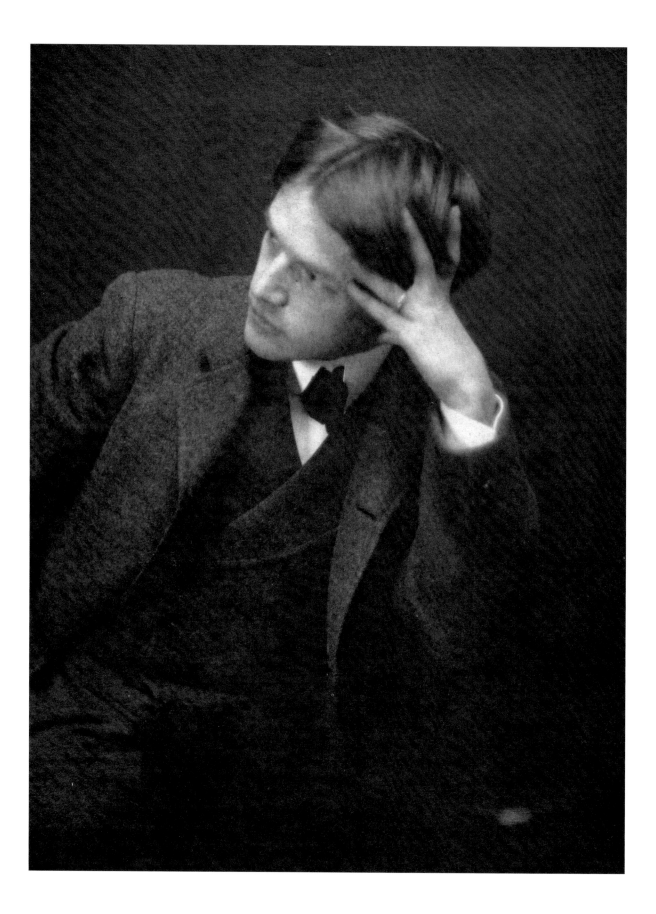

slightly forward and rests his turned head on his left hand. His fingers extend in different angles across the side of his head. The manner in which Ben-Yusuf captures this hand anticipates Alfred Stieglitz's study of hands more than fifteen years later as a means of expressing elements of an individual's inner character. Through this composition, Shinn's identity as a pensive and bohemian artist is readily conveyed.

A pastel self-portrait (right) that Shinn created during this same period bears striking similarities to this work by Ben-Yusuf. In both images, the artist wears a dark suit and turns his head in such a manner as to avoid direct eye contact. Also, by removing the figure from a recognizable context, each artist has emphasized the portrait's immediacy. Shinn had grown increasingly interested in the theater since coming to New York, and often socialized in the company of theatrical professionals. He inscribed his brooding self-portrait to Julia Marlowe, an actress whom he admired greatly. Ben-Yusuf's evocative photograph shares with this pastel the sense that it was created as a private gesture.

At the time when these two images were created, Shinn was at the beginning of his artistic career. Although he would make new work until his death in 1953, he is perhaps best remembered as one of the "Eight Men of Rebellion," who in 1908 united to stage a group exhibition at the Macbeth Galleries in protest at the conservative policies of the National Academy of Design. Their exhibition—and the controversy that ensued—signaled an important shift in a larger campaign to legitimate the work of a new generation of thoroughly modern artists. Later referred to as the "Ashcan School," for their embrace of a dark palette and their desire to depict the city in a realistic manner, this group was representative of

the broad changes that were occurring throughout New York at the beginning of the new century. Shinn was ultimately more than a *flâneur* rendering impressions of the place in which he lived. His work helped to transform how others understood the city, and his involvement with different galleries and cultural institutions contributed to New York's vitality as a center for the arts in America.

FHG

22 "The Lounger," *The Critic*, Vol. 38, no. 3 (March 1901): 197.
23 "Everett Shinn, 79, Noted Artist, Dies," *New York Times* (May 3, 1953): 89.
24 For a fuller study of Shinn's life and art, see Janay Wong, *Everett Shinn: The Spectacle of Life* (New York: Berry-Hill Galleries, 2000); and Edith DeShazo, *Everett Shinn, 1876–1953: A Figure in His Time* (New York: Clarkson N. Potter, 1974).

Self-portrait, Everett Shinn
Pastel on paper, 1901
National Portrait Gallery, Smithsonian Institution, Washington, D.C.

29.

Portrait of Miss S.

"Here there could be no mistaking the predominance of personality—the unanimous 'Oh!' of the spectators was a tribute, not to the brush-work of Reynolds's 'Mrs. Lloyd' but to the flesh and blood loveliness of Lily Bart." Thus, in her novel of New York society, *The House of Mirth* (1905), Edith Wharton described the first appearance of the beautiful Lily Bart at an evening of *tableaux vivants* performances. Like Bart, who "stepped, not out of, but into, Reynolds's canvas, banishing the phantom of his dead beauty by the beams of her living grace,"[25] the subject of Ben-Yusuf's *Portrait of Miss S.* has similarly stepped into the pose and costume of an alluring female figure. Ben-Yusuf reveals neither the name of her subject—beyond the tantalizing appellation Miss S.—nor the character she assumes, though the unusualness of her outfit suggests that she possibly enacts the role of a character from a work of art, literature, or theater. Does Miss S. perform the part of Aphrodite, Salome, or Judith—three beautiful women whose stories were well known at the turn of the century—or does she pose without a specific source in mind? No record exists to shed light on her identity or the circumstances behind this portrait's creation.

What Ben-Yusuf's image does reveal is a commitment to the long tradition of individuals using portraiture to construct a public persona— one that may or may not have much in common with their private character. Artists are active collaborators in this work, responding to and shaping the identity of their subjects, and Ben-Yusuf's *Portrait of Miss S.* is another example of the photographer's fascination with the outcomes of these exchanges. Although little is known about Ben-Yusuf's subject, much can be perceived based on the appearance Miss S. presents in this photograph. Above all else, her provocative

Portrait of Miss S.
Zaida Ben-Yusuf
Platinum print, c. 1899–1900
21.6 × 11.4 cm (8½ × 4½ in.)
National Museum of American History,
Behring Center, Smithsonian Institution,
Washington, D.C.

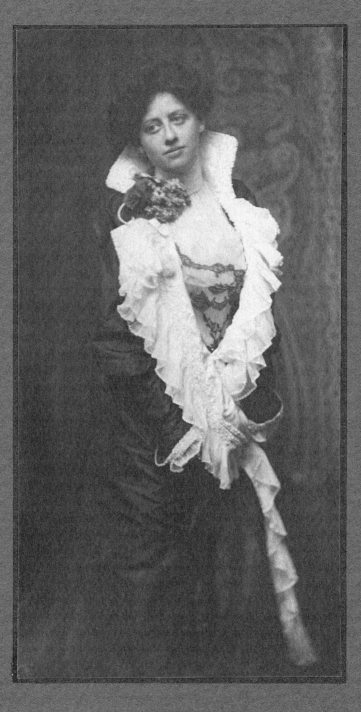

costume signals a desire to be recognized as a member of New York's bohemian set. Wearing a low-cut patterned lace dress and a high-collared, full-length cloak with pleated fringe, she stands out for her choice in fashion. Her alluring pose and facial expression complement this exotic outfit well. At this date, only a daring and independent woman would have chosen to be photographed in this manner.

While most women in turn-of-the-century New York subscribed to the prevailing fashions of the times, there arose a small and increasingly visible set that preferred "artistic dress," a style first associated with the British Aesthetic and Arts and Crafts movements. Equating restrictive clothing with limits on one's freedom, these women embraced dress reform as one part in their larger campaign for equality. The introduction of trousers and the elimination of corsets were hallmarks of a movement that was as much about health and gender politics as it was about beauty.[26] Self-consciously flamboyant, the outfit that Miss S. wears is in part an outgrowth of the changes in the world of women's fashion and is symptomatic of the enhanced freedoms—professional, political, and sexual—that many women sought during this period.

Ben-Yusuf was clearly pleased with the resulting portrait, as she chose to include it along with four other photographs in the exhibition of American women photographers that Frances Benjamin Johnston organized for the Paris Exposition of 1900. On the reverse of the print's mount, her signed instructions to the exhibition's framer—a rare instance in which Ben-Yusuf provided this type of direction—further indicate her regard for this particular print: "The <u>frame</u> <u>maker</u> is requested <u>not</u> to change the proportions of the mat. It should be left <u>exactly</u> the same as now is."

Perhaps not surprisingly, given the public outrage that often confronted the campaign for women's rights, much controversy surrounded the introduction of such new women's fashions as "artistic dress." Such critics as the economist Thorstein Veblen, for example, ridiculed the entire fashion industry as an example of conspicuous waste, most famously in his treatise of 1899, *The Theory of the Leisure Class*. Despite this and other charges, Ben-Yusuf was herself squarely among those who favored innovative forms of women's dress and new modes of feminine self-expression. As her self-portrait of 1901—an image that was published on repeated occasions in popular periodicals—reveals (opposite), Ben-Yusuf enjoyed dressing up in new fashions. The freedom to exhibit herself in a pose suggestive of her sexuality was not simply "an amusing experiment," as she described it in the *Saturday Evening Post*, it was also a liberating act.[27]

Ben-Yusuf's *Portrait of Miss S.* represents a woman not unlike herself. Courageous in transgressing the boundaries of conventional society, she epitomizes the ideals of the New Woman. Whether in their choice of career, social behavior, or fashion, this community of risk-taking women broke new ground. Yet the results of their efforts were at times mixed, for, like Edith Wharton's Lily Bart, many failed in their effort to transcend the obstacles that society placed before women as a whole. It is not known what became of Miss S. In Ben-Yusuf's portrait of her, though, one gets a glimpse at the promise of a new age for women.

FHG

25 Edith Wharton, *The House of Mirth* (New York: Charles Scribner's Sons, 1905): 134.

26 For a study of the dress reform movement, see Patricia Cunningham, *Reforming Women's Fashion, 1850–1920: Politics, Health, and Art* (Kent, Oh.: Kent State University Press, 2003).

27 Zaida Ben-Yusuf, "Advanced Photography for Amateurs," *Saturday Evening Post*, Vol. 174, no. 36 (March 8, 1902): 5.

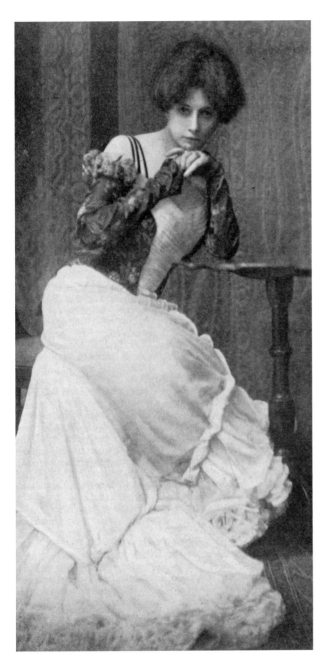

Self-portrait
Zaida Ben-Yusuf
Halftone print published in
Metropolitan Magazine, September 1901
Library of Congress, Washington, D.C.

Olive Mead

Violinist
Born Cambridge, Massachusetts
November 22, 1874–February 27, 1946

At a time when female musicians rarely had the opportunity to move beyond the domestic parlor, the violinist Olive Mead was one of a pioneering group of women who sought to perform before the public. During the nineteenth century few American women had succeeded in overcoming the prejudices that female musicians faced in their pursuit of a wider audience. Often ridiculed or simply ignored, many were forced to let go of their larger musical ambitions. Despite this unwelcome climate, Mead nurtured a public performing career that lasted more than twenty years. In a magazine profile, she cited hard work and preparation as key to the success of the quartet she founded in 1903. Mead was speaking to both women and men in the world of classical music when she exclaimed: "If others worked as hard they would probably be as successful. The trouble is, other quartette players are not willing to do what we do, practice three hours together every day. It took me a long time to get together players who had all the qualifications necessary, in fact we practiced a whole year before we ever appeared in public."[28]

Ben-Yusuf's portrait of Mead was taken a year or two after the violinist had created the Olive Mead Quartet—one of the earliest all-female string quartets in America.[29] Together with her partners Lillian Littlehales, Gladys North, and Vera Fonaroff, Mead traveled throughout the United States, performing in halls large and small. Reviews suggest that the quartet was almost universally well received. Not surprisingly, their all-female make-up frequently invited comment, and often framed the manner in which their performances were reviewed. At times they were complimented by being described as playing like or as well as men; yet, as the following review from the *New York Times* in 1905 indicates, they could also be held up as an example for men to emulate. In

Olive Mead
Zaida Ben-Yusuf
Halftone print published in
Photo-Era, May 1905
Smithsonian Institution Libraries,
Washington, D.C.

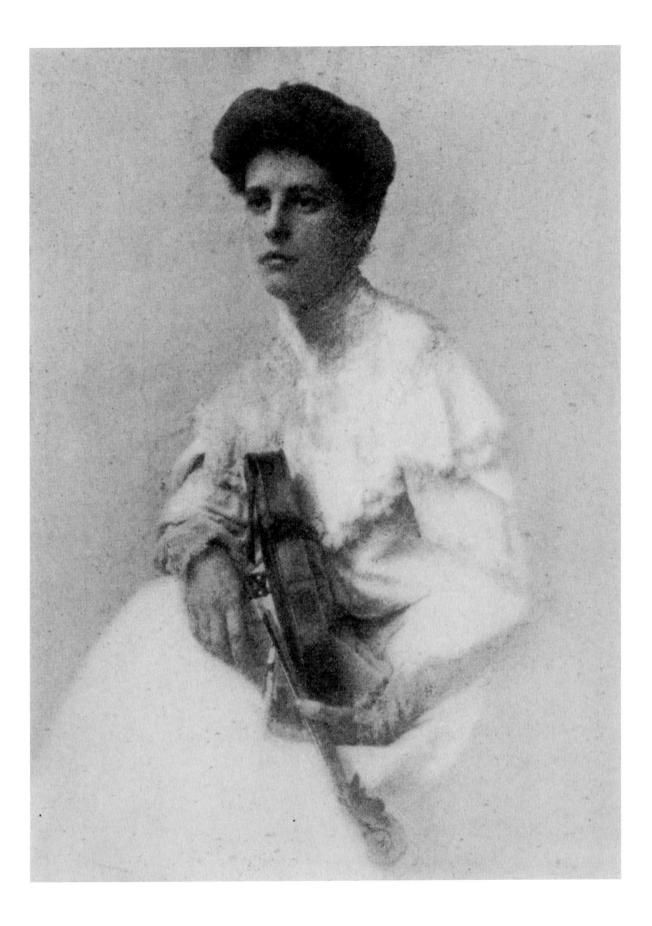

describing a concert at New York's Mendelssohn Hall, the critic wrote: "They have already set a standard that none of their masculine competitors in the domain of chamber music are in the habit of reaching, and the seriousness with which they approach their task, the hard work they have devoted to it and the uncommon skill, intelligence, and musical feeling with which they approach it, were delightfully in evidence last evening."[30]

Mead grew up in a Boston household where, as she related in 1905, "music was our life. My father was a violinist, my mother gave music lessons, my sister was a professional cellist and I played the violin as early as seven years and the piano before that."[31] As she grew older, she studied with outside instructors, including most importantly Franz Kneisel, one of the premier violinists of the day. Having come to America from Romania in 1885, Kneisel brought with him skills that were unmatched in the United States and an international cachet that inspired the ambition of his pupils. With Kneisel's support, Mead made her concert debut at Boston's Steinert Hall in 1894. Three years later, she traveled with him on an international tour that consolidated her growing reputation and led to frequent invitations to perform as a soloist with the Boston Symphony Orchestra.

Because New York was emerging as the most thriving city in America for classical music, Mead relocated there at the turn of the century. With a greater number of performing venues and a larger

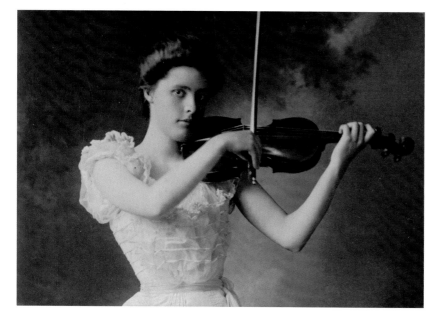

Olive Mead
Bartlett F. Kenney
Gelatin silver print, *c.* 1905
The Love Family Papers,
Irving S. Gilmore Music Library,
Yale University, New Haven, Connecticut

audience, the city enabled her to concentrate exclusively on her musical career. Yet, as she remarked nostalgically, her adopted home lacked the warmth and intimacy of the place where she grew up: "Boston is delightful to live in, but New York is necessary for work. I remember when I first came to New York the business aspect of everything simply amazed me, in fact in a measure disheartened me, for at home everything had been for art. . . . When I came to New York I met hardly anyone who wanted to play for the love of it; they all asked, 'Is there any chance for business?'"[32]

Nevertheless, New York provided Mead with opportunities that she could find in no other American city. In addition to leading the Olive Mead Quartet, she also served for a time as the conductor of the orchestra of the Women's Philharmonic Society of New York. This organization served as an important institution for female musicians, and, though she managed her own group, she also made time to participate in their concerts and outreach activities, including efforts to bring music to lower-income communities traditionally under-served by arts organizations.

While it is unknown whether Mead played a role in the campaign for women's suffrage—a movement that culminated in the passage of the Nineteenth Amendment to the Constitution in 1920—like many young women of her generation, she embraced her feminine independence. Although she married, she never abandoned her maiden name during the years when she was performing. Refusing to be defined or limited by others, she carved out a successful career that allowed her to reach a level of prominence that few female musicians had achieved before. In their respective professions she and Ben-Yusuf were

much alike. Comparing Ben-Yusuf's portrait of Mead with another of her by a commercial photographer in Boston (opposite), one senses Ben-Yusuf's respect for Mead as a woman and a musician. Her composition lays emphasis on Mead's individuality and pays equal attention to both her graceful bearing and her chosen occupation. To Ben-Yusuf, Mead is more than simply a gifted violinist; she is an accomplished woman whose pursuit of excellence as a musician merits admiration.

FHG

28 "A Chat with Olive Mead," *Musical America*, Vol. 5, no. 25 (May 4, 1907): 11.
29 A letter to the photographer F. Holland Day indicates that *Photo Era* initially approached Day about photographing Olive Mead for a special issue "devoted exclusively to musical celebrities of American birth." The violinist was performing in Boston in February 1905, yet Day—whose studio had been destroyed in a fire three months earlier—declined this invitation. Ultimately, it was Ben-Yusuf's portrait of Mead that *Photo Era* published in this special issue. Photo Era Publishing Co. to F. Holland Day, February 25, 1905, letter in the F. Holland Day Papers, Archives of American Art, Smithsonian Institution.
30 "The Olive Mead Quartet," *New York Times* (January 6, 1905): 5.
31 "A Chat with Olive Mead," 11.
32 *Ibid.*

The
New York Stage

At the beginning of the twentieth century, New York City supported no fewer than thirty reputable theaters, making it far and away the most important center for the dramatic arts in America. In the coming decades, the number of theaters and patrons who frequented them would continue to increase steadily. This success was in part a product of the city's economic and population growth. Yet it was also the result of changes within the theater industry. The introduction of electricity at the Lyceum Theater in 1885 ushered in a new era, as did innovations in the realm of set design and methods of acting. Perhaps most important to the theater's growth was the revolution then unfolding in the larger world of celebrity culture. Big-name stars had long dominated the New York stage; however, the proliferation of illustrated publications that chronicled the lives of actors and actresses only heightened their profile during this period. Photographic portraiture played a key role in furthering this visibility, and few within the theater community were reluctant to pose for the myriad commercial photographers at work in New York, many of whom established studios within or not far from the theater district. Ben-Yusuf was among those who took advantage of the demand for such portraits, and reproductions of her images appeared regularly in newspapers and magazines. Yet, unlike the vast majority of celebrity photographers, she was less interested in marketing her photographs to a mass audience and more concerned with creating likenesses that captured a subject's individuality in a style that was modern, not melodramatic.

Augustin Daly

Theater producer, playwright
Born Plymouth, North Carolina
July 20, 1838–June 7, 1899

"Daly was everything: he could write plays; he
could produce them; he probably could have acted
them if he had wanted to. At any rate, he could tell
others how to act, and his theatre was the best
school of acting that America has known."[1] This
tribute in *The Critic* was characteristic of the
celebratory memorials that followed Augustin
Daly's death in 1899. Having produced his first play
when he was only seventeen, Daly had spent his
entire adult life in the world of the theater. While
others preceded him in establishing New York as
a venue for reputable drama, Daly was influential
not only in elevating standards for theatrical
production, but also in reshaping important
elements of it. His innovative work as a director—
in rethinking methods of acting and in reimagining
stage scenery and lighting—helped make American
theater modern.

Ben-Yusuf photographed Daly only a year
before his unexpected death at age sixty. Given the
theater's centrality in his life, it is appropriate that
his office was the setting for this portrait session.
Daly's zeal for the dramatic arts took hold when he
was a teenager. After the death of his father, when
Augustin was three, his mother moved the family
from North Carolina to New York City. There
Daly and his older brother Joseph were drawn
to the theater. School became increasingly
unimportant, and by the age of sixteen Augustin
Daly's formal education had come to an end. More
interested in writing and producing theatrical
performances than in acting in them, he staged
a wide range of shows, from adaptations of
Shakespearian classics to melodramatic potboilers,
one of the most memorable of which was *Under the
Gaslight* (1867), a work notable for the dramatic
rescue of its hero—a wounded Civil War veteran
who has been tied to railroad tracks—from an
onrushing train.

Augustin Daly
Zaida Ben-Yusuf
Platinum print, 1898
24.1 × 12.4 cm (9½ × 4⅞ in.)
The Harvard Theater Collection,
Houghton Library, Harvard University,
Cambridge, Massachusetts

Daly opened his own theater, the Fifth Avenue, in 1869, but was forced to sell it to pay debts in 1877. The opening of Daly's Theater at Broadway and Thirtieth Street two years later heralded a new chapter in his career. Over the next two decades it would become recognized as one of the most important theaters in New York, in part because of the popularity of the productions he staged, but also because of his creative priorities. Daly's commitment to more naturalistic performances amid realistic settings represented a sea change in American dramatic productions. While he recruited theatrical stars to appear from time to time, he relied most often on his own stock company. Such figures as John Drew and Ada Rehan became household names under his direction. Though some critics complained of his preference for French and German plays, few failed to recognize his unrivaled place in the New York theatrical world.

Ben-Yusuf's studio had been open only a year when she began working with Daly. At the time, many photographers in New York specialized in portraiture of stage stars, and Daly's actors and

Augustin Daly
Zaida Ben-Yusuf
Platinum print, 1898
The Harvard Theater Collection,
Houghton Library, Harvard University,
Cambridge, Massachusetts

actresses regularly posed for many of them. Yet, in 1898, Daly began directing his company to Ben-Yusuf's studio. No reasons are known for this, but one can speculate that he admired the distinctive quality of the photographs she was producing. Unlike most studios, Ben-Yusuf created individualized poses for her sitters and employed the higher-quality platinum printing process for her portraits.

In addition to photographing members of his company, Ben-Yusuf arranged an occasion to photograph Daly at his Broadway office. In one image, he sits at his desk, wearing a felt hat and a dark suit. In a second view, he stands before the office fireplace with his hands in his pockets and his beloved bulldog, Phisto, at his side.[2] In both portraits, he strikes the pose of a well-seasoned professional. Although Daly spent generously on his productions and on his collection of rare books, he was also renowned for dressing in a modest fashion. "He always looked the working manager. I don't think I ever saw him in a dress suit. It was the same sack coat, the same felt hat, and the same Mr. Daly," exclaimed one critic, who declared that Ben-Yusuf's portrait of the seated producer was "the best likeness of Mr. Daly that I have seen."[3] Joseph Daly agreed about the importance of this portrait, making it in 1917 the frontispiece of his biography of his younger brother.

Ben-Yusuf admired Daly greatly. His efforts at directing business her way were only part of the reason she warmed to him. Calling him "one of the most interesting men I have known," she mentioned in a later article the fondness with which his company regarded him and the creative energy that he brought to his work. Ben-Yusuf also wrote about a specific portrait session he attended, recalling how "he was very much interested in what I was doing and moved furniture about and helped arrange backgrounds. I believe he even sat beside me on the floor, once, to look for an effect I was trying to get."[4] Ben-Yusuf was clearly pleased with the resulting images, as she submitted Daly's portrait in the fall of 1898 to both the London Photographic Salon and the photographic exhibition sponsored by the American Institute at the National Academy of Design.

In Daly, Ben-Yusuf met a man whose passion for the theater was equivalent to her own interest in photographic portraiture. As *Harper's Weekly* exclaimed at his death, "He was a very important man in New York, for we have been used for many years to look to him, more than any other man, for theatrical performances in which persons of polite tastes could find entertainment. Beyond doubt he was the leading manager of his day in this country."[5]

FHG

1 "The Lounger," *The Critic*, Vol. 35, no. 865 (July 1899): 579.
2 Daly's fondness for this dog merited occasional coverage in the New York papers. "Mr. Daly and His Dog," *New York Times* (March 14, 1887): 5; and "Strayed from Daly's Theatre," *New York Times* (January 27, 1895): 8.
3 "The Lounger," 579–80.
4 Zaida Ben-Yusuf, "Celebrities Under the Camera," *Saturday Evening Post*, Vol. 173, no. 48 (June 1, 1901): 14.
5 "Augustin Daly," *Harper's Weekly*, Vol. 43, no. 2217 (June 17, 1899): 593.

32.

Ada Rehan

Actress
Born Limerick, Ireland
April 22, 1857–January 8, 1916

Of the many actors and actresses who strode the
boards at Daly's Theater, no figure became more
famous than Ada Rehan. During a period when
theatrical stars were increasingly leaving stock
companies to forge independent careers, Rehan
devoted almost her entire acting career to those
plays directed by Augustin Daly. Although others
encouraged her at times to leave his company,
she remained committed to him. Close friends,
the two complemented each other well. Both
possessed abundant energy, versatility, and
professionalism; above all else, both were consumed
by the theater and worked tirelessly to infuse it
with spark and originality.[6]

In twenty years with Daly, Rehan performed
more than two hundred roles. While much praised
in contemporary farces and romantic melodramas,
she is best remembered for her work in
Shakespearian dramas. In nineteenth-century
America, Shakespeare's plays were revered, and an
actor's or actress's renown was often measured by
the ability to interpret and perform his celebrated
characters. In this regard, Rehan excelled. Her
portrayals of his comic heroines especially—such
figures as Rosalind in *As You Like It*, Viola in *Twelfth
Night*, and Katharina in *The Taming of the Shrew*—set
the standard for the period. Even in England and
throughout Europe, where Daly's company toured
on eight separate occasions, Rehan received high
praise and attracted a wide following.

Ben-Yusuf photographed the famous actress
in the fall of 1898 to publicize her appearance as
Portia in that season's production of Shakespeare's
The Merchant of Venice. As she did in almost all of
her portraits of theatrical celebrities, Ben-Yusuf
presents Rehan in costume, posing in the manner
of the character she was then portraying. It is
not known whether this and at least one other
photograph of Rehan were taken in Ben-Yusuf's

Ada Rehan
Zaida Ben-Yusuf
Halftone print published in
Harper's Weekly, December 24, 1898
Private collection

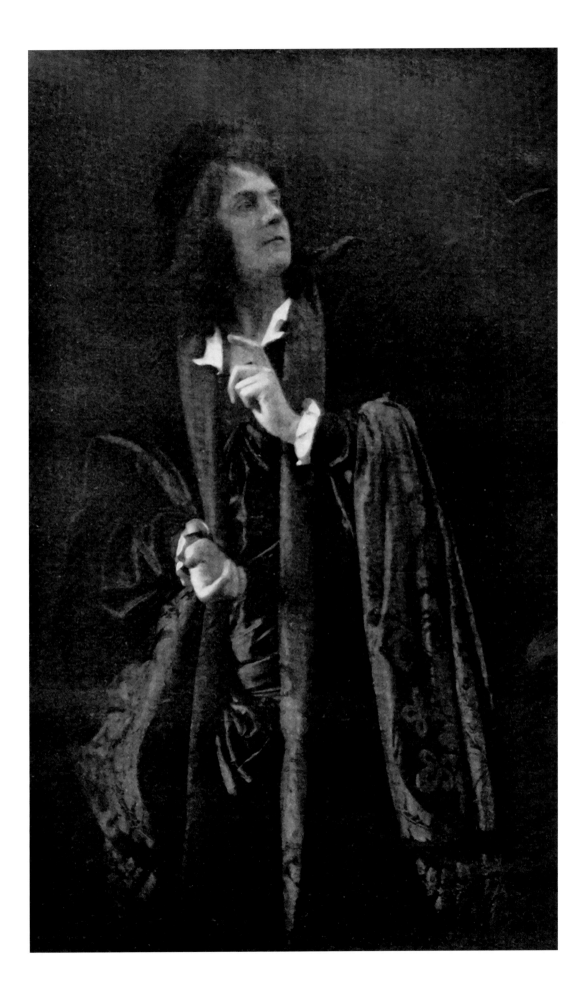

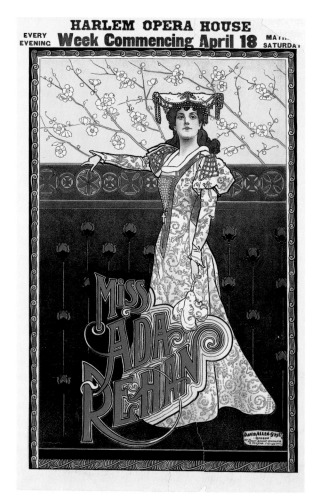

Ada Rehan
David Allen & Sons, Ltd.
Chromolithographic poster, 1895
National Portrait Gallery, Smithsonian
Institution, Washington, D.C.;
gift of Mr. and Mrs. Leslie J. Schreyer

studio, at Daly's Theater, or somewhere else. Whatever the case, the two worked together to recapture a pose from the climactic trial episode at the play's end. In this scene, Portia disguises herself as a young lawyer named Balthazar, in order to defend a friend who is unable to repay a loan and faces the prospect of losing a pound of his flesh. When pleading for mercy does not work, she outwits Shylock, the man to whom the money is owed, and wins the case. Ben-Yusuf and Rehan both bring their skills to bear in portraying Portia's intellectual self-command and the dramatic tension of the moment.

Rehan had never before played Portia, and critics and audiences alike were eager to see her performance. According to reviews, the play was a triumph. Critics commented in particular on the originality of Rehan's interpretation, especially evident in the famous trial episode. As John Corbin of *Harper's Weekly* observed, rather than entering the scene with "an air of conscious power," Rehan's Portia "expresses doubt of the outcome of the suit, and anxiety for her friends." She gave "the scene an intensity of emotion more dramatic than any previous actress, to my knowledge, has given it. Because of this intelligence in conceiving dramatic effects and in expressing them, Miss Rehan's Portia not only marks the highest point yet attained in the development of her powers, but is absolutely the most original and interesting interpretation of the part of recent years."[7] Ben-Yusuf's portrait accompanied this and at least one other review at the time.

In Rehan, Ben-Yusuf discovered a woman who resembled her in some respects. Rehan was an immigrant who came to America at age five and pursued acting partly as a way to make ends meet. Discovered by Daly and signed to his company in 1879, she had to work hard to attain lead roles and

to build a reputation. She did not marry, but instead dedicated much of her life to her profession, performing and touring with Daly almost every season. Like Ben-Yusuf, she was a woman who saw in her work the opportunity to create something of lasting significance. To do so, she eschewed tradition, choosing instead to invent herself anew in the world of the theater. As the critic William Winter later wrote, "Ada Rehan was a passionate lover of beauty. . . . She could be conventional, having learned how to be so; but the conventional was not her natural way—for her temperament had in it something of the romantic quality of the ideal gypsy."[8]

Tall and graceful, Rehan was also regarded as an especially lovely woman. Throughout her career, artists portrayed her in a variety of media. Perhaps most famously, in 1892, the Chicago sculptor Richard H. Park invited her to serve as the model for a monumental silver statue of Justice to be displayed in the Montana pavilion at the following year's World's Columbian Exposition. When reports surfaced that *Justice* was to be the largest silver sculpture in the world—comprising 725 kilograms (1600 lbs) of Montana silver and set on a plinth of pure gold—and that Rehan had been judged "a perfect physical woman," the actress found herself at the center of a squabble with others who thought they were more deserving.[9] Ultimately, Rehan accepted the invitation, and the resulting sculpture was among the highlights of the Chicago fair.

Rehan was at the peak of her career when Daly unexpectedly died in 1899. Heartbroken, she announced her retirement from the theater and removed herself from the public spotlight. Despite being in her early forties, she chose a new life, one that allowed more time for herself. When she decided in 1903 to return to the stage to star in a

repertoire of her favorite Shakespeare roles, her performances were greeted with a mixed reception. Thereupon, admitting a sense of indifference about the theater, she cut short the tour and retired for good. In retrospect, with Daly at her side, Rehan was one of the most accomplished actresses of her day. At her death in 1916, their partnership remained the focus of public tributes. As William Winter exclaimed, "Daly rendered many, various, and important services to the theater of his time, but his recognition and development of the genius of Ada Rehan were the most valuable of them all."[10]

FHG

6 No full-length biography of Rehan was written in the twentieth century, although she figures prominently in two about Augustin Daly: see Joseph Daly, *The Life of Augustin Daly* (New York: The Macmillan Company, 1917); and Marvin Felheim, *The Theater of Augustin Daly* (Cambridge, Mass.: Harvard University Press, 1956).
7 John Corbin, "Drama," *Harper's Weekly*, Vol. 42, no. 2192 (December 24, 1898): 1273.
8 William Winter, *The Wallet of Time*, Vol. 2 (New York: Moffat, 1913): 136–37.
9 "Rehan's Reply," *Boston Daily Globe* (December 10, 1892): 1.
10 "Ada Rehan, Famous Actress, Is Dead," *New York Times* (January 9, 1916): 17.

33.

Julia Marlowe
Actress
Born Cumberland, England
August 27, 1866–November 12, 1950

Together with Ada Rehan, Julia Marlowe was regarded as one of the leading actresses in turn-of-the-century New York. Yet, whereas Rehan's fame was always linked with that of her associate Augustin Daly, Marlowe cherished professional independence. Even as a young actress, she resisted invitations to join a stock company, choosing instead to hire actors and actresses from other companies to fill productions in which she starred. Likewise, she often refused to be directed, insisting on affixing her own stamp to each performance. This desire to manage one's own career was increasingly prevalent and led to significant changes in the way theatrical productions in America were organized. Despite the risks involved in setting out on her own, Marlowe proved that she had star quality, playing more than one hundred roles over a professional career that lasted nearly half a century.[11]

Marlowe's longevity as an actress can in part be accounted for by an all-consuming passion for the theater. From the time she was a young child growing up in Cincinnati, her parents having moved there from England when she was four, Marlowe knew that she wanted to be an actress. She was only twelve when she began touring with a local company. Equally important to her success was her ability to adapt to a wide range of roles and to present these characters in an up-to-date and appealing fashion. Although she never fully embraced the most innovative developments in contemporary theater, refusing to act in so-called "problem plays" by such modernist playwrights as George Bernard Shaw and Henrik Ibsen, Marlowe did inject a degree of realism into the roles she performed that set her apart from an earlier generation of actresses.

Created in 1899, Ben-Yusuf's photograph of Marlowe dates from a period when the actress

Julia Marlowe
Zaida Ben-Yusuf
Halftone print published in
The Marlowe Book, 1899
Museum of the City of New York

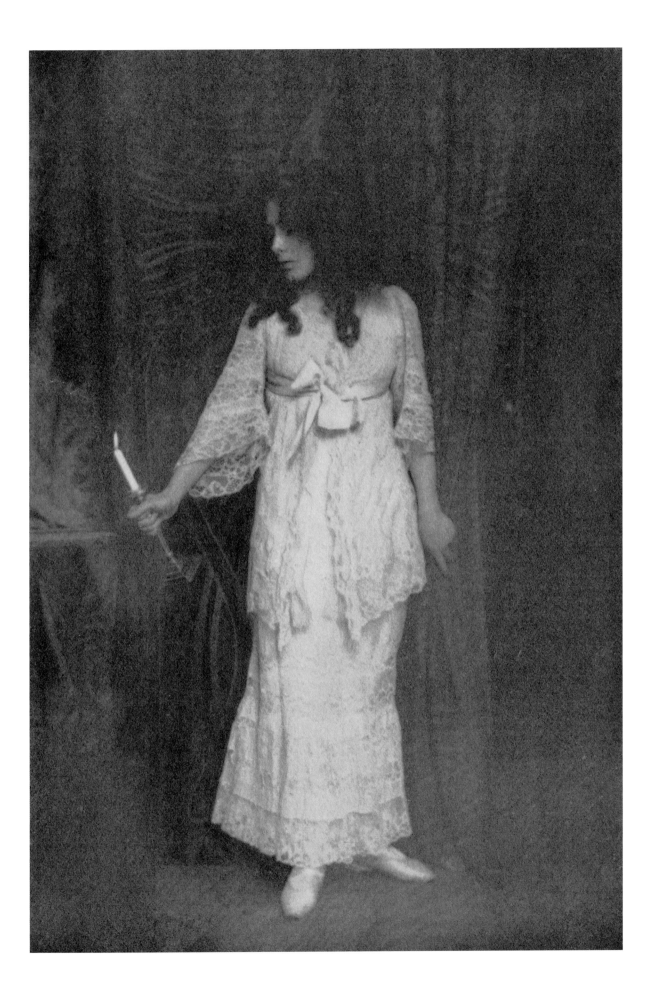

agreed, largely for financial reasons, to appear in a string of popular romances. Her marriage to fellow actor Robert Taber was then falling apart—the two had stopped acting together two years earlier and were officially divorced in 1900—and Marlowe felt compelled to leave behind the Shakespearian roles she favored in order to star in productions in which she was assured of making money. One such play was *Colinette*, a historical drama that enjoyed wide success on its premiere in Paris during the fall of 1898. Set in France after Napoleon's defeat and

Julia Marlowe
Irving R. Wiles
Oil on canvas, 1901
National Gallery of Art, Washington, D.C.;
gift of Julia Marlowe Sothern

the restoration of the monarchy under King Louis XVIII, *Colinette* is a romantic comedy that satirizes the French nobility. Upon being presented with the opportunity to play its title character in an American production, Marlowe agreed, well aware of the work's popular reception abroad. Ben-Yusuf's portrait shows the thirty-two-year-old actress recreating a scene from this play.

Despite good crowds, *Colinette* received only tepid praise in the press. Most reviewers found the play's story rather weak and its characters undeveloped. Yet, as the writer for *The Critic* put it in an essay that was characteristic of the critical response, the production's failure had little to do with its star. Instead, he identified the culprit as Henry Guy Carleton, the translator of the French script: "Mr. Carleton has handled the intrigue weakly, and the dramatic interest is nil, so that Miss Marlowe has to carry the whole burden of the play, or nearly all of it, upon her own fair shoulders. This she contrives to do very creditably."[12] Marlowe's popularity ensured that the production fulfilled its run during the spring season and prompted producers to reintroduce it the following fall. As she later recalled, "*Colinette* served my purposes. . . . Since my contract with my new management provided me with a certainty each week and a share of the profits, I was free from anxiety."[13]

Marlowe's acclaim attracted numerous photographers and artists to create likenesses of her. In recent years, a spate of picture magazines and illustrated books about the theater had appeared to promote new plays and the actors and actresses who starred in them. Marlowe rarely failed to oblige these image-makers during this period of her career, understanding well the benefits of public exposure. Commentators noticed this rapport. As the theater critic for the *New York*

Times wrote in 1899, she "is a fine subject for photography. The play of light and shadow on her mobile countenance is ever changing. In her pictures, therefore, she is of infinite variety."[14] Marlowe did not seem to favor a certain class of artist, agreeing to pose for little-known photographers who mass-manufactured portraits on cheap card stock as well as for such well-regarded painters as Irving Wiles (opposite).

Ben-Yusuf's photograph differs greatly from most images of the actress. Subsequently published in a picture book about Marlowe, the portrait shares few qualities with the other photographs in the volume.[15] Whereas others favored a conventional approach, rendering the figure sharply focused amid a contrived setting, Ben-Yusuf worked to capture a sense of Colinette's character as performed by Marlowe. Depicting the actress emerging from a shadowy background with a candle in her hand, Ben-Yusuf shows greater concern for capturing the play's atmosphere of intrigue than for the particular details of Marlowe's physical appearance and costume. Ben-Yusuf's recurrent desire to create an individual likeness—one that was different from other portraits of a particular subject—reveals itself again in this photograph.

Ben-Yusuf was clearly pleased with the image, as she chose to include it in three separate exhibitions over the course of the next year. Perhaps to emphasize her goal of trying to animate the play's eponymous character, she titled the work *Colinette* on each occasion. More than simply a likeness of Julia Marlowe, the photograph is a demonstration of Ben-Yusuf's ability to use the medium of photography to poetic effect. Critics who reviewed her contributions to these exhibitions all singled out this photograph for praise. Joseph Keiley's remarks in *Camera Notes* were typical,

exclaiming that "everyone who saw the picture found it attractive; those familiar with the play because of the very clever manner in which it illustrated the conflict of love and fear and doubt raging within the mind of Colinette—those unfamiliar with it by reason of its tonal charm and because it excited their great curiosity as to its story."[16]

Like Ben-Yusuf, Marlowe made a name for herself for her ability to represent others. Marlowe's life in the theater, though, lasted much longer than Ben-Yusuf's photographic career. In the years that followed, Marlowe continued to add new roles to her repertoire, and rededicated herself to performing Shakespeare's great female characters. She remarried in 1911, to the English actor Edward Hugh Sothern. Increasingly aware that her acting style had more in common with Victorian tastes than with modernist sensibilities, she retired from the theater in 1924. As many noted at the time, her decision to do so marked the end of an era in American theatrical history.

FHG

11 Biographies of Marlowe include Charles E. Russell, *Julia Marlowe: Her Life and Art* (New York: Appleton & Company, 1926); and Edward H. Sothern, *Julia Marlowe's Story*, ed. Fairfax Downey (New York: Rinehart & Company, 1954).

12 J. Ranken Towse, "The Drama," *The Critic*, Vol. 34, no. 863 (May 1899): 463.

13 Quoted in Sothern, 154.

14 Edward Dithmar, "The Drama," *New York Times* (April 23, 1899): 13.

15 *The Marlowe Book: A Collection of Pictures Representing Julia Marlowe in Some of Her Most Notable Impersonations* (New York: R.H. Russell, 1899).

16 Joseph Keiley, "The Salon," *Camera Notes*, Vol. 3, no. 3 (January 1900): 147.

Minnie Maddern Fiske

Actress
Born New Orleans, Louisiana
December 19, 1865–February 15, 1932

In reviewing *A Bit of Old Chelsea* in the spring of 1898, the critic for the *New York Times* praised Minnie Maddern Fiske's acting as having "the simplicity of nature," while specifying that she was "not to be classed with those marvels of overelaborate 'character-work,' in which extravagant make-up and persistent queerness fascinate the common mind."[17] In describing Fiske's performance, the writer acknowledged the split between the exaggerated gesturing and open asides characteristic of dramatic acting in the mid-nineteenth century, and the internalized subtlety of the new realism in theater. Fiske managed to bridge that divide. Trained in melodrama, she developed theories of subtext, psychological motivation, and the use of silence that mark her as a pioneer of modern theater.[18]

Born into a family of actors, Fiske claimed her first theatrical appearance came when she toddled on stage in the middle of a performance, crying "Mama" and embracing her mother. It disrupted the play but delighted the audience, and within a year she was performing in the *entr'actes* of her parents' productions. At three, she played the doomed Duke of York in *Richard III*, and soon after, her mother took her to New York, where she starred at every stage of her career, from child star to *ingénue* to heroine to *grande dame*.

Fiske did so in spite of her running battle with the Theatrical Syndicate and its boss, Charles Frohman. Established in 1896, the Syndicate owned the contracts for most of the major stars and, through them, access to theaters. If an actor did not sign on with the Syndicate, he or she was literally locked out, or, in the case of a major draw such as Fiske, forced to fit performances around the Syndicate's schedule. Fiske and her husband, Harrison Grey Fiske, protested at these practices as unjust. More than that, the couple

Minnie Maddern Fiske
Zaida Ben-Yusuf
Platinum print, 1899
21.5 × 8.4 cm (8⁷⁄₁₆ × 3⁵⁄₁₆ in.)
Library of Congress, Washington, D.C.,
Prints & Photographs Division

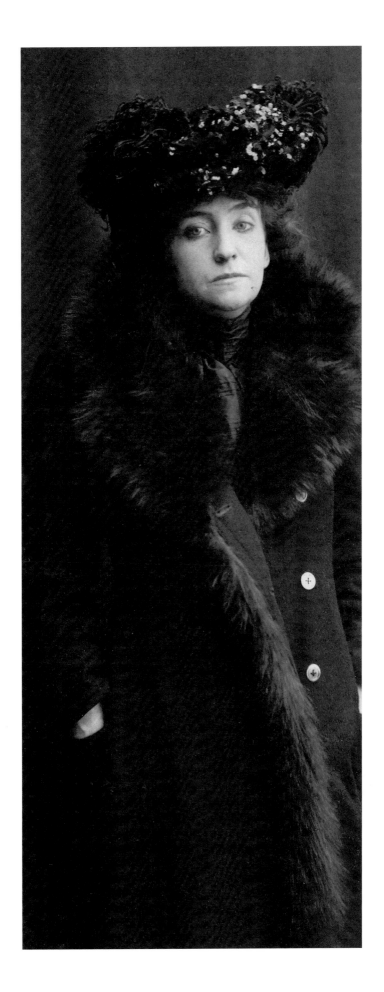

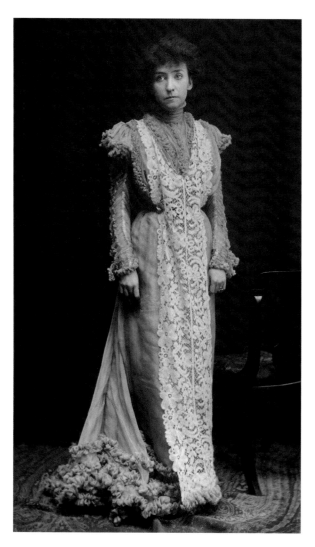

Minnie Maddern Fiske
Zaida Ben-Yusuf
Platinum print, 1898
Library of Congress, Washington, D.C.,
Prints & Photographs Division

opposed the Syndicate's emphasis on the star system over the endorsement of more balanced companies. In 1901, increasingly frustrated at the organization's imperious ways, the Fiskes contracted with the Manhattan Theater on Thirty-third Street and were finally able to develop a company of actors who were sympathetic to the actress's evolving theories of acting. In response, the Syndicate ordered its actors to boycott the *Dramatic Mirror*, the daily that Harrison Grey Fiske edited, and the source of the family's only regular income.

Settled in her own house, yet all the while anxious about the Syndicate's power, Fiske introduced concepts that she had been developing for years. She stressed ensemble acting. She insisted that her actors read the play together and discuss the characters before taking to the stage. She had them rehearse in a room, instead of on stage, so that they behaved more naturally. And she urged them to forget the audience. Above all, she insisted on the power of strategically placed moments of silence to an audience steeped in a tradition of grand declamation, exclaiming, "I am growing to realize the beauty of silence."[19] Fiske was based at the Manhattan Theater until 1906, when the Syndicate collapsed and she was permitted to extend her reach. During her time there, the Fiskes produced a range of plays—including Henrik Ibsen's *Hedda Gabler* and *A Doll's House*—that marked her full transition to the new "advanced drama," theater that flouted the smugness of Victorianism and probed for flaws behind a façade of respectability.

Ben-Yusuf photographed Fiske on at least two occasions. One series of images shows the actress in the elaborate tea gown she wore in the 1898 production of *Love Finds the Way* (left), of which one critic wrote: "The emotional force, the

graphic skill of expression, and the freedom from exaggeration in Mrs. Fiske's acting make the play worth seeing." The rest of the review stressed that she was the only thing worth seeing in the play.[20] A year later, Ben-Yusuf again met Fiske to create a portrait to publicize her leading role in *Becky Sharp*, an adaptation of William Makepeace Thackeray's *Vanity Fair*. Again, Fiske triumphed. As the theater critic for *The Bookman* wrote, "To see one of the subtlest and most original creations of English fiction put upon the stage, and then to admit that there was not one side of that character which was not adequately and vividly brought out by the actor, amounts to saying that Mrs. Fiske's representation of Miss Sharp takes its place on the highest planes of the actor's art."[21] In many ways, Becky Sharp, the low-born opportunist of *Vanity Fair*, became Fiske's signature role, and she revived it regularly for years. In 1915, she appeared in a movie version of the novel as the young Becky; by then she was over fifty.

In this particular photograph, Fiske stands tall in a winter coat; its wide fur collar frames her face, and a squat, spangled hat covers her forehead. The effect accentuates her small face and fine features, particularly her large, expressive eyes. Her mouth is held in a firm line, suggesting both her character's resolve and her own commitment to silence. Ben-Yusuf was pleased with the print, selecting it to be exhibited in New York later that fall and again the following year at F. Holland Day's prestigious *New School of American Photography* exhibition in London.

Fiske continued to perform until her health gave out. In late 1931, she was forced to leave the touring company of *Against the Wind* to recuperate from "auto-intoxication," a diagnosis based on the belief that, under certain conditions, the body could poison itself. She died less than a year later.

Throughout the country, the nation lamented the death of a woman who had helped to advance the craft of American acting from the dramatic posturing of her childhood to the subtle realism of the twentieth century.

EOW

17 "Dramatic and Musical," *New York Times* (April 12, 1898): 9.
18 For further studies of Minnie Maddern Fiske, see Archie Binns, *Mrs. Fiske and the American Theatre* (New York: Crown Publishers, 1955); and Frank Carlos Griffith, *Mrs. Fiske* (New York: The Neale Publishing Company, 1912).
19 "Mrs. Minnie Maddern Fiske," *New York Times* (May 1, 1898): 14.
20 "The Week at Theatres," *New York Times* (April 17, 1898): 9.
21 Norman Hapgood, "The Drama of the Month," *The Bookman*, Vol. 10 (October 1899): 119.

35.

Florence Kahn

Actress
Born Memphis, Tennessee
March 3, 1876–January 13, 1951

From an early age, Florence Kahn aspired to greatness in the dramatic arts. Yet the traditional system that underlay the New York theater world rarely permitted young actresses to work outside prescribed conventions. Reluctant to join a stock company where she would do little more than decorate the stage and admire the male lead, Kahn struggled to forge a career, and triumphed where her detractors had failed—but not before clashing with several leading men.

Kahn was born in Memphis, the only daughter in a family with three sons. She was an early graduate of Franklin Sargent's American Academy of Dramatic Arts, a school that encouraged innovation and valued an acting company over the star system. Her earliest work, for just such a company, earned critical attention. In reviewing a production in 1899, the critic for the *New York Times* proclaimed that Kahn "was full of promise" and that "she lacks beauty, but not presence."[22] Commenting on the same performance, another reviewer declared that "Miss Kahn has a mobile and striking face and a fine voice. Her enunciation is clear, and she has an unusual command of physical strength. She also has a remarkable head of hair."[23] Whether it was for her promise or her striking face, Richard Mansfield—a theatrical giant of the day who both managed and acted—offered Kahn the opportunity to become his company's leading actress.

During this period, Ben-Yusuf photographed Kahn on repeated occasions, most probably to publicize the various roles she was then performing. This portrait shows the twenty-three-year-old actress curled in on herself, elbow to knee. Her right hand cups her cheek, and she turns her head to look toward the camera. Her coyness and mystery are augmented by the soft-focus effect that was characteristic of the photographic process

Ben-Yusuf selected, the gum bichromate print.
Developed by photographers with an interest
in the medium's aesthetic potential, this process
was briefly in vogue among early pictorialists
because the sketchy result could be augmented
by watercolor or pencil line to create a more
"artistic" effect. The dream-like portrait of Kahn
seems more ideal than real, a result reinforced by
Ben-Yusuf's later publication of the photograph
over the title *Study of a Summer Girl*. A later
portrait of Kahn in a role from Shakespeare's
Henry V is a more conventional theatrical study
(right). In this image, she wears Classical drapery,
holds a sword, and stares warily to her left, as if
on guard.

Kahn's talent may have won her the position
with Mansfield's company, but her inexperience,
and presumed submissiveness, may have been
factors in her selection. Theatrical companies that
were led by such individuals as Mansfield typically
had only one star. Plays were chosen and actors
cast with the goal of enhancing the status of the
lead performer. Given Mansfield's reputation for
being demanding, Kahn must have entered into
his company with a mixture of excitement and
trepidation. The following notice by the critic
Edward Dithmar surely gave her pause: "Miss
Kahn goes at once, I believe, to join Mr. Mansfield.
The sympathy and best wishes of her fellow-
workers in the theatrical vineyard will go with
her."[24] Within a year, the strain was already
showing. As Dithmar reported, "The gossips say
that Miss Kahn has proved herself too self-willed
and intractable to get along with the highly
emotional producer of plays. Last spring, it will be
remembered, she left his company suddenly after
Mansfield told her that she ought to have a
company of her own supporting her, instead
of supporting him."[25]

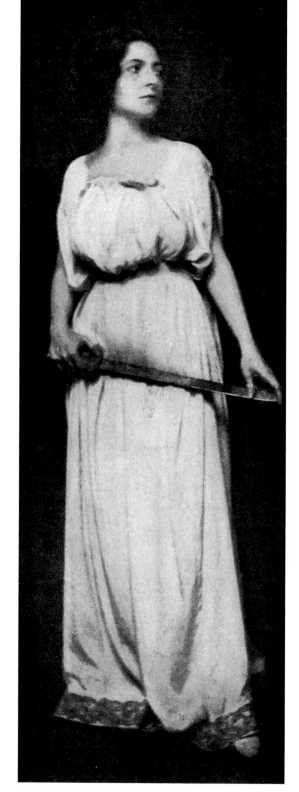

Florence Kahn
Zaida Ben-Yusuf
Halftone print published in
Munsey's Magazine, January 1901
Morris Library, University of Delaware,
Newark

In fact, Kahn did not last long with Mansfield, nor with three other actor-managers who hired her as their leading actress. Instead, she increasingly sought out parts that suited her, going where she could do her best work. The plays of Henrik Ibsen were especially attractive to her. In reviewing her role as Hilda Wangel in *The Master Builder*, critics noted that "opinion has been greatly divided as to the success of the performance, but there has been no difference as to what Miss Kahn's personality did for it. There has been a demand for more Ibsen with this captivating young woman as his interpreter."[26] Over the next few years, Kahn appeared also in Ibsen's *When We Dead Awake*, *Rosmersholm*, and *Hedda Gabler*, in most cases to critical acclaim. It is difficult to speculate whether she deliberately sacrificed broad popularity to work at the theatrical cutting edge—celebrity might have eluded her in any case—but that was the effect.

Then Kahn found both fame and challenging work in England. In 1910, she traveled to London to play Rebecca in *Rosmersholm* and was greeted as a star. She was such a popular success that she stayed to tour the country, giving dramatic readings, including one performance for King Edward VII. Ironically, she succeeded where Richard Mansfield, born an English citizen, had failed. Despite repeated efforts, he never triumphed in England as he had in the United States. During that same tour, Florence Kahn met the British humorist and theater critic Max Beerbohm. By the spring they were engaged, and she had decided to retire from the stage. While she resurfaced twenty years later to perform in Luigi Pirandello's *The Life I Gave You*, Kahn—now known as Lady Beerbohm following the knighting of her husband—effectively gave up her passion for acting. She died in 1951 at their home in Italy.

EOW

22 "Some of May Irwin's Ideas," *New York Times* (November 19, 1899): 18.
23 "Dramatic and Musical," *New York Times* (November 29, 1899): 4.
24 Edward A. Dithmar, "At the Play and with the Players," *New York Times* (March 4, 1900): 16.
25 "Theatrical News and Gossip," *Washington Post* (November 25, 1900): 28.
26 "Men, Women and Events," 512–513.

36.

Elsie Leslie

Actress
Born Orange, New York
August 14, 1881–October 31, 1966

On a winter evening in 1890, nine-year-old Elsie Leslie stood before the curtain of New York's Broadway Theater holding Samuel Clemens's hand. It was the opening night of the dramatized version of his *The Prince and the Pauper* and the famous author was making a speech. According to a reviewer, "The little girl was not a bit embarrassed, though. She smiled at the spectators and glanced from time to time inquiringly up at Mark Twain's lips as if wondering when he would stop talking."[27] Elsie Leslie's self-possession was not surprising. She had made her theatrical debut in 1885, and by the time she was seven, she was hailed as a child star for her performance as Little Lord Fauntleroy, the popular eponymous hero of Frances Hodgson Burnett's much-loved novel.

Leslie's training came almost by accident. Born in New York to a family with no theater ties, little Elsie Leslie Lyde impressed a family friend, the actor Joseph Jefferson, with her gift for mimicry. He persuaded her parents to allow her to appear as Rip's daughter Meenie in his signature play *Rip Van Winkle*. From there, she went on to star as Editha in Daniel Frohman's production of *Editha's Burglar*, a melodrama based on another popular Burnett novel. After her success in *The Prince and the Pauper*, her parents put a stop to her days as a child star and sent her to school. She left a disappointed public behind. Legendary actor Edwin Booth wrote to her: "Dear Little Lady: Mr. [Lawrence] Barrett and I were delighted with your charming performance of 'Little Lord Fauntleroy,' and we both wish you health and happiness."[28] Yet there was no bigger fan than Clemens, who proclaimed her the "sweetest girl in the world."[29]

Out of the spotlight for nearly a decade, Leslie resumed her acting career in 1899. To publicize her comeback, Ben-Yusuf created this portrait of the actress in her new role as Lydia Languish, the

Elsie Leslie
Zaida Ben-Yusuf
Platinum print, 1899
24.5 × 14.3 cm (9⅝ × 5⅝ in.)
Library of Congress, Washington, D.C.,
Prints & Photographs Division

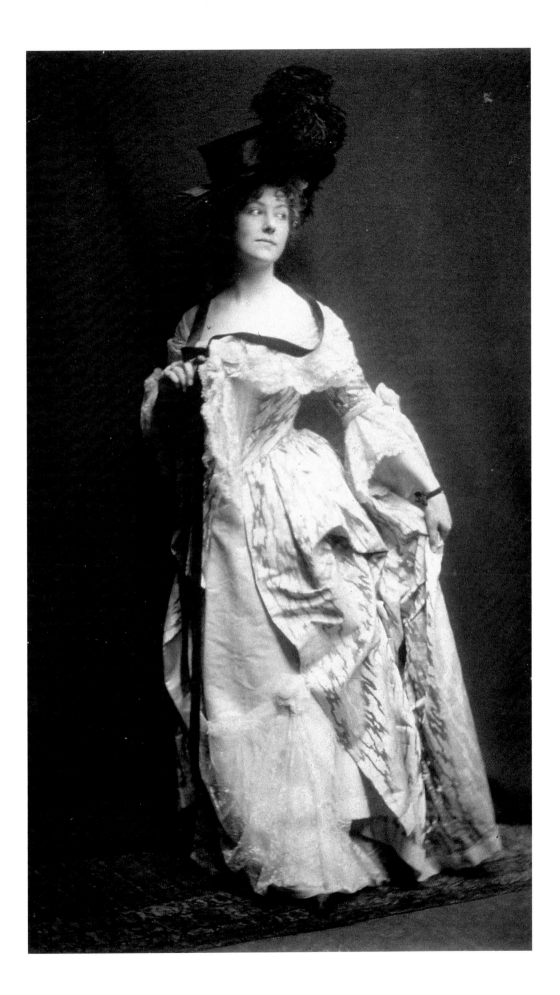

Elsie Leslie
Napoleon Sarony
Albumen silver print, 1888
Library of Congress, Washington, D.C.,
Prints & Photographs Division

hopelessly romantic *ingénue* in Richard Sheridan's comedy *The Rivals*. Wearing a classic eighteenth-century *robe à la française*, the eighteen-year-old glances pensively to her left as though unaware of the photographer. Ben-Yusuf was pleased enough with the result to submit the portrait to the prestigious Philadelphia Photographic Salon later that fall, where a reviewer remarked that "the charm in Miss Leslie's portrait lies chiefly in the skimming light which falls caressingly on this charming impersonation of Sheridan's famous character."[30]

Reviewers of Leslie's performance agreed that she was charming, but they were less enthusiastic about her acting. As though reluctant to criticize the popular darling, one reviewer sympathized, "The Lydia Languish of Elsie Leslie, who was a child actress only the other day, is pretty and

understandable and effective in its dainty little way. Lydia's is not an easy part to play." Another writer stated frankly that "the theatergoer who has been particularly anxious to see what the result of early stage training will be is distinctly disappointed. . . . Perhaps she was spoiled by her success in her early days; perhaps she is too pretty."[31]

Leslie continued to act, but never received the adulation as an adult that she had earned as a child; she retired from the stage in 1911. By 1936, she had dropped so far out of sight that a *New York Times* reporter advertised: "Want present whereabouts of Elsie Leslie, who played title role 'Little Lord Fauntleroy.'" Two weeks later, the paper ran an article reporting that Leslie had married Edwin J. Milliken in 1919 and "is still extant (living in a hotel near Park Avenue), charming, the voice beautifully modulated, the hair still full of Fauntleroy glints (natural ones, too)." Although Leslie's life ended in quiet seclusion, her early stardom set a pattern for marketing other child actors throughout the twentieth century. And for those who saw those early performances, she was "America's first dream child, a sort of Shirley Temple of the Nineties."[32]

EOW

27 "Amusements, Elsie Leslie," *New York Times* (January 21, 1890): 4.
28 "Theatrical Gossip," *New York Times* (November 28, 1888): 8.
29 "Fine Yachts to Attend Big Race," *Chicago Daily Tribune* (September 13, 1901): 9.
30 Francis J. Ziegler, "Philadelphia's Photographic Salon," *Brush and Pencil*, Vol. 5, no. 3 (December 1899): 108–116.
31 Edward A. Dithmar, "The Week at the Theatres," *New York Times* (October 16, 1898): 18. "Women Here and There," *New York Times* (October 23, 1898): 20.
32 "Want Present Whereabouts of Elsie Leslie," *New York Times* (March 27, 1936): 1. B.R. Crisler, "Film Gossip of the Week," *New York Times* (April 12, 1936): 3.

Elsie de Wolfe

Actress, interior decorator
Born New York City
December 2, 1865–July 12, 1950

"I would ask for good taste before all other blessings, even before that of wealth and social position. Good taste is such a sure guarantee of a woman's character. It is an unseen, indescribable halo which sheds an enveloping radiance over a woman's whole personality."[33] Thus wrote the trend-setting actress Elsie de Wolfe in 1897. Although de Wolfe achieved only marginal success on the theatrical stage, she would emerge at the turn of the century as one of the most stylish and socially adept ladies of her day. As an actress and later an interior decorator, she defined what was fashionable, and, in doing so, contributed to the growing acceptance of professional careers for women. For her, "good taste"—that often elusive combination of beauty, grace, and refinement—served as the beacon toward which all modern women should strive.

It is not known how well Ben-Yusuf knew de Wolfe; however, it is likely that they were more than passing acquaintances. The young photographer's first studio was a mere two blocks away from the actress's home, and Ben-Yusuf photographed many of the cultural elite who attended her celebrated Sunday afternoon salons. As importantly, Ben-Yusuf shared the actress's regard for "good taste" in matters of fashion, art, and travel. This concern is evident in her full-length portrait of de Wolfe. Created at the time when she was appearing as a ghost in Robert Marshall's *The Shades of Night* at New York's Lyceum Theater, the photograph presents de Wolfe in the pose of an actress looking toward one who is not pictured. Ben-Yusuf understood a tasteful portrait to be one that was uncluttered by studio props, original in its composition, and expressive of the subject's individuality—all characteristics of this image. In particular, de Wolfe wears a fashionable gown with a dark-colored lace overdress and a long strand of pearls. Her hair is drawn up like that of a Gibson girl, and she stands in the midst of Ben-Yusuf's studio, which is empty save for an Oriental carpet on the floor and a decorative wall-hanging on the rear wall. The portrait highlights not simply her beautiful dress, but the ease with which she wears it.

Elsie de Wolfe's rise to prominence had as much to do with her own power of self-invention as with her elite upbringing in New York and British society. While she attended private schools as a girl and made her debut in London society at age seventeen, she turned to acting as a way to support herself after her father's death in 1890 left her with relatively little money. For the next fourteen years, de Wolfe appeared regularly on the New York stage. Although some admired her acting in comedy roles, it was her stylish Parisian dresses that made her famous. Each season she returned from Europe with the latest couture, which she wore on stage to the delight of critics and audiences alike. The redecoration of her town house on Irving Place—which she shared with her partner, Elisabeth Marbury, a successful agent and theatrical producer—also attracted considerable attention. As the historian Henry Adams observed in 1901, the home became the focus of much social activity: "I went to the Marbury salon and found myself in a mad cyclone of people. Miss Marbury and Miss de Wolfe received me with tender embraces, but I was struck dumb by the brilliancy of their world. They are grand and universal."[34]

Ultimately, de Wolfe tired of the public life of an actress and chose instead to devote her energies to the emerging profession of interior decoration. Given her reputation and her social connections, she had little difficulty in making the transition to this new line of work. Following her first major commission in 1905—the decoration of the rooms

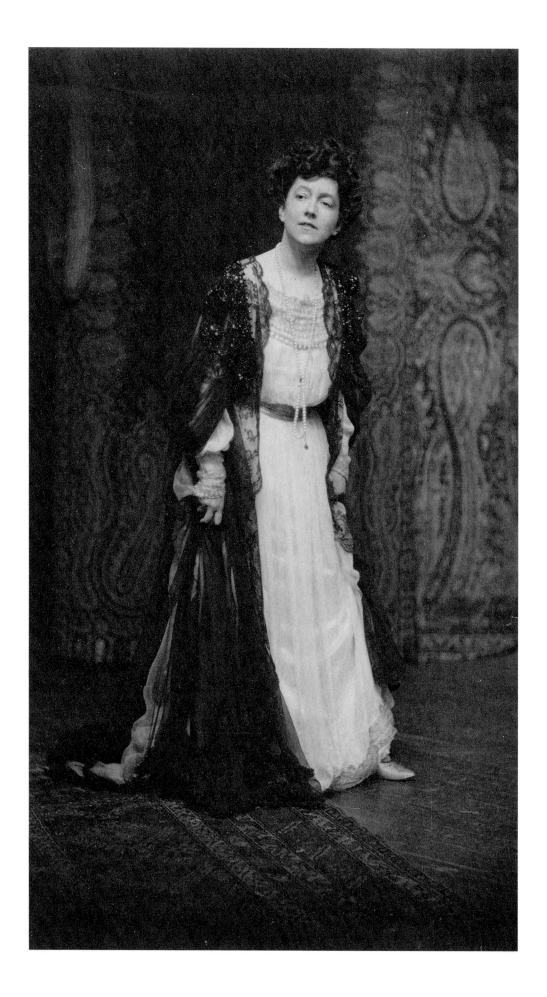

of the Colony Club, a New York women's club recently designed by Stanford White—she attracted many clients, including some of the city's wealthiest families. In this work she exhibited her characteristic creativity and "good taste," rejecting the dark overabundance typical of Victorian parlors for a design concept that favored simplicity and natural elegance. She introduced such patterns as flowered chintz, and brought indoors the trellis for climbing plants. So popular did de Wolfe become as an interior decorator that in 1913 she wrote a book on the subject, *The House in Good Taste*.

Elsie de Wolfe remained throughout her life one of the most influential tastemakers in America. In 1926, a *mariage blanc* gave her the title of Lady Mendl, which added to her cachet. When she was seventy, Parisian fashion designers named her the best-dressed woman in the world.[35] Yet, important as her achievements in fashion and design were, de Wolfe's legacy extends beyond the pursuit of beauty. During the First World War, she worked as a frontline nurse in France and was awarded the Croix de guerre and the Légion d'honneur for her efforts. As importantly, her example as a professional helped both to inspire countless American women to pursue independent careers and to ensure their standing in the workplace.

FHG

33 Elsie de Wolfe, "The Well-Dressed Woman," *Cosmopolitan Magazine*, Vol. 24, no. 2 (December 1897): 130.

34 Worthington Chauncey Ford, ed., *Letters of Henry Adams, 1892–1918*, Vol. 2 (New York: Kraus Reprint, 1969): 311.

35 "Lady Mendl Dies in France at 84," *New York Times* (July 13, 1950): 25.

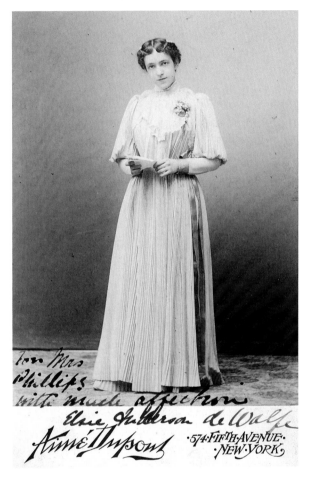

Elsie de Wolfe
Aimé Dupont
Gelatin silver print, *c.* 1898
Philip H. Ward Collection of Theatrical Images, Rare Book and Manuscript Library, University of Pennsylvania, Philadelphia

New York
as Crossroads

Although for centuries an important hub of commerce and immigration, during the latter half of the nineteenth century New York City increasingly became a crossroads for visitors from near and far. Travelers—taking advantage of dramatic developments in transportation—made their way to New York for different reasons: some to tour the city's historic and cultural landmarks, others to visit family and friends, and still others to pursue some type of professional opportunity. The popularization of the public lecture circuit brought celebrated figures from the arts and sciences routinely to the city, where they publicized themselves and their work. These individuals added to the sense of sophistication and cosmopolitanism that more and more defined the expanding city. In bringing new vistas of the world to New York's doorstep, they helped to remove certain age-old provincial attitudes, while simultaneously contributing to a fresh belief in the city's exceptionality. Ben-Yusuf—an outsider herself—photographed many of these men and women, in part to satisfy the demand from different periodicals for celebrity portraits. Yet the opportunity to photograph such figures also fulfilled her greater ambition to surround herself with individuals of special distinction. The people represented in this section speak to New York's importance as a destination and a meeting point for an international set of writers, artists, and explorers.

38.

James Burton Pond

Lecture manager
Born Cuba, New York
June 11, 1838–June 21, 1903

In the summer of 1899, the author William Dean Howells was considering embarking on a lecture tour, partly to meet pressing financial obligations. He wrote to his friend Samuel Clemens for his opinion of the lecture manager James Burton Pond, who had organized similar tours for him. Clemens's response was revealing. About the sixty-one-year-old promoter, he wrote, "I cannot imagine Pond's making a statement of any kind upon any subject that I would dream of believing. He is as good a soul as lives, & one cannot help being fond of him, but … Pond is not an interesting liar; it's the only fault he has. If his parents had taken the least pains with his training, it could have been so different."[1] Nonetheless, Pond was so adept at promotion that he emerged as the leading lecture manager in America for authors and other celebrity orators at the century's end. His work contributed greatly to New York's emergence as the most prized destination for visiting speakers.[2]

Pond's own life was itself not uninteresting. Born into a farming family in western New York State, he had little desire to follow in his father's footsteps, and, at the age of fifteen, apprenticed himself to a printer. At eighteen, he left for Kansas to fight alongside the abolitionist John Brown, leaving only after Brown's defeat at Osawatomie. After wandering through the West as a journeyman printer, he moved to Wisconsin in 1860 to publish a small-town newspaper. When the Civil War broke out, he closed the paper and joined the Union army, rising in two years to the rank of lieutenant. Pond's battalion was stationed in Kansas, where the guerrilla forces of Confederate William C. Quantrill had been terrorizing local communities. Under Pond's leadership, Quantrill was rebuffed at the Battle of Baxter Springs. For this achievement Pond was later awarded the Medal of Honor.

With the war's end, Pond—now a major—drifted westward. By 1873 he was living in Salt Lake City when opportunity led him toward his life's work. That year, Ann Eliza Young, the nineteenth wife of Brigham Young, left both her husband and the Mormon Church amid great controversy. Fascination with polygamy and sympathy for this woman made her a natural draw, and Pond seized on the idea of sending her on a national speaking tour. The result was a resounding success, prompting Pond to pursue this enterprise full-time. By 1879 he had settled in New York to take advantage of the vogue for such engagements. There he managed tours for such luminaries as Ralph Waldo Emerson, Thomas Nast, and the preacher Henry Ward Beecher. With Beecher he traveled 482,800 kilometers (300,000 miles) over a twelve-year period to oversee more than 1200 separate lectures.

Although most clients were fond of him and appreciative of the opportunity to capitalize on their renown, Pond's tours did not always go smoothly. When the young Winston Churchill, fresh from his experience in the Boer War, gave a lecture in New York in 1900, many of his "sponsors" claimed that Pond had used their names on advertising posters without their permission. In addition, some Americans opposed British action in South Africa and criticized Churchill's appearance in New York. Complaining of fatigue, though also upset about the uproar, for which he blamed Pond, Churchill stopped the tour in Ontario. Pond responded by declaring that his client only wanted more money. Indeed, Churchill left disappointed that the tour did not generate the profits for which he had hoped.

The Everett House, Pond's home and office in New York, was just a block from Ben-Yusuf's first studio at 124 Fifth Avenue. It was here that she

James Burton Pond
Zaida Ben-Yusuf
Platinum print, *c.* 1898
15.9 × 18.8 cm (6¼ × 7⅜ in.)
National Portrait Gallery, Smithsonian
Institution, Washington, D.C.

James Burton Pond
Zaida Ben-Yusuf
Platinum print, *c.* 1898
Center for Creative Photography,
University of Arizona, Tucson

first photographed him. Pond must have been pleased with the results, as he sent much business in her direction over the next few years. In fact, Ben-Yusuf's studio became the preferred destination for lecturers who needed publicity images prior to heading out on tour. In this portrait, Pond presents himself as a substantial man, the Civil War hero turned man of business, carefully tending his accounts. He sits on an ornately carved chair before a desk, intently writing in a notebook. As in many of Ben-Yusuf's images, the light falls from above, highlighting Pond's head and hands and the papers before him. Wearing a double-breasted frock coat—stretched into folds across his thick middle—and striped pants, he fashions himself as a respectable gentleman.

Pond died in 1903 at his home in Jersey City. His obituaries celebrated his life and listed his triumphs in both war and business. "He never seemed to be in any humor but the happiest," the *New York Times* wrote. His wider impact was noted by others, including the *Washington Post* reporter who exclaimed that Pond "was perhaps the most successful and most widely known lecture manager in the world. It might almost be said that he created the profession of piloting famous men and women on lecture tours."[3] In an age of the self-made man, Pond became a celebrity by promoting and, in some cases, creating the celebrity of others.

EOW

1 Quoted in Henry Nash Smith and William M. Gibson, eds., *Mark Twain–Howells Letters: The Correspondence of Samuel L. Clemens and William D. Howells, 1872–1910* (Cambridge, Mass.: The Belknap Press, 1960): 703–704.

2 The best book about Pond is his collection of personal profiles, *Eccentricities of Genius* (New York: G.W. Dillingham Company, 1900).

3 "Major J. B. Pond is Dead," *New York Times* (June 22, 1903): 1. "Maj. James B. Pond Dead," *Washington Post* (June 22, 1903): 3.

39.

Elbert Hubbard

Editor, publisher
Born Bloomington, Illinois
June 19, 1856–May 7, 1915

In addressing a gathering of photographers in 1902, Elbert Hubbard explained that when he was first asked "Is photography art?" he joked, "My dear boy, art is a matter of haircut and neckties." By that standard, Hubbard—pictured by Ben-Yusuf with his pageboy locks and flowing scarf—was every inch the artist. Yet his teasing comment suggests something more: that an artist creates his or her own identity. Certainly, few people at the turn of the century had deliberately fashioned their public image as much as he had.[4]

Hubbard's rebellion against the conventions of society began at an early age. His childhood was filled with school and religion, but he rejected both, refusing to be baptized and completing his education at age sixteen. It was only when he went to work selling soap for his cousin that he seemed to find his way. In a short period of time, he had hired his own sales teams to canvass the countryside, while he shared their commissions. When the soap company broke up in 1875, he chose to join his cousin's partner, John Larkin, in his new firm in Buffalo, New York.

While working at the Larkin Soap Company, Hubbard was attracted to the lectures and book circles that grew out of the Chautauqua movement in western New York State. Desirous of being an author, he published his first book in 1891 under the feminine *nom de plume* Aspasia Hobbs. *The Man: A Story of Today* was not a success; nevertheless, he resigned his sales position a year later and set off for Harvard as a special student, leaving his wife, Bertha, and their children in Buffalo. Although he dropped out of Harvard before graduating, his time there determined the next steps in his life. First, his long-term lover, Alice Moore, joined him in Boston and was soon pregnant. Secondly, he became fascinated with publishing, particularly small designer books and specialty magazines.

Hubbard deferred dealing with the impending consequences of Moore's pregnancy by traveling to England, where he visited William Morris's Kelmscott Press, an important force in the growing Arts and Crafts movement. He later claimed that Morris urged him to start his own small press in America. When he did return to New York, he sorted out his domestic affairs, ultimately deciding to return to Bertha, and then began work on the first of what he envisioned as a series of booklets describing the homes of famous men. When he could not interest a publisher, a friend with a print shop, Harry P. Taber, suggested that Hubbard print and market the series himself. The strategy worked, and he soon had a contract for the booklets. He and Taber also collaborated to publish *The Song of Songs* and *The Journal of Koheleth*, as well as Taber's monthly magazine, *The Philistine*. The books were artistic but not popular successes, and when Taber's capital ran out in 1895, Hubbard bought his Roycroft Printing Shop in East Aurora, New York, and moved his family there.

Over the next five years, Hubbard built the Roycroft complex into the center of the Arts and Crafts movement in America. He attracted craftsmen by paying them well and leaving them alone to pursue their ideas. Workers were never admonished for wasting money. The Fra, as Hubbard was called by his followers, saw wasting time as much the greater sin. He introduced such worker-friendly ideas as the twenty-minute mid-morning walk; at Christmas, he divided a percentage of company profits among his employees. In spite of the Roycroft's celebration of handicrafts, Hubbard encouraged his workers to streamline production and to introduce mechanization wherever possible.

Nowhere was that mechanization more effective than in the newly energized Roycroft Press.

Hubbard's gift for marketing increased circulation of *The Philistine*, but it was the publication in 1899 of *A Message to Garcia* that drove circulation from 2000 in 1895 to 110,000 in 1902. In this essay, Hubbard argued that the real hero of the Spanish–American War of 1898 was Lieutenant Andrew S. Rowan, who was smuggled into Cuba on the eve of war, carrying a message from President McKinley to General Calixto García, the leader of the Cuban rebel forces. According to Hubbard, Rowan's heroism rested on his unquestioning obedience, a quality that Hubbard lamented was lacking in the modern worker: "Slipshod assistance, foolish inattention, dowdy indifference and half-hearted work seem the rule."[5] Given its rousing rhetoric and pro-management message, this pamphlet was soon in great demand, especially by corporations. Within days of its publication, the New York Central Railroad asked for 100,000 copies to give to its employees. Having been translated into many languages, it is believed to be one of the ten bestselling books of all time.

Ben-Yusuf photographed Hubbard roughly a year after the publication of *Garcia*, and still in the wake of its impact. He was then in New York at the outset of a lecture tour being orchestrated by James Burton Pond. Every inch the man of action, the unsmiling Hubbard peers to the right from under the brim of a Western-style hat, as though unaware of the photographer. Despite his apparent detachment, Hubbard was clearly pleased with the photograph. He signed this particular print to his friend the photographer Frances Benjamin Johnston and used it as the frontispiece of his biography a year later.

Hubbard appreciated photography and even allowed that it could be art, as he explained in his address of 1902: "Whether photography is art, or not, depends upon the photographer. Art is not a

Elbert Hubbard
Zaida Ben-Yusuf
Platinum print, *c.* 1900
23.8 × 15.5 cm (9⅜ × 6⅛ in.)
Library of Congress, Washington, D.C.,
Prints & Photographs Division

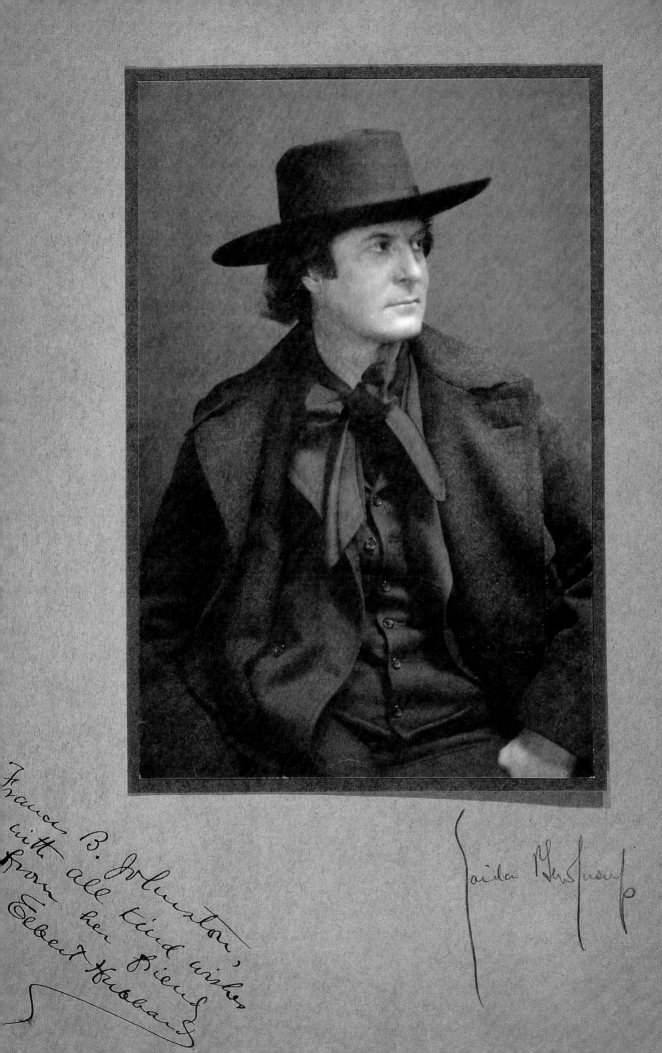

*Frances B. Johnston,
with all kind wishes
from her friend
Elbert Hubbard*

thing separate and apart; art is the beautiful way of doing things."[6] Elbert Hubbard embraced this philosophy in all his endeavors. Even his death in 1915 seemed orchestrated for the greatest effect. He and Alice Moore Hubbard, whom he had married after Bertha divorced him, drowned when German torpedoes sank the ocean liner *Lusitania*, a misfortune that may not have been entirely disappointing to him. On the eve of sailing, he stated in an interview that, "speaking from a strictly personal viewpoint … I would not mind if they did sink the ship. It might be a good thing for me. I would drown with her. That's about the only way I could succeed in my ambition to get into the Hall of Fame. I'd be a real hero and go right to the bottom."[7]

EOW

4 Elbert Hubbard, "Is Photography Art? Address at the National Convention, Buffalo, NY," *Photo-Era*, Vol. 9, no. 3 (September 1902): 129. Biographies of Hubbard include David Arnold Balch, *Elbert Hubbard: Genius of Roycroft* (New York: Frederick A. Stokes Company, 1940); Freeman Champney, *Art And Glory: The Story of Elbert Hubbard* (New York: Crown Publishers, 1968); and Charles F. Hamilton, *As Bees in Honey Drown: The Love, Lives, and Letters of the Roycroft's Alice and Elbert Hubbard* (Tavares, Fla.: SPS Publications, 1997).

5 Elbert Hubbard, *A Message to Garcia* (East Aurora, NY: Roycroft Press, 1899): unpaginated.

6 Hubbard, "Is Photography Art?" 129.

7 "Hubbard Hope is Realized," *Los Angeles Times* (May 8, 1915): 14.

Group portrait of Frances B. Johnston, James B. Pond, and Elbert Hubbard at Johnston's studio in Washington, D.C.
Frances B. Johnston
Gelatin silver print, *c.* 1900
Library of Congress, Washington, D.C., Prints & Photographs Division

40.

Anne Douglas Sedgwick

Author
Born Englewood, New Jersey
March 28, 1873–July 19, 1935

In 1902, Anne Douglas Sedgwick returned to New York City for the first time in more than a decade to visit family and friends. Although she had grown up there, she had lived in Europe on and off since age nine, when her parents had relocated the family to a new home near relatives in England. Sedgwick trained initially to be a painter and, as a single woman, took classes at the prestigious Académie Julian in Paris. Her painting was accomplished enough to merit inclusion in the Paris Salon. While her return to America enabled her to reconnect with old acquaintances, professional concerns played an equally important role in her decision to come home. It was not her art, though, but rather her writing about which others wished to speak with her. Greeted as a "new literary light"—in the words of one critic—the twenty-eight-year-old author found her writing being compared in the literary magazines to the work of such famous English authors as George Eliot and Jane Austen.[8] She had not been accorded this type of reception before.

Sedgwick belonged to a class of well-educated and well-connected women who enjoyed a wider latitude of opportunities than most women of their day. Independent-minded, she postponed marriage to pursue her interest in the arts and literature. While she would become a dedicated writer—publishing seventeen novels and two collections of short stories over a career that lasted more than three decades—she entered the literary field seemingly on a whim. As she later exclaimed in an autobiographical sketch, "I slipped into professional novel writing almost by accident, for I had thought of myself as a painter. But I used to tell long stories to my sisters, and these, later on, grew into attempts at novels (the first was a Jacobite romance) with plenty of love scenes, as my auditors begged for them."[9] Sedgwick wrote simply

for pleasure at first, but in 1898, with the help of an "enthusiastic friend," she decided to pursue publication. Although it was not a popular success, her first novel, *The Dull Miss Archinard*, encouraged her to continue this "literary flight."[10]

By 1902, novel-writing had become a more serious concern for Sedgwick. The Century Company's decision in the fall of 1901 to serialize in its monthly magazine her third novel, *The Rescue*, and to republish her two earlier novels under its own imprint prompted wide notice in the literary press. This endorsement by one of America's leading publishing houses also led critics to consider her work more seriously. The majority of reviewers declared her a rising star. Regarding *The Rescue*, the story of a widow who is saved from an unbearable family situation by a younger man who discovers a photograph of her from an earlier period, the writer for *The Critic* declared it "one of the signal books of the year," and suggested that "it is a book that marks a period, sets a standard from which future achievements will probably be dated. . . . Miss Sedgwick is young. But there is nothing young in 'The Rescue.'"[11]

In the light of this turn of events, Sedgwick decided to embark for America. It can be surmised that Century's editors requested her presence, as they worked to finalize and then publicize the release of her three novels. Ben-Yusuf's portrait of Sedgwick dates from this period. As it accompanied at least two reviews of *The Rescue*, the likeness was most probably created as part of the publicity campaign launched by Century in spring 1902. Interestingly, Ben-Yusuf was not the only artist who portrayed Sedgwick during the eight months that she spent in the States. Richard Watson Gilder, the editor of *Century Magazine* and Sedgwick's host for part of her visit, commissioned the renowned American portraitist Cecilia Beaux to

create a drawing of her that could be published in his magazine (page 206). For undetermined reasons, neither Ben-Yusuf's photograph nor Beaux's red-chalk drawing was published in *Century* at the time. Beaux did like her portrait well enough to include it a year later in a one-person exhibition at New York's Durand-Ruel Gallery.[12]

Sedgwick's visit was not entirely taken up with work-related affairs. In addition to traveling to Ohio to see relatives, she accompanied the Gilders to their country home in the Berkshires. These travels and her encounters with a host of different individuals gave her the opportunity to study and critique American manners, an activity she seemed to relish. She wrote frequently to friends in England, often revealing a sense of ambivalence about her former home. As she related to one friend, "Though it is charming here—so many dear people, so much that is so sympathetic—I could never be happy living here. I wonder why; because in temperament and point of view I am far more American than English."[13] Being in America allowed Sedgwick to reflect on her own identity as an American living abroad, as well as on other expatriate writers with whom she was often compared, most especially Edith Wharton and Henry James. Although she admired elements of James's writings, she confessed that "I am so glad to have found out that Americans are not like the ones he draws. He ought to go to America! But he is afraid of America. . . . He always seems to me, through his books, like a person who has always been too afraid of ugliness. I don't believe he has ever taken any risks in his life, or ever 'lived out dangerously into the world.'"[14]

In America, Sedgwick found her first critical and popular success as an author. Her visit also furthered her understanding about the country and her relationship to it. Like Wharton and James, she

Anne Douglas Sedgwick
Zaida Ben-Yusuf
Platinum print, 1902
17.8 × 10.2 cm (7 × 4 in.)
George R. Rinhart

Miss Anna Stryker Sedgwick

from a Photograph by Miss Ben Greuef

Anne Douglas Sedgwick
Cecilia Beaux
Red-chalk drawing on paper, 1902
Anne Palmer

was drawn to create characters for whom ideas of home and identity were central concerns. However, over the next three decades, she returned only twice, preferring to live in the English countryside with Basil de Sélincourt, the English writer whom she married in 1908. Toward the end of her life, she reflected in a letter to a friend on her feelings for her native land: "I left America when I was little more than a baby and England has always been my home; but I think it always remains a different kind of home if one has those different kinds of roots, and I have always been aware of a nostalgic yearning, and of severance."[15]

FHG

8 "Miss Sedgwick's Three Novels," *Town and Country*, no. 2930 (July 5, 1902): 27.
9 Quoted in "Anne D. Sedgwick, Novelist, is Dead," *New York Times* (July 22, 1935): 15.
10 "General Gossip of Authors and Writers," *Current Literature*, Vol. 33, no. 1 (July 1902): 109.
11 Aline Gorren, "Miss Sedgwick and 'The Rescue,'" *The Critic*, Vol. 40, no. 7 (July 1902): 58, 60.
12 Tara Leigh Tappert, *Cecilia Beaux and the Art of Portraiture* (Washington, D.C.: Smithsonian Institution Press, 1995): 82.
13 Anne Douglas Sedgwick to Mina Pitman, June 15, 1902, letter published in Basil de Sélincourt, ed., *Anne Douglas Sedgwick: A Portrait in Letters* (Boston: Houghton Mifflin Company, 1936): 39.
14 Anne Douglas Sedgwick to Katherine Dunham, September 10, 1902, letter published in Sélincourt, ed., 47.
15 Anne Douglas Sedgwick to Mrs. Ellis Stone, February 11, 1933, letter published in Sélincourt, ed., 235.

41.

Francis Marion Crawford

Author
Born Bagni di Lucca, Italy
August 2, 1854–April 9, 1909

During a period when contemporary authors increasingly favored literary realism—a form of fiction that put fact ahead of romance—Francis Marion Crawford was outspokenly opposed to this trend. Fiction, in his opinion, was meant to entertain, and thus idealized characters were more attractive than those who endured the travails and vagaries of modern life. Particularly appalling to Crawford was the so-called "purpose" novel, "an odious attempt to lecture people who hate lectures, to preach at people who prefer their own church, and to teach people who think they know enough already."[16] Crawford expounded these views in his tract *The Novel: What It Is* (1893), and demonstrated in more than forty published works his preference for larger-than-life stories often set in foreign locales and during earlier historic periods. While Crawford is less well known today than his realist contemporaries—such authors as William Dean Howells, Henry James, and Edith Wharton—he enjoyed a wide reputation in his time as one of America's most distinguished and prolific novelists.

Although he was born and spent most of his life in Italy, Crawford regarded himself as an American on account of his family ancestry and his years of schooling in New England. Living abroad, he professed, gave him a unique perspective on America and furthered his respect for the country.[17] His father, the celebrated sculptor Thomas Crawford, had likewise been an expatriate, having relocated from New York City to Rome in 1835 to pursue an artistic career. Despite being overseas, Thomas Crawford fulfilled a number of commissions for buildings in his native land, including the bronze *Statue of Freedom* atop the U.S. Capitol dome in Washington, D.C.

Like his father, Francis Marion Crawford maintained regular correspondence with American friends and professional colleagues in the years after deciding to make Italy his permanent home. In addition, he traveled back to the United States often to promote his writings and to conduct other business. The lecture manager James Burton Pond orchestrated at least one national speaking tour for him, a five-month cross-country excursion in the fall and winter of 1897–98. According to Pond's recollections, audiences showered Crawford with praise. Pond also highlighted the good times that they shared, describing his time with Crawford as "one of the most enjoyable and delightful companionships that I have ever had."[18]

Ben-Yusuf's three-quarter-length portrait of Crawford was taken in her studio two years after this trip. Pond—who often brought clients to Ben-Yusuf—was probably responsible for setting up this session during one of Crawford's periodic visits to New York. Ben-Yusuf supposedly had difficulty in achieving this portrait, recalling that Crawford was "so tall and big that he upset all my previous calculations as to what my camera would do."[19] Despite this challenge, she captured the forty-five-year-old author in a manner that conveyed his characteristic self-confidence. Holding a cigar in one hand and facing the camera head-on, he is the epitome of the masculine sophistication made popular during this period by such men as Theodore Roosevelt. Crawford and Roosevelt were, in fact, friends, and each visited the other during their respective travels.

Crawford regarded this and other prints that Ben-Yusuf created on this occasion as a great success. For publicity, his publisher, the Macmillan Company, reproduced these portraits often in its advertisements and distributed them to magazines that were reviewing his writings. Ben-Yusuf also teamed up with Crawford and the New York publisher Frederick Keppel to produce a limited edition of one of these images. Signed by

Crawford and mounted on Van Gelder paper, an imported handmade card stock preferred by many fine art photographers, this large-format print satisfied the demand for a quality likeness of the famous author.

While he enjoyed visiting the States, Crawford always returned to his home and family in Italy. It was there that he found the subjects that most interested him as a writer, including, importantly, Italian Renaissance history. His fictional romances often revolved around significant events and historic figures of that period. The popularity of these works in the States contributed greatly to American perceptions of Italy, its people, and its institutions, and furthered American interest in travel abroad. Crawford also returned to Italy because of the peace that life afforded him there. Ensconced behind the walls of a large villa overlooking the coastal town of Sorrento, he lived, according to a profile of 1903, "undisturbed by the outside world … surrounded with the beauty and romance of an old Italian garden, from which one has an entrancing view toward Pompeii, Vesuvius, and the creamy walks of Naples."[20] From this seat, far removed from American "progress," Crawford had indeed found an ideal place to lose himself in colorful dreams of romance and adventure.

FHG

16 "Marion Crawford on the Novel," *New York Times* (May 14, 1893): 19.

17 In an interview in 1896, Crawford spoke about his feelings for America. In response to a question about whether it is a "good thing for an American to live long away from his country," he responded, "You have to get away from America now and then to see what big things and great things our country and our people are. I am proud of my Americanism, and though I was born in Italy I am an American in every sense of the word." Quoted in Frank Carpenter, "F. Marion Crawford," *Los Angeles Times* (February 2, 1896): 13.

18 Pond, 463.

19 Ben-Yusuf, "Celebrities Under the Camera," *Saturday Evening Post*, Vol. 173, no. 48 (June 1, 1901): 14.

20 "Marion Crawford's Recent Work," *Town & Country*, Vol. 57, no. 44 (January 10, 1903): 23.

209

42.

Anthony Hope Hawkins

Author
Born London, England
February 9, 1863–July 8, 1933

The British author Anthony Hope Hawkins wrote novels that were "the craze of a generation," according to one obituarist.[21] During a period when many novelists in Europe and America were dedicated to depicting modern society in realistic detail, Hawkins crafted adventurous romances set in mythical kingdoms. Such characteristic works as his novel *The Prisoner of Zenda* (1894)—the tale of a young man who saves the king of Ruritania from evil forces by serving as his double—reinvigorated the literary genre of romantic fiction and propelled Hawkins to the forefront of popular literature at the turn of the century.

Ben-Yusuf created at least four portraits of Hawkins in her Fifth Avenue studio during the author's tour of North America in the fall and winter of 1897. This trip marked his first visit to the United States, and at each city where he alighted he was greeted with warm enthusiasm. While Hawkins described the visit as a "vacation," it was in fact a carefully orchestrated money-making tour that included seventy-six scheduled public readings in cities stretching as far west as St. Paul, Minnesota.[22] The celebrated lecture manager James Burton Pond was responsible for organizing Hawkins's visit. There to meet him upon his arrival in New York harbor, Pond accompanied the thirty-four-year-old author on his travels and left little time for him to dawdle.

During his time in New York, Hawkins presented readings at private clubs and public theaters. He lodged at the Everett House, a fashionable hotel on Union Square only a block from Ben-Yusuf's studio. In accounts of his visit by Ben-Yusuf and various newspaper reporters, Hawkins supposedly charmed all whom he met. Ben-Yusuf recalled, "Mr. Hawkins has a most soothing, delightful effect on one. He is so absolutely modest and unassuming that you can't forget who he is for sheer delight at finding him so entirely lacking in that self-conscious manner we find in so many other writers."[23]

The son of an Episcopal vicar who served for a time as a school headmaster, Hawkins was educated at Balliol College, Oxford, and initially pursued a career as a barrister in London. He entertained political ambitions, but, following his drubbing in a parliamentary election in 1892, he abandoned that course. He began to write fiction, in part to fill time during slow hours at work, and discovered, in the process, that his temperament was better suited to writing. He published his first books—including *The Prisoner of Zenda*—under the pseudonym Anthony Hope, so as not to detract from his legal work. Although he later published under his full name, he continued to be popularly known in both England and America just as Anthony Hope.

Anthony Hope Hawkins
Zaida Ben-Yusuf
Platinum print, 1897
23.6 × 14.9 cm (9⁵⁄₁₆ × 5⁷⁄₈ in.)
Philadelphia Museum of Art, purchased with the Lola Downin Peck Fund, the Alice Newton Osborn Fund, and with funds contributed by The Judith Rothschild Foundation in honor of the 125th anniversary of the Museum, 2002

Your good friend
Anthony Hope Hawkins

In this full-length portrait, Ben-Yusuf captures the author sitting casually on the edge of a writing desk. His dress matches a newspaper description of Hawkins published upon his arrival. He wears a "coat of black, and a vest of the same color unadorned except for a gold watch chain of heavy links, trousers of grey with narrow black stripe, and black square-toed shoes. His collar was cut squarely, open at the throat, and the tie, loosely made up, was of blue with tiny white spots."[24] Ben-Yusuf's time with her British compatriot was clearly memorable, and the resulting photographs pleased her very much. During the following year she included examples from this portrait session at two photographic exhibitions, one in New York and the other in London. Various critics singled out this photograph for praise in their reviews, including Sadakichi Hartmann, who dwelled at length on Ben-Yusuf's instincts as a portraitist. He wrote: "In subordinating her knowledge of composition to that which the momentary situation in gestures and attitudes affords, she is a truer artist than if she would try, like Miss Käsebier, to introduce her own personality at every occasion. Perhaps she relies too much on unforeseen happy incidents, but as they happen rather frequently the critic has no special reason to find fault with her method."[25]

Hawkins's first visit to America was an unqualified success and prompted the author to return at regular intervals in the future. On his next trip, in 1903, he met Elizabeth Somerville Sheldon, an American from Vermont who would later become his wife.

Although his productivity as a novelist declined in the last two decades of his life, Hawkins remained a well-regarded writer whose work in the realm of fantasy drew continued praise. In addition to being translated into many languages, his works were adapted for the theater and, later, for the cinema. In recognition of his service to the Ministry of Information during the First World War, Hawkins was knighted by King George V. He died at age seventy after a prolonged illness.

FHG

21 "Anthony Hope Dies; Noted for Novels," *New York Times* (July 9, 1933): 20.
22 "Anthony Hope is Here," *New York Times* (October 17, 1897): 21.
23 Ben-Yusuf, "Celebrities Under the Camera," 14.
24 "Anthony Hope is Here," 21.
25 Sadakichi Hartmann, "A Purist," *Photographic Times*, Vol. 31, no. 10 (October 1899): 452.

Anthony Hope Hawkins
Zaida Ben-Yusuf
Platinum print, 1897
The J. Paul Getty Museum, Los Angeles

43.

Paul-César Helleu

Artist
Born Vannes, France
December 17, 1859–March 23, 1927

"These American girls! When I walk out of this hotel on a beautiful clear day, at the hour when all the world is on the street, and turn into Fifth Avenue, with the hundreds of automobiles and the thousands of people on the sidewalks—ah, what girls I see there! All, all are beautiful—society girls just the same as the little humble hatmaker hurrying along the sidewalk."[26] Visiting New York during the winter of 1912–13, Paul-César Helleu attracted wide notice for his pronouncements about the beauty of women in New York. On assignment for the French weekly *L'Illustration*, he came hoping to identify and then depict the eight most beautiful women in America, a mission that resulted in a series of drypoint etchings, Helleu's chosen artistic medium. These works—published in the *New York Times*—further enhanced his reputation as a portraitist of women. He was also employed during this time in painting the ceiling of Grand Central Station with the signs of the zodiac. Like other European artists seeking a wider market for their work, Helleu found New York a tremendous boon for his career.

Ben-Yusuf had met and photographed the French artist during his first visit to New York ten years earlier. He traveled then in the company of the American expatriate John Singer Sargent, a close friend who had once shared a studio with him in Paris. Well regarded in the States, Sargent helped to put Helleu in touch with some of New York's most elite art patrons, and assisted in getting examples of the artist's work exhibited at a Fifth Avenue gallery and published in a leading periodical. Ben-Yusuf's portrait of Helleu was taken to promote his visit to New York and his exhibition at the Taft-Belknap Galleries—a space only seven blocks from Ben-Yusuf's studio. The photograph also accompanied an article on the art of portrait etching that he wrote for *Metropolitan Magazine*. In profile and with his arms crossed, Helleu looks self-confident and at ease in his surroundings. He appears the model of Continental sophistication.

Such was the reputation that the forty-three-year-old artist had forged for himself. Educated at the Ecole des Beaux-Arts in the atelier of Jean-Léon Gérôme—where he befriended Sargent—he ultimately rejected his teacher's highly finished academic style and strove hard to make a name for himself as an Impressionist painter. His friend Edgar Degas invited him to participate in the now-famous Impressionist exhibition of 1886 in Paris, but Helleu refused when he learned that the works of Paul Gauguin—an artist whom he abhorred—were to be included. This exhibition proved to be the last in a series of eight annual salons organized by the Impressionists.[27]

It was during this period that Helleu first began working in drypoint etching, a process in which the artist draws directly on to a copper plate that is then inked and printed. Few embraced this difficult technique, as it required a strong hand and a quick eye, and allowed little room for retouching or mistakes. Yet it appealed to Helleu, and before long he was known as a portraitist, with a special gift for depicting women. In explaining his affinity for female subjects, he later wrote, "The quick turn of a pretty woman's head, the curve of her shoulder, the lifting of her eyebrows—all these things are the delight of the trained etcher. His needle is ready to travel as swiftly as the emotions of his fair sitter. Before she has had time to lower her lids or lose the smile on her lips, the radiance of her hidden thought is caught upon the copper."[28]

Helleu at first portrayed close friends and family, but increasingly during the 1890s was commissioned to depict women from the elite stratum of European society. The elegant and

strikingly modern poses that he employed and his distinctive sweeping lines appealed to many would-be subjects. His affable personality also enabled him to ingratiate himself with his patrons. He returned to several subjects on repeated occasions, including Consuelo Vanderbilt (page 216). The beautiful daughter of an American railroad magnate, in 1895 she was compelled by her overbearing mother to marry the Duke of Marlborough, who in spite of his title was financially strapped. Helleu claimed repeatedly in print that Consuelo was "his favorite," an opinion that probably raised interest among potential clients in the United States.[29]

It was Helleu's search for feminine beauty—and for a new clientele—that led him to embark on his first transatlantic voyage in the fall of 1902. While he had never before traveled to New York, previous exhibitions of his work there had elicited much praise. Alongside Sargent, he made the rounds of New York society, securing many commissions. With his characteristic charm and speedy hand, he created dozens of portraits. He gravitated not simply to the affluent women of Manhattan, but also to the community of artists and theatrical stars who comprised an important element of New York society. Among his subjects were the famous actress Ethel Barrymore and Irene Langhorne Gibson, the glamorous wife of the artist Charles Dana Gibson (creator of the "Gibson girl"). Given Ben-Yusuf's attraction to those with fashionable taste, she was undoubtedly pleased by the opportunity to create Helleu's portrait.

Sadly, Helleu's first visit to New York was cut short by the news that his fifteen-year-old daughter was sick with typhoid fever, an illness that would ultimately prove fatal. The artist and his wife, Alice, had lost another daughter five years earlier, and these deaths proved devastating to the

Paul-César Helleu
Zaida Ben-Yusuf
Halftone print published in
Metropolitan Magazine, March 1903
Library of Congress, Washington, D.C.

splendor that characterized aspects of upper-class society at the turn of the century. As Helleu explained to a *New York Times* reporter in 1912: "When I see a beautiful face, then I want to make a picture. If the face is really beautiful, then I am inspired, and I work fast, and the work is a success. . . . I like only the beautiful and the young to picture. Age and ugliness, I do not wish to picture."[31]

FHG

26 "Helleu Talks of Pictures He Did for the Times," *New York Times* (March 16, 1913): 8.

27 Victoria Law, *Paul-César Helleu, 1859–1927: An Exhibition of Oils, Pastels, and Drypoints* (London: Richard Green, 1991): unpaginated.

28 Paul Helleu, "The Portrait Etcher and His Art," *Metropolitan Magazine*, Vol. 17, no. 3 (March 1903): 330.

29 Helleu, 330; and "An Etcher of Woman's Alertness," *Town & Country*, Vol. 57, no. 22 (August 9, 1902): 18.

30 "Two Liners in Port," *New York Times* (January 2, 1903): 14; and Law, unpaginated.

31 "Famous French Artist Seeks America's Prettiest Girls," *New York Times* (November 24, 1912): 10.

Consuelo Vanderbilt
Paul-César Helleu
Drypoint etching, *c.* 1900
National Portrait Gallery, Smithsonian Institution, Washington, D.C.; partial gift of Kathryn S. and John J.A. Michel

44.

Carsten Borchgrevink

Explorer
Born Christiania (Oslo), Norway
December 1, 1864–April 23, 1934

Through her photographic practice Ben-Yusuf met many whose achievements merited special distinction. Few, though, exhibited the sheer heroism of the explorer Carsten Borchgrevink. When he entered Ben-Yusuf's studio in the spring of 1902, he was widely regarded as one of the most intrepid explorers of his generation, having less than two years earlier led the first year-long expedition to survey the continent of Antarctica. No man had previously attempted to survive a winter in this cold and desolate land, and the story of his trip—not to mention his various discoveries—captivated the general public and the scientific community alike.

Explorers from Britain, America, and Russia had discovered Antarctica and surveyed its coastline from on board ship decades earlier. Yet, after a period of intense interest during the first half of the nineteenth century, curiosity about the continent waned considerably—in part because of the extraordinary hurdles that confronted anyone who looked to build upon earlier expeditions, but also because of a general ambivalence about its larger worth. The challenge of simply reaching the ice-locked continent was considerable. Surveying its interior was altogether a new test that required a substantial financial commitment, elaborate planning, and a willingness to endure extreme conditions—even to risk death—in a land about which little was known.[32]

Beginning in the 1890s, interest in the commercial fishing possibilities of the waters surrounding Antarctica precipitated a wave of new exploration, as expeditions from nine different countries were launched during the next three decades. The son of a barrister, Borchgrevink had been aboard a whaling vessel that landed at Cape Adare in Antarctica in January 1895, and this experience inspired him in the years immediately after his return to organize his own expedition with the primary goal of locating the South Magnetic Pole.

Borchgrevink raised £40,000 from a British publisher to underwrite the trip, the news of which brought criticism from the Royal Geographical Society, which was then planning its own Antarctic expedition. Aboard an old Norwegian whaler that he renamed the *Southern Cross*—a ship powered by both sail and steam—Borchgrevink left London in August 1898. Six months later, he dropped anchor at Cape Adare, where he set up camp and prepared to spend the next year with nine crew members

"Southern Cross" in the Pack-Ice near Balleny Island, January 23, 1899
Louis Bernacchi
Halftone print published in
Carsten Borchgrevink, *First on the Antarctic Continent*, 1901
Smithsonian Institution Libraries, Washington, D.C.

and a pack of sled dogs. The *Southern Cross* was sent back to New Zealand with instructions to return a year later. Alone on this massive continent, Borchgrevink and his colleagues conducted a comprehensive survey of the local region, mapping its terrain, studying its environment, and collecting a trove of natural specimens. They also conducted a series of scientific measurements that enabled them to identify the approximate location of the South Magnetic Pole.[33]

Most importantly, the expedition members concentrated their efforts on staying alive, especially when the severe winter season closed in upon them. For six consecutive months they endured average temperatures below zero degrees. From the beginning of May to the end of July, they were shrouded in darkness, as the sun never rose above the horizon. And the ferocious winds never seemed to let up. As Borchgrevink later wrote, he "found these gales blowing over forty miles an hour on more than twenty-six per cent of the day, and our exact anemometers registered some gales that were blowing over 100 miles an hour. Under these latter conditions it was not only difficult to move, but difficult to exist. During our sledge journeys these gales often compelled us to lie idle under a snow covering, while the food continued to be used up."[34] Yet, though they lost one man, he and his crew were in relatively fine health when the *Southern Cross* returned on schedule in January 1900 to pick them up.

Many honors and awards were bestowed on Borchgrevink on his return, and his illustrated account of the expedition, *First on the Antarctic Continent*, published by his sponsor in 1901, only heightened his international standing. In the spring of 1902, he traveled to America, where he was feted by the nation's scientific community. In New York, he stayed at the Everett House, the hotel in which

the lecture manager James Burton Pond had an office. Pond was arranging Borchgrevink's travels in the States and was responsible for bringing the famed explorer to Ben-Yusuf's studio.

Although Borchgrevink never traveled again to Antarctica, choosing instead to spend the rest of his life in his native Norway, he was recruited during his short time in America to join an expedition from New York to the Caribbean island of Martinique, where the volcanic Mount Pelée had recently erupted, causing the death of more than 30,000 local inhabitants. Less than a week after this natural tragedy, Borchgrevink was sailing south with two other distinguished geologists under the auspices of the National Geographic Society and the secretary of the U.S. Navy.

This scientific team remained in Martinique only long enough to survey the damage and to make a preliminary study of the volcanic activity on the island. Upon returning to New York, Borchgrevink became the first person to provide an eyewitness account of the destruction. This photograph—together with his report—was published not long after in *Frank Leslie's Popular Monthly*. Describing Borchgrevink as "a resolute explorer, a vigorous writer, and a well-equipped man of science," the editors of *Leslie's* provided its readers with not only the latest news from "one of the supreme tragedies of history," but also a glimpse at one of the heroes of the age.[35]

FHG

32 For an overview of the early expeditions to Antarctica, see Michael Rosove, *Let Heroes Speak: Antarctic Explorers, 1772–1922* (Annapolis, Md.: Naval Institute Press, 2000).

33 For a thorough report of this expedition, see Carsten Borchgrevink, *First on the Antarctic Continent: Being an Account of the British Antarctic Expedition, 1898–1900* (London: George Newnes, 1901).

34 "In the Antarctic Circle," *New York Times* (March 16, 1902): 15.

35 "Editorial Note," *Frank Leslie's Popular Monthly*, Vol. 54, no. 3 (July 1902): 232.

Alberto Santos-Dumont

Aviator
Born Cabangu, Brazil
July 20, 1873–July 24, 1932

Mankind's fascination with flight—though centuries old—was especially marked at the turn of the century. In Europe and America, scientists and engineers joined with amateur enthusiasts to explore new possibilities in aeronautics. While Orville and Wilbur Wright would make history at Kitty Hawk, North Carolina, in December 1903, it was in Paris that the greatest number of aviation pioneers then resided. Prominent among them was Alberto Santos-Dumont, a Brazilian who is credited as the first man to achieve heavier-than-air flight before a significant public audience. Characterized by "enthusiasm and imagination and a courage that amounted to recklessness," Santos-Dumont displayed an unrelenting drive throughout his life to further the advance of aviation.[36]

This ambition explains Santos-Dumont's presence in New York City in April 1902, and may account for his willingness to sit for his portrait at Ben-Yusuf's studio. He came to encourage the development and funding of an aviation competition at the upcoming Louisiana Purchase Exposition in St. Louis. During his two weeks in the United States, he visited a host of dignitaries, scientists, and potential investors, including President Roosevelt, Thomas Edison, and the Smithsonian Institution secretary, Samuel Langley, whose own experiments with flight had likewise become an obsession. Although Santos-Dumont had not made arrangements to demonstrate his airship on this visit, he promised to do so later that summer and during the St. Louis Exposition, so long as a suitable amount of money was raised as a prize for achieving certain aeronautical feats. He believed strongly that others should make a financial commitment to encourage the type of experimentation that would result in progress.

While such work was not inexpensive, Santos-Dumont's belief was grounded as much in

Alberto Santos-Dumont
Zaida Ben-Yusuf
Platinum print, 1902
20 × 15.6 cm (7⅞ × 6⅛ in.)
Library of Congress, Washington, D.C.,
Prints & Photographs Division

Santos-Dumont Circling the Eiffel Tower
Unidentified photographer
Gelatin silver print, 1901
National Air and Space Museum,
Smithsonian Institution, Washington, D.C.

principle as it was in a need for sufficient money
to underwrite his ventures. Santos-Dumont was in
fact a very rich man, having grown up on one of
the largest coffee plantations in Brazil. His interest
in flight was an outgrowth of an early fascination
with machinery—especially locomotives and
automobiles—on his family's estate. Having moved
to Paris to study engineering in 1891, Santos-
Dumont discovered there the sport of ballooning,
a hobby that soon became an all-consuming
passion. In 1898, he built the first of the fourteen
cigar-shaped dirigibles that he would design over
the course of the next decade. He regarded these
motorized, steerable balloons as experimental
aircraft that might some day provide the public
with a more efficient means of transportation.
He also looked upon them as a sort of pleasure
craft. Always well dressed, Santos-Dumont enjoyed
drinking champagne and having lunch in his
balloon, and often he created a spectacle by landing
on the Champs-Elysées or at his favorite restaurant
in the Bois de Boulogne.

Santos-Dumont was more than a dilettante,
though, and competed tirelessly to set new
standards for flight. In October 1901, aboard one
of his dirigibles, he won the Deutsch Prize for
being the first man to fly from the Parisian
suburb of St-Cloud—home of the Aéro Club de
France—to the Eiffel Tower and back in less than
thirty minutes. Widely hailed at the time as one of
the greatest aeronautical feats ever, this achievement
brought the twenty-eight-year-old pilot
international fame. His decision to give away
three-quarters of his 100,000 franc prize to the
poor in Paris and to split the remaining quarter
among his crew made him even more popular in
the public's eyes. Yet failure and near-tragedy
also marked his flying career, leading at least
one newspaper to state in an editorial that it was

"inevitable" that he would perish in pursuit of new aviation goals.[37] Indeed, only two months before traveling to America, he had lost his airship and almost his life during an overseas test run on the French Riviera, the details of which were published with Ben-Yusuf's photograph in *McClure's Magazine* in July 1902.[38]

Santos-Dumont was greeted in New York by both fanfare and controversy. Although he was much celebrated for his singular achievements, some were skeptical of his prowess as an engineer, believing that others were more responsible for recent advances in aeronautical design and fabrication. While certain accusations were overstated, it was true that the Brazilian employed the best talent and that his accomplishments were the result of much collaborative work. More significant, though, was the opinion that such aviation pioneers as Santos-Dumont had become enthralled by a technology that many believed lacked broad application. Instead, a new school of thought advocated the production of a heavier-than-air aircraft the motor and design of which would permit it to ascend by its own power rather than by heated air. As a writer for the *New York Times* remarked two days after Santos-Dumont's arrival, "He would lose thereby the present glory that results from balloon trips on carefully selected days at places where crowds are easily collected, but in the distance he would see a worthier fame, and whether he succeeded or failed, he would have the proud satisfaction of not wasting his time on toys."[39]

Santos-Dumont was in New York less than a week before rushing off to meet officials in Washington, D.C., and St. Louis. For the most part, his days were occupied by meetings with potential investors who might underwrite a significant aviation prize at the Louisiana Purchase Exposition. Many in France had been generous in establishing such prizes, and he hoped that enthusiasts in America might likewise step forward. It was also during this time that he agreed to pose before Ben-Yusuf's camera. Details about this occasion are few, but the resulting photograph suggests Santos-Dumont's interest in presenting himself to a larger American audience. The portrait hides the fact that he was short and of slight build, a source of some anxiety to him. Instead, it accentuates his self-confidence and cosmopolitan bearing. In this image, he is a modern pioneer, not one who is "wasting his time on toys."

In subsequent years, Santos-Dumont would continue his aeronautical experiments to great acclaim. Inspired by the Wright brothers, he moved beyond his interest in dirigibles and joined others in investigating the problems associated with heavier-than-air flight. While the Wrights had earlier demonstrated their aircraft to small private audiences in North Carolina and Ohio, Santos-Dumont made international headlines on November 12, 1906, when before a large crowd he won the Archdeacon prize for the "first" powered flight of more than 25 meters (80 feet). Although the Wright brothers had made such a trip almost three years earlier, viewers outside Paris that day believed that they were witnessing a world's first. Santos-Dumont died of natural causes in his native Brazil at the age of fifty-nine.

FHG

36 "First to Fly in Public," *New York Times* (July 26, 1932): 14.
37 "The Inevitable," *New York Times* (June 1, 1902): 15.
38 Sterling Heilig, "The Over-Sea Experiments of Santos-Dumont," *McClure's Magazine*, Vol. 19, no. 3 (July 1902): 195–206.
39 "Topics of the Times," *New York Times* (April 12, 1902): 8.

46.

Mary French Sheldon

Author, explorer
Born Beaver, Pennsylvania
May 10, 1847–February 10, 1936

Growing up in a well-to-do family and educated both in the United States and abroad, Mary French Sheldon had more opportunities to pursue various interests and careers than most women of her generation. She took advantage of her privileged background to work at different times as a publisher, a novelist, a playwright, a sculptor, a licensed medical doctor, and during the First World War as a Red Cross volunteer. Yet it was her feats as an explorer and a world traveler that made her one of the most celebrated women of her era. While she traveled around the world on three separate occasions, her greatest interest was the continent of Africa. In 1891, she became the first woman to lead an expedition into Africa accompanied only by hired African porters. Upon her return the Royal Geographical Society of Great Britain elected her a Fellow—the first time that they had conferred this distinction on a woman.[40]

Sheldon's fascination with Africa was a blend of her passion for adventure, science, and good works. Having married an American banker, Eli Lemon Sheldon, in 1870 and moved to London, she opened her home to various guests, most especially those with an interest in travel and exploration. It was through her fashionable salon that she befriended Henry S. Wellcome and Henry Morton Stanley, then the two most prominent British explorers of Africa. Sheldon was at the time in the middle of translating into English Gustave Flaubert's *Salammbô*—a historical novel set in northern Africa. The work on this translation and these new friendships furthered her desire to visit Africa herself. In addition, she hoped to make an original ethnographic contribution by observing and recording "the home life of the natives."[41] As a woman, she believed she would be better suited to gain access to the lives of African women.

Mary French Sheldon
Zaida Ben-Yusuf
Gelatin silver print, *c.* 1915
17.5 × 14.4 cm (6⅞ × 5¹¹⁄₁₆ in.)
Mary French Sheldon Papers, Manuscript Division, Library of Congress, Washington, D.C.

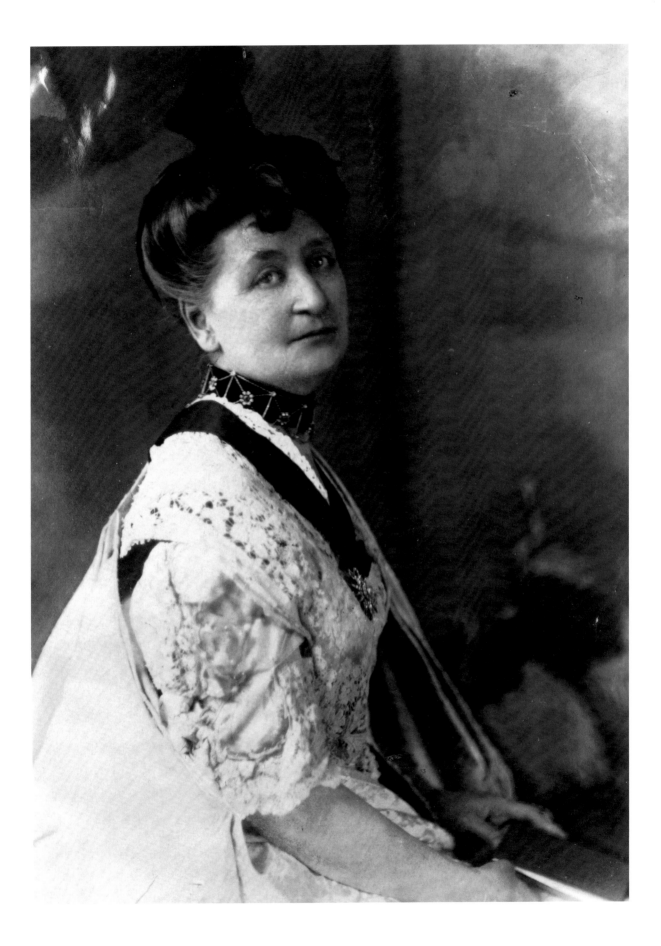

Mary French Sheldon
Zaida Ben-Yusuf
Gelatin silver print, *c.* 1915
Mary French Sheldon Papers, Manuscript
Division, Library of Congress, Washington, D.C.

Sheldon decided, with the advice of Wellcome and Stanley, to mount an expedition in the region around Mount Kilimanjaro in East Africa. She preferred to be unaccompanied, except for those Africans who would serve as guides and porters. As she later recalled, "I didn't take a woman with me because—well, because I get so absolutely obsessed by what I want to do that I simply can't bear to have my plans upset or altered. If I took another woman along, I thought, she might fall ill, and, out of common humanity, I should have to stop and care for her, and perhaps, be obliged to change my plans entirely." Regarding the company of men, she was likewise hesitant, feeling "afraid he would want to take care of me, and it would turn into his expedition instead of mine."[42] Although the British and German authorities in East Africa tried to put a stop to her plans by limiting the availability of African porters, she appealed successfully to the sultan of Zanzibar for assistance.

In March 1891, Sheldon began her expedition, loaded down with nearly three tons of baggage and with a team of 138 Africans at her side. Over the next three months, she traveled overland almost eight hundred kilometers (500 miles) from the coastal town of Mombasa to Kilimanjaro and back. While she rode at times in a specially constructed palanquin, she found that walking at the head of the group went a long way toward maintaining discipline among her charges. During her travels she made copious notes on the peoples she encountered. She also took photographs with the nine cameras she brought, and recorded voices with a phonograph. Her most heroic achievement, though, was to scale the steep rock embankments to explore Lake Chala, a body of water at the bottom of a volcanic crater near Kilimanjaro that had never before been surveyed by a white person. Although she had a frightening encounter with

a python, had to whip one of her charges for insubordination, and was injured while crossing a river about a week from the trip's end, Sheldon and the rest of her company arrived back safely, to the astonishment of many and the relief of all.

In addition to writing a popular book about her expedition, Sheldon joined the lecture circuit in Europe and America following her return. She used these occasions not only to describe her expedition, but also to speak out about popular misconceptions regarding Africa and her desire to cultivate, in communities throughout the continent, an American-style educational system. To her, Africa was not a hostile, barren place, but an undeveloped, resource-rich land with a vibrant native population. The success of her book and lecture tour was such that organizers of the World's Columbian Exposition in Chicago in 1893 requested objects from her trip for display in two different exhibition spaces.

Sheldon was well received at home—and supposedly in Africa too—in part because of the regal bearing she assumed in public. Dressed in fashionable outfits, she made an impression wherever she went. Ben-Yusuf's portrait of her conveys something of this magnificence. In a profile of Sheldon published in 1915, Ben-Yusuf recalled getting to know her years earlier in London, and noted with enthusiasm her unique taste in fashion. Having made the decision to travel in Africa, Sheldon "went first to Paris and there she bought the most wonderful, most gorgeous gowns to be imagined, low-necked evening dresses, really too theatrical for ordinary drawing-room wear, hats and all sorts of beautiful things. Then she started. Whenever her outriders announced that they were approaching a village—the more ferocious the better—Mrs. Sheldon dressed herself in those gorgeous clothes and when the natives saw

her they thought she was a goddess and almost worshipped her."[43] Indeed, included in her baggage was a white gown from the Parisian dressmaker Charles Worth that she wore repeatedly on her trip. Sheldon proudly embraced the name given to her by the Africans with whom she traveled, Bébé Bwana—the "White Queen."

Sheldon's interest in Africa and her commitment to its future welfare were neither fleeting nor superficial. In subsequent years, she returned twice. For fourteen months, beginning in the fall of 1903, she worked in the Congo Free State, investigating reports of atrocities in that Belgian colony. Two years later, she traveled in Liberia and reported positively on the progress that that nation was then making. Like Ben-Yusuf, Sheldon was a stylish, independent woman who pursued her interests with a passion rarely equaled in her day.

FHG

40 The best study of Sheldon's life and legacy is Tracey Jean Boisseau's *White Queen: May French-Sheldon and the Imperial Origins of American Feminist Identity* (Bloomington: Indiana University Press, 2004).

41 "A Woman to Explore Africa," *New York Times* (December 14, 1890): 6.

42 "With Gayest Parisian Clothes and Worshipped as a Goddess, She Explored Alone in Africa," *Washington Post* (February 21, 1915): 3.

43 *Ibid.*

Appendix 1:
Timeline of the Life of Zaida Ben-Yusuf

Compiled by Frank H. Goodyear and Jobyl A. Boone

Items in roman *refer to events in Ben-Yusuf's life.*

1869

Esther Zeghdda Ben Youseph Nathan (hereafter Zaida Ben-Yusuf, or ZBY) is born November 21, 1869, in London, England. She is the first-born daughter of Anna Kind Ben Youseph Nathan, from Berlin, and Mustafa Moussa Ben Youseph Nathan, a native of Algeria. On ZBY's birth certificate, her father is listed as a "gentleman" from Hammersmith in west London.

1881

Anna Ben-Yusuf works as a governess in the coastal town of Ramsgate, Kent, England. She is thirty-six years old and separated from her husband, with four daughters: Zaida (age 11), Heidi (age 8), Leila (age 4), and Pearl (age 3). During this period, Mustafa Ben-Yusuf presents occasional lectures on Arab culture on behalf of the Moslem Mission Society. He also enrolls at, but does not graduate from, the University of Cambridge.

1890

Jacob Riis publishes How the Other Half Lives, *illustrated with engraved prints of New York City tenements. These images are based on Riis's photographs.*

Madison Square Garden, designed by the celebrated architectural firm of McKim, Mead & White, opens. The building is lit by thousands of patterned lights and has a searchlight mounted on the roof.

1891

Anna Ben-Yusuf works as a milliner on Washington Street in Boston. The date and circumstances of her immigration are unknown. In London, Mustafa Ben-Yusuf and his second wife, Henrietta Crane, have a daughter. They name their child Zaida.

1892

A group of English photographers dissatisfied with the Photographic Society of Great Britain establishes the Brotherhood of the Linked Ring. Founding members include George Davison and Henry Peach Robinson. Their first salon is held at the Dudley Gallery in London the following year.

The immigrant-processing station opens on Ellis Island in New York harbor.

1893

Mussa Ben-Yusuf, the infant son of Mustafa Ben-Yusuf and Henrietta Crane, dies in London. The child's death certificate indicates that Mustafa works as a "licensed victualler."

New York Stock Exchange securities plunge, beginning a four-year depression.

1895

ZBY emigrates to the United States and works as a milliner at 251 Fifth Avenue in New York. Her mother remains in Boston, working as a milliner and living with ZBY's sister Pearl.

1896

The *Cosmopolitan Magazine* publishes two of ZBY's "photographic art studies" in the article "Some Examples of Recent Art," in the April issue.

The Society of Amateur Photographers of New York and the New York Camera Club consolidate in May to form the Camera Club of New York. Although offered the presidency, Alfred Stieglitz becomes the club's vice-president.

The Washington Salon and Art Photographic Exhibition is held in May at the Cosmos Club in Washington, D.C. Sponsored by the Camera Club of the Capital Bicycle Club, this exhibition includes works by club members and invited participants, and is considered the first American photographic salon.

ZBY exhibits one photograph in the Fourth Photographic Salon of the Linked Ring, held September 24 through November 7, at the Dudley Gallery in London.

ZBY travels to Europe in the fall and meets Linked Ring co-founder George Davison. She shows him examples of her photography, and he encourages her to continue this work. At the time Davison writes a monthly column, "English Notes," for the *American Amateur Photographer.*

Thomas Edison's vitascope shows the first American moving pictures at Koster & Bial's Music Hall in New York.

William McKinley is elected president of the United States.

Separate but equal accommodations for blacks and whites are deemed constitutional by the U.S. Supreme Court in Plessy v. Ferguson.

1897

ZBY's essay "Practical Lessons in Millinery" appears in the January 30 issue of *Harper's Bazaar*.

In the spring, ZBY moves to 124 Fifth Avenue, near Union Square, where she opens a portrait photography studio.

The first issue of Camera Notes, *the official journal of the Camera Club of New York, is published in July. Stieglitz serves as editor.*

ZBY contributes four photographs to the Fifth Photographic Salon of the Linked Ring, from October 4 through November 6.

On October 21, ZBY writes to Alfred Stieglitz regarding his invitation to reproduce an example of her portraiture in *Camera Notes*. About her photography, she explains that she is "very much in earnest about it all." Stieglitz publishes her work in *Camera Notes* the following April, and again in July.

The *New York Daily Tribune* publishes on November 7 an article about ZBY and mentions that her studio opened "only six months ago." The article describes the elaborate decorations that adorn the space, as well as her work creating advertising posters. *Leslie's Weekly* publishes a separate profile of her on December 30.

The City of New York turns over 105 hectares (261 acres) of land in the Bronx to the New York Zoological Society. The Bronx Zoo is to open two years later.

The new Delmonico's restaurant opens on Fifth Avenue at Forty-fourth Street.

Fire destroys the main immigration building at Ellis Island. All records are lost.

1898

ZBY exhibits two photographs at the Eastman Photographic Exhibition held at New York's National Academy of Design in January. In April, she contributes two works for an exhibition in Austria sponsored by the Vienna Camera Club.

On February 15, the U.S. battleship Maine *is sunk in Havana harbor, precipitating the Spanish–American War.*

Theodore Roosevelt resigns as assistant secretary of the Navy on May 6 to become lieutenant colonel of the First U.S. Volunteer Cavalry Regiment, the "Rough Riders." Later in the year, he becomes the governor of the state of New York.

ZBY publishes a two-part essay, "The Making and Trimming of a Hat," in the July and August issues of *Ladies' Home Journal*.

ZBY exhibits ten photographs at the American Institute's 67th Annual Fair at the National Academy of Design, held from September 26 through October 8. She also takes charge of the exhibition's decorations. Her portrait of the actress Virginia Earle wins third place in the "Portraits and Groups" class. She also contributes five photographs to the Sixth Photographic Salon of the Linked Ring in London from September 30 through November 5.

The First Philadelphia Photographic Salon is held at the Pennsylvania Academy of the Fine Arts from October 24 through November 12. Jurors include the painters Robert Vonnoh and William M. Chase, neither of whom appears at the judging; the illustrator Alice Barber Stephens, and the photographers Robert Redfield and Alfred Stieglitz. ZBY does not participate.

ZBY exhibits an extensive collection of her photographs alongside the work of Frances Benjamin Johnston at the Camera Club of New York from November 9 through 26. William Murray writes a lengthy review of ZBY's contribution to this exhibition in *Camera Notes*, published the following April.

The *Illustrated American* publishes a page-long profile of ZBY in its November 11 issue, featuring several reproductions of her photographs.

The five boroughs of New York City merge. With 3.4 million residents, New York becomes the world's second largest city.

1899

A blizzard on February 11 paralyzes New York City for a month.

ZBY photographs Theodore Roosevelt, governor of New York, in March.

ZBY is profiled with other female photographers in the March issue of the *American Amateur Photographer*.

The Windsor Hotel is destroyed on March 17 in the deadliest fire ever on Fifth Avenue.

ZBY travels to Boston in July to visit her mother and to meet F. Holland Day. Day completes a series of portraits of ZBY during their time together.

ZBY moves her studio to 578 Fifth Avenue, most probably in the fall. The Windsor Hotel, destroyed by fire just months before, is located across the street.

ZBY contributes two photographs to the Seventh Photographic Salon of the Linked Ring in London from September 22 through November 4.

On September 30, a parade down Fifth Avenue honors Admiral George Dewey, the hero of the Spanish–American War.

In the October issue of the *Photographic Times*, Sadakichi Hartmann publishes a lengthy profile of ZBY. Describing her as "a purist," Hartmann writes that "it is doubtful if there is in the entire United States a more interesting exponent of portrait photography."

ZBY exhibits four photographs at the Second Philadelphia Photographic Salon at the Pennsylvania Academy of the Fine Arts, from October 22 through November 19. F. Holland Day, Gertrude Käsebier, Clarence White, Frances Benjamin Johnston, and Henry Troth serve as the jurors.

In December, ZBY exhibits nine photographs at the Photographic Salon of the American Institute in New York.

ZBY photographs Major General Leonard Wood on December 16, the day of his departure from New York to take command of the provisional government in Cuba.

1900

In May ZBY exchanges letters with Frances Benjamin Johnston about a proposed exhibition of work by American women photographers at the Universal Exposition in Paris. Hastily assembled as a substitute for a canceled exhibition of American salon photographers, it opens in July. ZBY contributes five portraits. The exhibition travels later to St. Petersburg, Moscow, and Washington, D.C.

In October, Gertrude Käsebier and the British photographer Carine Cadby become the first women elected to the Linked Ring.

The Royal Photographic Society in London hosts an exhibition of American photographers organized by F. Holland Day. Entitled the *New School of American Photography*, it runs from October 10 through November 8 and features four photographs by ZBY.

Partially as a response to F. Holland Day's New School exhibition, Alfred Stieglitz takes charge of the Third Photographic Salon at the Pennsylvania Academy of the Fine Arts. Jurors include Gertrude Käsebier, Clarence White, Frank Eugene, and Eva Watson Schütze. The exhibition runs from October 21 through November 18. ZBY does not participate.

ZBY contributes three photographs to an exhibition from November 28 through December 1 organized by Clarence White in his hometown, Newark, Ohio.

The Associated Press news service is founded in New York City.

William McKinley is re-elected president of the United States, with Theodore Roosevelt as his vice-president.

1901

ZBY exhibits four photographs from May 2 through November 9 in a display juried by Alfred Stieglitz at the Glasgow International Exhibition in Scotland.

ZBY photographs former president Grover Cleveland during a fishing excursion at Hop Brook, near Tyringham, Massachusetts.

ZBY publishes "Celebrities Under the Camera" in the June 1 issue of the *Saturday Evening Post*. In this essay, ZBY describes many of her encounters with subjects she has photographed.

In the September issue of *Metropolitan Magazine*, ZBY publishes "The New Photography—What It Has Done and Is Doing for Modern Portraiture." She discusses her commitment to "a middle way" between the radicalism of certain fine art photographers and

the more prosaic approach of the majority of commercial photographers.

The anarchist Leon Czolgosz shoots President McKinley during a reception at the Pan-American Exhibition in Buffalo, New York. On September 14, McKinley dies, and Theodore Roosevelt becomes president.

ZBY is profiled as one of the "foremost women photographers in America" in the November issue of *Ladies' Home Journal*.

At the Fourth Philadelphia Photographic Salon, held from November 18 through December 14 at the Pennsylvania Academy of the Fine Arts, ZBY exhibits ten photographs. Alfred Stieglitz leads a boycott of this salon when he loses the authority to develop the exhibition to his liking.

Beginning on November 23, ZBY publishes the first of six illustrated articles for the *Saturday Evening Post* on the topic "Advanced Photography for Amateurs."

Approximately 70 percent of New York's population is living in tenements. In a movement toward reform, the Tenement Law is passed, requiring all new buildings to provide more air and light.

1902

Stieglitz organizes American Pictorial Photography *at New York's National Arts Club. The exhibition runs from March 5 through March 22. Considered the inaugural exhibition of the "Photo-Secession," it includes the work of thirty-two photographers felt by Stieglitz to aspire to a higher purpose. ZBY does not participate.*

Stieglitz publishes his last issue of Camera Notes *and then resigns as editor. Although it is dated July, it appears in May. Juan Abel, the former librarian at the Camera Club, assumes the editorship, but the magazine closes after only three further issues.*

The June 27 issue of the *New York Times* includes ZBY in a list of debtors. She owes $119 to Henrietta Prades, and is ordered by a local judge to make payment.

Photographer Edward Steichen returns to New York from Paris in August, intending to open a portrait studio.

ZBY exhibits two photographs at the Tenth Photographic Salon of the Linked Ring in London between September 19 and November 1.

1903

Stieglitz publishes the first issue of his new journal, Camera Work, *in January.*

ZBY travels by steamship to Japan, arriving in Yokohama in April. She tours Kobe and Nagasaki before continuing on to Hong Kong for a brief sojourn. Returning to Japan, she rents a house for the summer in Kyoto, with the stated purpose of living "in native fashion." She travels to Tokyo and Nikko during her stay, and returns to New York in the fall.

The Salon Club of America is established in December by Louis Fleckenstein and Carl Rau, accepting members from across the United States and from all schools of art photography.

On December 17, at Kitty Hawk, North Carolina, aviation pioneers Orville and Wilbur Wright are the first to achieve controlled, sustained flight with a heavier-than-air machine.

The Williamsburg Bridge, connecting Brooklyn and Manhattan, opens to traffic.

1904

ZBY publishes the first of four illustrated articles, "Japan Through My Camera," in the April 23 issue of the *Saturday Evening Post*.

Sadakichi Hartmann mentions ZBY's contributions to the newly formed Salon Club of America in the July issue of the *American Amateur Photographer*.

The New York City subway opens in October. This underground line runs twenty-two miles, from City Hall to 145th Street.

A fire destroys the Boston studio of F. Holland Day on November 11.

Sponsored by the Salon Club of America, the First American Photographic Salon opens in New York in December. ZBY is listed in the catalogue as a member, though she does not submit any work.

1905

On January 12, the *New York Times* again includes ZBY in a list of debtors.

ZBY's essay "A Kyoto Memory" is published in the February issue of the *Booklover's Magazine*. That same month, *Leslie's Monthly Magazine* publishes ZBY's illustrated article "Women of Japan."

In March, Theodore Roosevelt is inaugurated for a second term as president of the United States.

In September, Anna Ben-Yusuf begins teaching at the Pratt Institute in Brooklyn. She is an instructor of millinery in the Department of Domestic Arts.

Beginning October 14, *American Art News* publishes a weekly profile of an American artist accompanied by a portrait by ZBY. This feature lasts seven weeks.

On November 23, ZBY delivers an illustrated lecture, "Japanese Homes," at Pratt's Assembly Hall.

Alfred Stieglitz's inaugural exhibition at the Little Galleries of the Photo-Secession at 291 Fifth Avenue opens on November 24. One hundred photographs by thirty-nine photographers are featured. ZBY does not participate.

1906

ZBY publishes twenty architectural photographs to accompany Katharine Budd's article "Japanese Houses" in the January issue of the *Architectural Record*. The February issue features ZBY's article on Japanese architecture, "The Period of Daikan."

In March, ZBY serves as a member of the National Preliminary Jury for the Second American Photographic Salon, held at the Art Institute of Chicago. However, she does not contribute work.

The architect Stanford White is shot dead in June by the socialite Harry Thaw in the roof garden of Madison Square Garden, which White had helped to design. Thaw's wife and White's mistress, the actress Evelyn Nesbit, witness the incident.

In September, *Photo Era* publishes three photographs by ZBY from her visit to the Mediterranean island of Capri. The accompanying article suggests that she "passed considerable time there not long ago, exploring its mountains, rocks, and grottoes."

In October, ZBY exhibits one portrait at the Third Annual Exhibition of Photographs at the Worcester Art Museum in Massachusetts.

Theodore Roosevelt is awarded the Nobel Peace Prize on December 10 for his efforts toward ending the Russo–Japanese War in 1905.

1907

ZBY publishes an essay, "The Honorable Flowers of Japan," in the March issue of *Century*.

Some time this year ZBY decides to close her studio.

The New York stock market crashes in March. Another panic ensues in mid-October. On November 4, the financier J. P. Morgan calls New York's most powerful bankers to his home and detains them until they construct a plan to shore up the failing market.

The Salon Club of America is dissolved.

1908

"The Eight" opens in February at the Macbeth Galleries, at 450 Fifth Avenue. This exhibition includes the group of artists who would later become known as the Ashcan School.

In June, ZBY publishes in the *Saturday Evening Post* the first of three essays about living in England. In that same month, Anna Ben-Yusuf resigns her position at Pratt to establish a school of her own on West 23rd Street.

ZBY returns to New York on November 9 aboard the S.S. *Vaderland* after a period abroad. An article in the next day's *New York Times* indicates that she has apparently traveled 56,300 kilometers (35,000 miles), including a visit to Japan. The writer describes her as an "artist-lecturer."

Henry Ford introduces the Model-T automobile, available for $850.

William H. Taft is elected president of the United States.

1909

On November 21, ZBY celebrates her fortieth birthday in London.

Anna Ben-Yusuf dies in New York on December 8.

1911

The London phone book lists ZBY as a photographer in the Chelsea district of London.

On March 25, 146 immigrant workers, mostly women and children, are killed when fire consumes the Asch Building of the Triangle Shirtwaist Company.

1912

In April, bound for New York from Southampton, England, the Titanic *strikes an iceberg and sinks, with the loss of 1502 lives.*

In October, Sadakichi Hartmann writes that ZBY "has given up the vanities of the photographic world for an unrestrained life in the South Sea Islands." Few in New York seem to know her whereabouts.

Woodrow Wilson is elected president of the United States.

1913

The Armory Show in New York introduces modern European art to the United States.

1914

Archduke Franz Ferdinand is assassinated at Sarajevo in June, prompting the beginning of the First World War. In August, Germany declares war on France and begins a military offensive toward Paris.

The Panama Canal officially opens on August 15, after more than a decade of construction.

On September 15, ZBY arrives in New York on a ship from Le Havre, France. Her naturalization papers indicate that she had been living in Paris at the time. She finds an apartment at 40 West 39th Street.

1915

The British ocean liner R.M.S. Lusitania *is sunk by a German U-boat off the coast of Ireland on May 7, and 1198 are killed, including 128 Americans. This act of aggression against a commercial vessel helps sway American popular opinion in favor of joining the war.*

Alfred Stieglitz writes to ZBY on December 8, enclosing a check for $6.00 from the sale of her copies of *Camera Work*. She replies to him three weeks later, thanking him for his help in selling these copies.

1916

The May 17 issue of the *New York Times* includes ZBY in a list of debtors. She owes $261 to Elizabeth Lorillard, a New York socialite.

1917

In March, ZBY takes out an advertisement in the *New York Times*, seeking "a young lady, or beginner, clever at sewing."

The United States declares war against Germany and enters the First World War. The first American troops arrive in France in October.

1918

Germany signs the armistice treaty on November 11, ending the First World War.

1919

On June 30, ZBY files a declaration for naturalization in New York. She lists "photographer" as her occupation and 142 West Forty-fourth Street as her address. In her statement, she lists her age as thirty-nine—ten years younger than she actually is. ZBY celebrates her fiftieth birthday on November 21.

1920

ZBY visits Cuba in the fall, returning to New York on October 24.

The Nineteenth Amendment to the Constitution is enacted, granting suffrage rights to women.

1921

ZBY returns to New York on September 29, after a trip to Jamaica. Passenger records list her as a "retired artist."

1924

ZBY works for the Reed Fashion Service in New York City. During this period, she travels often to give lectures on such topics as "Personality in Dress" at local department stores.

1926

ZBY is appointed the style director of the annual spring fashion show of the Retail Millinery Association in New York. She later becomes the director of this organization.

1930

Census records indicate that ZBY has married Frederick J. Norris, a textile designer, and that they live in a rented apartment in Greenwich Village. There are few details about this marriage.

1933

On September 27, ZBY dies at the age of sixty-three at the Methodist Episcopal Hospital in Brooklyn. A brief notice of her death is published in the *New York Times*.

Other Portraits by Zaida Ben-Yusuf

This list represents named subjects photographed by Ben-Yusuf whose portraits have not been reproduced in this book. None of these portraits has been located.

Minnie Ashley (lifedates unknown; actress)

Nancy Huston Banks (lifedates unknown; author)

Rosa Boote (lifedates unknown; actress)

Kenyon Cox (1856–1919; artist)

Frederick Dielman (1847–1935; artist)

Virginia Earle (1875–1937; actress)

Paula Edwardes (lifedates unknown; actress)

James L. Ford (1854–1928; author)

Mabelle Gillman (lifedates unknown; actress)

Frances and Carolyn Gordon (lifedates unknown; actresses)

Ernest Haskell (1876–1925; artist)

William Travers Jerome (1859–1934; lawyer)

Mary Cadwalader Jones (lifedates unknown; socialite)

Gustav Kobbé (1856–1918; music and art critic)

Elinor Macartney Lane (1864–1909; author)

Agnes Christina Laut (1871–1936; author)

Richard Le Gallienne (1866–1947; author)

George Lesoir (lifedates unknown; actor)

James Powers (1862–1943; actor)

Winifred Rhoades (lifedates unknown; minister)

Hallie Ermine Rives (1865–1956; author)

Moriz Rosenthal (1862–1946; pianist)

Annie Russell (1864–1936; actress)

William Sampson (1840–1902; naval officer)

Henrietta Schroeder (1876–1942; horticulturalist)

Cyril Scott (1866–1945; actor)

Robert Shackleton (1860–1923; author)

Louis Evan Shipman (1869–1933; author)

Penrhyn Stanlaws (1877–1957; artist)

H.S. Taber (lifedates unknown; actor)

Nelson Jarvis Waterbury (lifedates unknown; lawyer)

Thomas Whiffen (lifedates unknown; actor)

Jesse Lynch Williams (1871–1929; author)

Selected Bibliography

ARCHIVAL SOURCES

Papers of the Camera Club of New York, New York Public Library, New York City.

Curtis Publishing Company Records, Rare Book & Manuscript Library, University of Pennsylvania, Philadelphia.

F. Holland Day Papers, Archives of American Art, Smithsonian Institution, Washington, D.C.

Family Records Centre, National Archives, London, England.

Frances Benjamin Johnston Papers, Library of Congress, Washington, D.C.

Gertrude Käsebier Papers, Morris Library, University of Delaware, Newark.

Papers of the Linked Ring Brotherhood, National Media Museum, Bradford, England.

Alfred Stieglitz Papers, Beinecke Rare Book and Manuscript Library, Yale University, New Haven, Connecticut.

WRITINGS BY ZAIDA BEN-YUSUF

"Advanced Photography for Amateurs, No. I—Portraits." *Saturday Evening Post*, Vol. 174, no. 21 (November 23, 1901): 4–5.

"Advanced Photography for Amateurs, No. II—Landscapes." *Saturday Evening Post*, Vol. 174, no. 25 (December 21, 1901): 8–9

"Advanced Photography for Amateurs, No. III—Night Photography." *Saturday Evening Post*, Vol. 174, no. 28 (January 11, 1902): 8–9.

"Advanced Photography for Amateurs, No. IV—Apparatus." *Saturday Evening Post*, Vol. 174, no. 32 (February 8, 1902): 6–8.

"Advanced Photography for Amateurs, No. V—Making the Picture." *Saturday Evening Post*, Vol. 174, no. 36 (March 8, 1902): 4–5.

"Advanced Photography for Amateurs, No. VI—Methods and Materials with Examples by the Author." *Saturday Evening Post*, Vol. 174, no. 40 (April 5, 1902): 10–11.

"American vs. English Prices." *Saturday Evening Post*, Vol. 180, no. 52 (June 27, 1908): 18.

"Celebrities Under the Camera." *Saturday Evening Post*, Vol. 173, no. 48 (June 1, 1901): 13–14.

"The Cost of Living in London." *Saturday Evening Post*, Vol. 180, no. 49 (June 6, 1908): 5–7.

"The Honorable Flowers of Japan." *Century Magazine*, Vol. 73, no. 5 (March 1907): 697–705.

"Japan Through My Camera." *Saturday Evening Post*, Vol. 176, no. 43 (April 23, 1904): 6–7.

"Japan Through My Camera." *Saturday Evening Post*, Vol. 176, no. 44 (April 30, 1904): 14–15.

"Japan Through My Camera." *Saturday Evening Post*, Vol. 176, no. 49 (June 4, 1904): 6–7.

"Japan Through My Camera." *Saturday Evening Post*, Vol. 177, no. 6 (August 6, 1904): 8–9

"A Kyoto Memory." *Booklover's Magazine*, Vol. 5, no. 2 (February 1905): 182–85.

"The Making and Trimming of a Hat—First Lesson: Ribbon Trimming." *Ladies' Home Journal*, Vol. 15, no. 8 (July 1898): 17.

"The Making and Trimming of a Hat—Second Lesson: Making a Straw Braid Hat." *Ladies' Home Journal*, Vol. 15, no. 9 (August 1898): 19

"The New Photography—What It Has Done and Is Doing for Modern Portraiture." *Metropolitan Magazine*, Vol. 16, no. 3 (September 1901): 390–97.

"Our Practical Cousins." *Saturday Evening Post*, Vol. 181, no. 23 (December 5, 1908): 48–51.

"The Period of Daikan." *Architectural Record*, Vol. 19, no. 2 (February 1906): 145–50.

"Women of Japan." *Leslie's Monthly Magazine*, Vol. 59, no. 4 (February 1905): 417–22.

PRIMARY SOURCES

Abel, Juan. "Women Photographers & Their Work." *The Delineator* 58, no. 3 (September 1901): 406–11.

"American Portraiture." *American Amateur Photographer*, Vol. 12, no. 3 (March 1900): 111–112.

"An Artist-Photographer." *Current Literature*, Vol. 34, no. 1 (January 1903): 21.

Barnes Ward, Catherine Weed. "Photography as a Profession for Women." *American Amateur Photographer*, Vol. 3, no. 5 (May 1891): 172–76.

—— "Photography from a Woman's Standpoint." *American Amateur Photographer*, Vol. 2, no. 1 (January 1890): 10–13.

—— "Women as Photographers." *American Amateur Photographer*, Vol. 3, no. 9 (September 1891): 338–41.

—— "Women in Photography." *American Amateur Photographer*, Vol. 8, no. 3 (March 1896): 95–98.

Barton, Marion. "In Woman's Realm: A Remarkable Woman Photographer." *Illustrated American*, Vol. 24, no. 456 (November 11, 1898): 377.

Ben-Yusuf, Anna. "Is It a Disadvantage to Be a Woman?" *Boston Globe* (July 7, 1895): 20.

Bisland, Margaret. "Women and Their Cameras." *Outing*, Vol. 17, no. 1 (October 1890): 36–43.

Brook, T. Mobley. "Figure Studies and Pictorial Portraiture." *American Amateur Photographer*, Vol. 9, no. 1 (January 1897): 29–34.

Budd, Katharine. "Japanese Houses." *Architectural Record*, Vol. 19, no. 1 (January 1906): 2–26.

Caffin, Charles. *Photography as a Fine Art*. New York: Doubleday, Page & Company, 1901.

Crane, Frank. "American Women Photographers." *Munsey's Magazine* 1, no. 4 (July 1894): 398–408.

Day, F. Holland. "Art and the Camera." *Camera Notes*, Vol. 2, no. 1 (July 1898): 3–5.

—— "Opening Address: The New School of American Photography." *Photographic Journal*, Vol. 25, no. 2 (October 1900): 74–80.

—— "Portraiture and the Camera." *American Annual of Photography and Photographic Times Almanac, 1899* no. 14 (1899): 19–25.

Felix, Frederick. "Young Women and Photography." *American Amateur Photographer*, Vol. 8, no. 1 (January 1896): 3–4.

Frohman, Daniel. "Actress Aided by Camera." *Cosmopolitan Magazine*, Vol. 22, no. 4 (February 1897): 413–20.

Fuguet, Dallett. "Portraiture as Art." *Camera Notes*, Vol. 5, no. 2 (October 1901): 79–82.

Green, Floride. "Specialized Photography." *New York Daily Tribune* (June 27, 1898): 5.

Hartmann, Sadakichi. "Aesthetic Activity in Photography." *Brush and Pencil*, Vol. 14, no. 1 (April 1904): 24–41.

—— "American Photography at Russell-Square." *British Journal of Photography* 47, no. 2117 (November 30, 1900): 767.

—— "A Few American Portraits." *Wilson's Photographic Magazine*, Vol. 49, no. 670 (October 1912): 457–59.

—— "A Few Reflections on Amateur and Artistic Photography." *Camera Notes*, Vol. 2, no. 2 (October 1898): 41–45.

—— "A New Departure in American Pictorialism." *Photograms of the Year* (1904): 37–42.

—— "Portrait Painting and Portrait Photography." *Camera Notes*, Vol. 3, no. 1 (July 1899): 3–21.

—— "A Purist." *Photographic Times*, Vol. 31, no. 10 (October 1899å): 450–55.

—— *The Valiant Knights of Daguerre: Selected Critical Essays on Photography and Profiles of Photographic Pioneers*. Berkeley: University of California Press, 1978.

—— "A Walk Through the Exhibition of the Photographic Section of the American Institute." *Camera Notes*, Vol. 2, no. 3 (January 1899): 86–89.

Hines, Richard. "Women and Photography." *American Amateur Photographer*, Vol. 11, no. 3 (March 1899): 118–24.

Hoeber, Arthur. "A Portrait and a Likeness." *Camera Notes*, Vol. 2, no. 3 (January 1899): 73–76.

Hughes, Rupert. "Art in Portrait Photography." *Cosmopolitan Magazine*, Vol. 26, no. 2 (December 1898): 123–34.

—— "Triumphs in Amateur Photography—IV." *Godey's Magazine*, Vol. 136, no. 813 (March 1898): 257–65.

"In the Art World." *New York Times* (February 19, 1898): 24.

Johnston, Frances Benjamin. "The Foremost Women Photographers in America, Sixth Article: Zaida Ben-Yusuf." *Ladies' Home Journal*, Vol. 18, no. 12 (November 1901): 13.

—— "What a Woman Can Do with a Camera." *Ladies' Home Journal*, Vol. 14, no. 10 (September 1897): 6.

Käsebier, Gertrude. "Studies in Photography." *Photographic Times*, Vol. 30, no. 6 (June 1898): 269–72.

Maclean, Hector. "The Two Chief Photographic Exhibitions of the Year—II. The Salon." *Photographic Times*, Vol. 29, no. 2 (February 1897): 70.

"Miss Ben-Yusuf Returns." *New York Times* (November 10, 1908): 13.

Moore, Clarence. "Women Experts in Photography." *Cosmopolitan Magazine*, Vol. 14, no. 5 (March 1893): 580–90.

Murray, William. "Miss Zaida Ben-Yusuf's Exhibition." *Camera Notes*, Vol. 2, no. 4 (April 1899): 168–72.

—— "Mr. W.M. Hollinger on Photographic Portraiture." *Camera Notes*, Vol. 2, no. 4 (April 1899): 160–61.

"People Talked About." *Leslie's Weekly*, Vol. 85, no. 2207 (December 30, 1897): 437.

"Pictorial Photographer." *New York Daily Tribune* (November 7, 1897): 4.

"Portraiture and the Photograph: The Thoughts of Portrait Painters." *Scribner's Magazine*, Vol. 27, no. 3 (March 1900): 381–84.

Pringle, Andrew. "The Naissance of Art in Photography." *The Studio*, Vol. 1, no. 3 (June 1893): 87–95.

Randall, John. "Photography as an Occupation for Women." *British Journal of Photography*, Vol. 47, no. 2099 (July 27, 1900): 473–74.

"Some Clever Photographs." *New York Times* (December 8, 1899): 6.

Staley, Kathryn. "Photography as a Fine Art." *Munsey's Magazine* 14 (February 1896): 582–91.

Stieglitz, Alfred. "Our Illustrations." *Camera Notes*, Vol. 3, no. 1 (July 1899): 24.

—— "Pictorial Photography." *Scribner's Magazine*, Vol. 26, no. 5 (November 1899): 528–37.

SECONDARY SOURCES

Alland, Alexander. *Jessie Tarbox Beals: First Woman News Photographer*. New York: Camera/Graphic Press, 1978.

Banta, Martha. *Imaging American Women: Idea and Ideals in Cultural History*. New York: Columbia University Press, 1987.

Berch, Bettina. *The Woman Behind the Lens: The Life and Work of Frances Benjamin Johnston, 1864–1952*. Charlottesville: University Press of Virginia, 2000.

Burns, Sarah. *Inventing the Modern Artist: Art and Culture in Gilded Age America*. New Haven, Conn.: Yale University Press, 1996.

Burrows, Edwin. *Gotham: A History of New York City to 1898*. New York: Oxford University Press, 1999.

Collins, Kathleen, ed. *Shadow and Substance: Essays on the History of Photography*. Bloomfield Hills, Mich.: Amorphous Institute Press, 1990.

Curtis, Verna, and Jane Van Nimmen. *F. Holland Day: Selected Texts and Bibliography*. New York: G.K. Hall & Co., 1995.

Daniel, Pete, and Raymond Smock. *A Talent for Detail: The Photographs of Miss Frances Benjamin Johnston, 1889–1910*. New York: Harmony Books, 1974.

Davidov, Judith Fryer. *Women's Camera Work: Self/Body/Other in American Visual Culture*. Durham, NC: Duke University Press, 1998.

Eisinger, Joel. *Trace & Transformation: American Criticism of Photography in the Modernist Period*. Albuquerque: University of New Mexico Press, 1995.

Fulton, Marianne, ed. *Pictorialism into Modernism: The Clarence H. White School of Photography*. New York: Rizzoli, 1996.

Gamber, Wendy. *The Female Economy: The Millinery and Dressmaking Trades, 1860–1930*. Urbana: University of Illinois Press, 1997.

Glenn, Susan. *Female Spectacle: The Theatrical Roots of Modern Feminism*. Cambridge, Mass.: Harvard University Press, 2000.

Gover, Cynthia. *The Positive Image: Women and Photography in Turn-of-the-Century America*. Ph.D. Dissertation, State University of New York at Stony Brook, 1984.

Greenough, Sarah. *Modern Art and America: Alfred Stieglitz and His New York Galleries*. New York: Bulfinch, 2000.

Griffith, Bronwyn, ed. *Ambassadors of Progress: American Women Photographers in Paris, 1900–1901*. Hanover, NH: University Press of New England, 2001.

Harker, Margaret. *The Linked Ring: The Secession Movement in Photography in Britain, 1892–1910*. London: Heinemann, 1979.

Hight, Eleanor. "Japan as Artefact and Archive: Nineteenth-Century Photographic Collections in Boston." *History of Photography*, Vol. 28, no. 2 (Summer 2004): 102–22.

Hirshler, Erica. *A Studio of Her Own: Women Artists in Boston, 1870–1940*. Boston: MFA Publications, 2001.

Hoffman, Katherine. *Stieglitz: A Beginning Light*. New Haven, Conn.: Yale University Press, 2004.

Homer, William. *Alfred Stieglitz and the Photo-Secession*. Boston: Little, Brown, 1983.

—— *Alfred Stieglitz and the Photo-Secession, 1902*. New York: Viking Studio, 2002.

—— *Pictorial Photography in Philadelphia: The Pennsylvania Academy's Salons, 1898–1901*. Philadelphia: Pennsylvania Academy of Fine Arts, 1984.

Jussim, Estelle. *Slave to Beauty: The Eccentric Life and Controversial Career of F. Holland Day, Photographer, Publisher, Aesthete*. Boston: David R. Godine, 1981.

Keller, Ulrich. "The Myth of Art Photography: A Sociological Analysis." *History of Photography*, Vol. 8, no. 4 (October–December 1984): 249–75.

Kitch, Carolyn. *The Girl on the Magazine Cover: The Origins of Visual Stereotypes in American Mass Media*. Chapel Hill: University of North Carolina Press, 2001.

Meech, Julia, and Gabriel Weisberg. *Japonisme Comes to America: The Japanese Impact on the Graphic Arts, 1876–1925*. New York: Harry N. Abrams, 1990.

Michaels, Barbara. *Gertrude Käsebier: The Photographer and Her Photographs*. New York: Harry N. Abrams, 1992.

Moffatt, Frederick. *Arthur Wesley Dow*. Washington, D.C.: Smithsonian Institution Press, 1977.

Naef, Weston. *The Collection of Alfred Stieglitz: Fifty Pioneers of Modern Photography*. New York: The Viking Press, 1978.

Panzer, Mary. *In My Studio: Rudolph Eickemeyer, Jr. and the Art of the Camera*. Yonkers, NY: The Hudson River Museum, 1986.

Peterson, Christian A. *Alfred Stieglitz's Camera Notes*. New York: W.W. Norton & Company, 1993.

—— "American Arts and Crafts: The Photograph Beautiful, 1895–1915." *History of Photography*, Vol. 16, no. 3 (Fall 1992): 189–232.

Poulson, Elizabeth. "Catherine Weed Barnes Ward: Another Forgotten Victorian Photographer." *The History of Photography Monograph Series*, no. 8, 1984.

—— "Zaida." *The History of Photography Monograph Series*, no. 18, 1985.

Prieto, Laura. *At Home in the Studio: The Professionalization of Women Artists in America.* Cambridge, Mass.: Harvard University Press, 2001.

Pyne, Kathleen. *Art and the Higher Life: Painting and Evolutionary Thought in Late Nineteenth-Century America.* Austin: University of Texas Press, 1996.

—— *Modernism and the Feminine Voice: O'Keeffe and the Women of the Stieglitz Circle.* Berkeley: University of California Press, 2007.

Quitslund, Toby. *Her Feminine Colleagues: Photographs and Letters Collected by Frances Benjamin Johnston in 1900.* College Park: University of Maryland Press, 1979.

Roberts, Pam. *F. Holland Day.* Amsterdam: Van Gogh Museum, 2000.

Robinson, Edward. "Photographer Frances Benjamin Johnston (U.S. 1864–1952): The Early Years, 1889–1904." D.Phil. Thesis, The Faculty of Modern History, University of Oxford, 2005.

Rosenblum, Naomi. *A History of Women Photographers.* New York: Abbeville Press, 1994.

Sandweiss, Martha A., ed. *Photography in Nineteenth-Century America.* New York: Harry N. Abrams, 1991.

Schneirov, Matthew. *The Dream of a New Social Order: Popular Magazines in America, 1893–1914.* New York: Columbia University Press, 1994.

Smith, Joel. *Edward Steichen: The Early Years.* Princeton, NJ: Princeton University Press, 1999.

Smith, Shawn Michelle. *American Archives: Gender, Race, and Class in Visual Culture.* Princeton, NJ: Princeton University Press, 1999.

Smith-Rosenberg, Carroll. *Disorderly Conduct: Visions of Gender in Victorian America.* New York: Knopf, 1985.

Sternberger, Paul Spencer. *Between Amateur & Aesthete: The Legitimization of Photography as Art in America, 1880–1900.* Albuquerque: University of New Mexico Press, 2001.

Swinth, Kirsten. *Painting Professionals: Women Artists and the Development of Modern American Art, 1870–1930.* Chapel Hill: University of North Carolina Press, 2001.

Taylor, John. *Pictorial Photography in Britain, 1900–1920.* London: Shenval Press, 1978.

Taylor, William. *In Pursuit of Gotham: Culture and Commerce in New York.* New York: Oxford University Press, 1992.

Trachtenberg, Alan. *Reading American Photographs: Images as History, Mathew Brady to Walker Evans.* New York: Hill & Wang, 1989.

Van Hook, Bailey. *Angels of Art: Women and Art in American Society, 1876–1914.* University Park: Pennsylvania State University Press, 1996.

Weaver, Jane, ed. *Sadakichi Hartmann: Critical Modernist.* Berkeley: University of California Press, 1991.

Weaver, Mike, ed. *British Photography in the Nineteenth Century: The Fine Art Tradition.* Cambridge: Cambridge University Press, 1989.

Wexler, Laura. *Tender Violence: Domestic Visions in an Age of U.S. Imperialism.* Chapel Hill: University of North Carolina Press, 2000.

Whelan, Richard. *Alfred Stieglitz: A Biography.* New York: Little, Brown, and Company, 1995.

—— ed. *Stieglitz on Photography: His Selected Essays and Notes.* New York: Aperture Foundation, 2000.

Zurier, Rebecca, *et al. Metropolitan Lives: The Ashcan Artists and Their New York.* New York: W.W. Norton & Co., 1995.

Index